Telling Flesh

Telling Flesh

The Substance of the Corporeal

Vicki Kirby

ROUTLEDGE
New York and London

Published in 1997 by

Routledge
29 West 35th Street
New York, NY 10001

Published in Great Britain in 1997 by

Routledge
11 New Fetter Lane
London EC4P 4EE

Copyright © 1997 by Vicki Kirby

Printed in the United States of America
Design: Jack Donner

All rights reserved. No part of this book may be reprinted or reproduced or utilized in any form or by any electronic, mechanical, or other means, now known or hereafter invented, including photocopying and recording, or in any information storage or retrieval system without permission in writing from the publishers.

The author gratefully acknowledges permission to reprint previously published material here. Line drawings reprinted from *Course in General Linguistics* by Ferdinand de Saussure, edited by Charles Bally and Albert Sechehaye. Reprinted by permission of Peter Owen Limited, London.

Library of Congress Cataloging-in-Publication Data

Kirby, Vicki, 1950–
Telling flesh : the substance of the corporeal / Vicki Kirby.
 p. cm. Includes bibliographical references and index.
 ISBN 0–415–91030–7 (hb). — ISBN 0–415–91029–3 (pb)
 1. Body. Human—Social aspects. 2. Body, Human—Symbolic aspects.
 I. Title
 GN298.k57 1997
 306.4—dc21 97–9790
 CIP

For Pat and Roy

Contents

Acknowledgments ix

Introduction 1

one
Corporeal Complexity 7
The Matter of the Sign

two
Corpus Delicti 51
The Body *as* the Scene of Writing

three
Poststructuralist Feminisms 83
Part 1: Accommodating Matter: Drucilla Cornell

four
Poststructuralist Feminisms 101
Part 2: Substance Abuse: Judith Butler

five
Reality Bytes 129
Virtual Incarnations

Conclusion 149
Cannibal Subjects

Notes 163

Bibliography 183

Index 195

Acknowledgments

I am especially grateful to friends and colleagues who offered comments and suggestions on the manuscript: Sue Best, Sande Cohen, Elizabeth Grosz, Valerie Hazel, and Alan Rumsey. I would also like to acknowledge the importance of Liz Grosz in her capacity as a gifted and generous teacher. The intellectual charge that she brought to the first classes I audited on poststructuralism all those years ago were absolutely inspiring. Her encouragement and friendship have been invaluable to me.

I would also like to thank the following people for their help and support through the long gestation of my argument: Alia Arasoughly, Jonathan Bordo, Carolyn Burke, Pheng Cheah, Jim Clifford, Linda Dement, Julian Dibbell, Gary Dowsett, Ann Game, Jane Gilbert, Noel Gray, Dick Hebdige, Marie de Lepervanche, Meaghan Morris, Mahmut Mutman, Dorothea Olkowski, David Schneider, Marita Sturken, Hayden White, Lilyn Brudner White, Liz Wilson, Anna Yeatman, and Meyda Yegenoglu.

My greatest debt, however, is to Geoff Batchen. He encouraged me to return to university and to begin this, my second career. He has been there throughout this project's development, editing my work, arguing with me about ideas and commitments, and introducing me to a rich array of intellectual resources that I would otherwise have missed. I want to thank Geoff for the rich conversation that my life has become.

I am also grateful for the following research support: Mellon-Pew Postdoctoral Fellowship 1994/95, California Institute of the Arts; Visiting Fellowship 1993, Humanities Research Centre, Australian National University; Foundation Fellowship 1993, Auckland University; Visiting Teaching Fellowship 1992, Centre for Women's Studies, University of Waikato, New Zealand; Australian Postgraduate Research Award 1990/91, University of Sydney; International Fellowship 1988/89, American Association of University Women; Regents' Research Fellowship 1989, University of California at Santa Cruz; Commonwealth Postgraduate Research Award

1987, University of Sydney, GHS and IR Lightoller Scholarship 1987, University of Sydney.

A version of part of chapter 2, "Corpus Delicti: The Body *as* the Scene of Writing," appeared under the titles of "Corpus delicti: the body at the scene of writing," in R. Diprose and R. Ferrell (eds.), *Cartographies: Poststructuralism and the Mapping of Bodies and Spaces,* Sydney: Allen and Unwin, (1991) and "Corporeal Habits: Addressing Essentialism Differently," in *Hypatia: Journal of Feminist Philosophy* 6, 3: 9–24.

Introduction

The question of corporeality has provoked critical thinkers over the centuries, and in more recent years is evident in the growing lists of new titles devoted to the body. Nevertheless, it seems appropriate that an introduction to yet another book on the body should have some claim for special attention, some justification that might prove persuasive to an already jaded reader. In pondering how I might go about this task, I've come to realize—albeit with the clarity of hindsight—that my work has been shaped by a rather bruising intellectual itinerary. The result is by no means a happy amalgam of insights gleaned from desultory studies in different academic departments. It is, I suspect, much more a response to the sort of blustering hostility that my questions have so often occasioned. The vehemence of this hostility has sometimes been bewildering. Yet I've always had a genuine curiosity about the motivations behind the sort of intellectual defensiveness that kicks in with the swiftness of a visceral reflex. The strategies are various yet consistent in their urgent need to shut down inquiry. As I've watched this phenomenon, I've been aware that on some deep level my critics had a better grasp of what they were defending than I had of what I might be threatening. But what was it, exactly, that made my questions so improper?

Now, I can't deny that the shoe has also been on the other foot. Some of my most interesting insights have come from finally, reluctantly perhaps, being made to think more carefully about a question that I've answered with dismissive impatience. Why, if it is indeed so silly, does a particular question possess some lingering ability to irritate me? It's something I've come to refer to as "the dumb question," because it's the sort of inquiry that seems naïve and quite ignorant about the discursive protocols that would rule it out of order. In a way, disciplinarity decides the impropriety of such questions when they fall outside a recognized genre of interrogation. Yet inasmuch as a prohibition is also an enticement, the "dumb question" remains irrepressible.

This book approaches the problematic of corporeality in a way that attempts to anticipate and to counter "the dumb question's" too-easy dismissal. For example, I've tried to disturb oppositional categories by sustaining the tension between them. I am critical of an empiricism that perceives data as the raw and unmediated nature of the world. However, I am just as critical of postmodern correctives that regard the apparent evidence of nature as the actual representation of culture. Put simply, my aim is to pose the nature/culture (body/mind) question in a way that cannot be resolved by taking sides in this way. This is an argument about rethinking politics and value, an argument that takes the insights of antihumanism so literally that the subject of humanness itself is placed in jeopardy.

The story begins simply enough. Like so many other women whose political consciousness was formed in the heady days of the 1960s and 1970s, I remained unconvinced that the roles and expectations inherited by men and by women and by other socially differentiated groups were natural determinations. I believed that if something was truly immutable, then it was indeed given by nature and there wasn't much we could do about it. But it was increasingly clear that so-called natural prescriptions were actually political assignments, historical and cultural values that could be questioned and transformed. My interest in such issues was focused through the lens of feminism. The two disciplines that provided the empirical evidence that things were significantly different in other times and in other places were anthropology and history. The sheer variety of gender roles and sexualities, the different divisions of labor, the many social arrangements that could equally be described as a "family," the seemingly arbitrary determinations of race and ethnicity in different locations—such fluidity across space and time showed that change was possible and inevitable.

Although the implications of such diversity fascinated me enough to begin a second degree in anthropology, there was something about my original understanding of the nature/culture division that began to bother me. My initial interest in the empirical facts of difference underwent a significant assault as I began reading in the area of poststructuralism. I don't want to belabor the details of this narrative, so suffice it to say that I converted to the claim that "there is no outside of text." This, however, is where my troubles really began. It seemed that what I understood by this enclosure of textuality bore little resemblance to its disciplinary interpretation within literary criticism, nor to its more generalized reading in critical and cultural studies. In the social sciences I was regarded as overly abstract, whereas in interdisciplinary spaces that underlined their theoretical credentials I was accused of being a naïve materialist. I certainly asked a lot of dumb questions.

An example of the sort of phenomenon that inspired my style of inquiry might prove helpful here. Surely any attempt to understand the body differently is provoked by images of the Hindu ritual festival of *thaipusam*.[1] However it might be conveyed through the conventions of ethnographic reportage, the descriptive minutiae of this ritual's context do little to explain what makes its performance so compelling. Even if we could presume to elaborate the cultural significance of this festival within Hinduism, as it is expressed in a specific geographical location, and as it might be understood and even experienced by a particular participant, such explanations cannot answer our prurient curiosity. It is not the explanations that this man or his society might make of his ritual action that fascinate us, but rather the simple fact of what this ritual action has apparently made of him. We are astonished voyeurs, entranced by the enigma of this man's fantastic and grotesque body, this spectacle that bends flesh and muscle into service—willing tongue, cheeks, belly, and hands to perform their very biology differently.

This particular devotee is part of a religious procession. He is walking a considerable distance with many others who are similarly impaled within what could be described as a type of elaborate metal scaffolding. The infrastructural support for these constructions is the devotee's own body. Myriad metal spokes are driven into the skin and organs. The hands may also be pierced and even the tongue immobilized by long spikes thrust through the face, lips, and neck. To be skewered by any one of these metal prongs would prove at least painful for most of us, and conceivably lethal. Bleeding, scarring, and internal injury would be the inevitable results of what, in a different context, could be read as abuse.

Yet for the serious thaipusam devotee, none of these effects is realized. This man does not bleed, nor does he scar. Indeed, whatever the *weltanschauung*, structural frame, or cultural text—call it what you will—through which this man's body is ciphered and located as "being in the world," one can only presume that this information also informs the very matter of his body's material constitution. This is data whose language and text is the very tissue of his body. Its interior and exterior surfaces, the skin and membranes that divide as they connect the complexity of its parts, have not functioned as borders that separate one body part from another. This confounding of the inside/outside division, although *within* the individual, suggests that perhaps even the relationship *between* individuals is also one of profound implication.

This image is provocative precisely because it problematizes orthodox understandings of just what a body is. The body, that universal, biological stuff of human matter, that "something shared" that the social sciences

install as the common ground of inquiry, is somewhat qualified here. The devotee would seem to share his body's peculiarly plastic articulation with other devotees. However, this cultural/ritual in-corporation is not generalizable, for it does not extend to the bodies of tourists, or even to other members of the devotee's own community who might witness the festival. Social scientists have tended to delimit their field of investigation to the interpretation and contextualization of the body, and medical discourse arbitrates the final truth of this universal translation. Consequently, researchers stop short of asking how it is that the cultural context that surrounds a body can also come to inhabit it. Ethnography's acknowledgment that there are remarkable and myriad interpretations of the body can therefore still presume an essential, universal body that is just variously explained.

However, if empirical observation is strangely blind to the implications of what it sees, many critical or postmodern approaches to the question of corporeality have also been shy of matter, despite claims to the contrary. Is it a dumb reading of Michel Foucault, for example, to consider that if discourse constitutes its object, then matter is constantly rewritten and transformed? Or is it absurd to assume, that if there is no outside textuality, then the differential of language is articulate in/as blood, cells, breathing, and so on?

As this is simply an introduction, I am forced to raise these questions in a way that I will render quite differently in the body of the argument. I am not content to pose such inquiry in a way that leaves the categories of nature and culture intact, as if the charge in my question only acknowledges the permeability of the body of nature to the inscriptive penetrations of the writing machine we call culture. I want to suggest instead that something a little more perverse and interesting might be going on.

As I said earlier, I converted to an appreciation that "there is no outside of language" some time ago. The importance of this assumption, or at least my particular interpretation of it, is explored in the first chapter and much of the second. I felt the need to address the work of Ferdinand de Saussure in order to explain how the question of language can render substance and corporeality entirely problematic. Although Jacques Derrida's work on language has inspired my efforts profoundly, I make only passing mention to him in these early chapters. Derrida's name, as well as the term "deconstruction," are often read as signs of an intellectual style whose moment has past. As I didn't want to deter the reader from pushing on and perhaps discovering something different in my own particular "take," I have tried not to use Derrida's name at every turn. I can only hope that the argument itself will constitute a more profound form of acknowledgment than the mere repetition of an authorizing proper name could allow.

Introduction

The struggle to make a difference is a parasitic enterprise, and an inevitable result of this is that my argument shares a sort of cloying proximity to the work of my chosen protagonists. Despite my criticisms, I am incapable of separating myself in any final way from the work I write about. In chapters 2–4, I discuss the work of Jane Gallop, Drucilla Cornell, and Judith Butler because, in their different ways, all of these writers acknowledge the complexity of a corporeal politics. I would like to think of my own argument as an attempt to sustain the importance of the questions these women have raised. Yet I also want to suggest that their reliance upon a psychoanalytic understanding of the sign, or a reading of "the discursive" that subordinates itself to an unproblematized category of "the social," returns us to the very nature/culture, body/mind divisions that are so politically insidious.

I also examine the question of corporeality and cyberspace, because current debate around this issue is instructive in its predictability. For most commentators, the separation of nature from culture is rendered palpable in the actual object, or interface, of the computer screen: a material body on one side is separated from the intellection of representational abstraction on the other. One of "the dumb questions" that I found especially provocative in regard to the Cartesianism of this apparent face-off, a question evoked by a paper about the relationship between Kant and virtual reality, was, "Does representation in the computer program have a body?" I was surprised when the speaker, whose paper attempted to complicate the mind/body division, responded with certainty that this was, of course, impossible: after all, "[p]ure representation can't have a body." As I remain dissatisfied with this sort of answer that pretends to know the nature of matter (as the matter of nature no less) and where it resides, I want to reiterate why it is politically and ethically important to question such affirmations of purity and self-presence.

Finally, in the conclusion, I explore the nature/culture division again, this time as it is called to defend the identity of humanness itself against an illiterate and unthinking "outside." By broaching the subject of the posthuman through antihumanism, I do not suppose that what is deemed to be outside culture or before mind, either in its conventional representations or in its more theoretically careful evocations, ever lacked for a supplement or was ever passively inarticulate. Opening the question of corporeality through the nature/culture divide, we are confronted by the alien within—in the form of a very real possibility that the body of the world is articulate and uncannily thoughtful.

one
Corporeal Complexity

The Matter of the Sign

> The two-sided linguistic unit has often been compared with the human person, made up of the body and the soul. The comparison is hardly satisfactory. A better choice would be a chemical compound like water, a combination of hydrogen and oxygen; taken separately, neither element has any of the properties of water.
>
> —Saussure, *Course in General Linguisitics*

an "irritating duplicity . . . impossible to pin down"
(Saussure, as cited in Gadet 1989: 64)

The *Course in General Linguistics* (Saussure 1974)[1] has been described as "the Magna Carta of modern linguistics" (Harris 1987: x), "an almost 'Copernican revolution' in the study of language" (Koerner 1973: 9), the ancestral text that "forms the groundbase on which most contemporary structuralist thinking now rests" (Hawkes 1977: 19). Yet the work that purportedly initiates a paradigm shift in modern thought is strangely orphaned. Routinely attributed to the Swiss linguist Ferdinand de Saussure, the *Course* was not actually written by him. First published in 1916, it was a compilation of students' notes that was posthumously conceived—born from the efforts of two colleagues who had not themselves attended Saussure's classes.

The task of reconstructing Saussure's thought is further complicated by what Françoise Gadet has termed Saussure's veritable "graphophobia," for the Master of Geneva showed an enduring reluctance to write (Gadet 1989:14). Saussure published very little during his lifetime, and it seems that even his remaining private notes were fortunate to survive. We might imagine the consternation felt by his devoted interpreters when, assuming they had only to collate the linguist's manuscripts with the students' class notes, they found instead, "nothing—or almost nothing—that resembled his students' notebooks. As soon as they had served their purpose, F. de Saussure destroyed the rough drafts of the outlines used for his lectures" (Bally and Sechehaye

1974: xxix). Even though some brief preparatory jottings and other desultory fragments of writing provided evidence of the general direction of Saussure's endeavors, the editors were mainly left to rely on a few student records, gleaned from three quite separate courses spanning a period of six years.[2] The result is both fascinating and frustrating in its ambiguity, a paradox of disparate propositions expressed in confusing and often contradictory terminology.

Still, there is something curiously fitting about this equivocal beginning that sees the Master animated by the ventriloquism of his disciples, eager to express "a thought which is not yet fully born" (Culler 1986: 19), "a thought still in search of its angle of attack" (Gadet 1989: 24). For the question of how to secure a beginning, an origin or entity that will guarantee the proper point of departure for interpretation, is the essential problematic that Saussure's work explores and that its difficulties enact. Saussure apprehends that any beginning must always be provisional because we are already underway, caught in the vertigo of an infinite regress of other beginnings that both motivate and limit the focus of our attentions. Consequently, a Saussurean approach to things involves a certain messy entanglement. Indeed, referring to the book that he was never to write, Saussure anticipated that the logical presentation of his ideas would be confounded by necessity:

> There is genuinely a necessary absence of any starting point, and if a reader wants to follow my thought carefully from one end of this volume to the other, he will, I am sure, recognize that it was *impossible to follow a very rigorous order*.
>
> I shall take the liberty of placing the same idea before the reader as many as three or four times, because *no one point of departure is more appropriate than another as a foundation for the demonstration*. (Saussure as quoted in Gadet 1989: 25)

Caught in the relentless involution of his own argument, Saussure was unable to represent the rebus of its apparent mystery. On a torn and undated page among his manuscripts, we glimpse the linguist's growing sense of defeat as he labored to explain the complexity of his approach while still retaining some semblance of persuasive clarity:

> In the case of linguistics, the torture [i.e., writing] is increased for me by the fact that the more simple and obvious a theory may be, the more difficult it is to express it simply, because I state as a fact that there is not one single term in this particular science which has ever been based on a simple idea, and that this being so, one is tempted five or six times between the beginning and end of a sentence to rewrite. (Saussure, cited in Starobinski 1979: 3)

If Saussure was paralyzed by the confounded nature of his own thought, it seems that later admirers of the *Course* have not felt themselves similarly encumbered. Interpreters of the *Course* have tended to defend the value of its legacy by separating its insights from the peculiar ambiguities of the text's perceived failures. Ironically, as a direct result of this, the most radical implications of Saussure's work have arguably eluded many of the linguist's commentators.[3] To give a different reckoning of "what Saussure saw without seeing, knew without being *able* to take into account" (Derrida 1984: 43) demands something more than a remedial corrective. It involves tracing the itinerary of Saussure's argument through some of those same disabling contradictions and apparent confusions in order to acknowledge their constitutive importance to his innovative vision. Once these ambiguities are not dismissed as careless mistakes, the provocations of Saussure's work can be engaged differently. At the same time, the complacency with which our received notions of materiality, politics, and corporeality are conventionally comprehended and deployed might also be challenged and dislodged.

The following discussion, even when it appears otherwise, could productively be read as an extended meditation on Saussure's first principle of linguistics, the arbitrary nature of the sign (Saussure 1974: 67). Trotted out in every semiotics primer, this principle is one of the better known features of Saussurean theory, even though it is probably the least original. Taken to mean that the signifier bears no intrinsic relationship to what it signifies, this notion is perfectly consistent with an inherited tradition of Western thought that dates back to the Stoics.[4] Even before then, we witness a similar view beginning to emerge in Plato's famous dialogue, the "Cratylus" (1875), where Hermogenes and Cratylus debate the relationship between language and reality as one given either "by nature" *(physei)* or "by convention" *(thesei)*.

It would seem, then, that the Copernican revolution in linguistics and critical theory does not derive from this inherited axiom. Saussure provides various clues to suggest that "the arbitrary nature of the sign," at least as he understands it, entails a deceptive complexity that may not be assumed in the work of his predecessors:

> No one disputes the principle of the arbitrary nature of the sign, but it is often easier to discover a truth than to assign to it its proper place. Principle 1 dominates all the linguistics of language; its consequences are numberless. It is true that not all of them are equally obvious at first glance; only after many detours does one discover them, and with them the primordial importance of the principle. (Saussure 1974: 68)

Saussure's elaboration of the nature of the linguistic sign provides one such detour through which the proper significance of this first principle of language might better be determined. Nevertheless, we could be forgiven for being skeptical. Jacques Derrida considers the sign's internal division "problematical at its root" (1985a: 20), and, according to Émile Benveniste, Saussure's brilliant reconceptualization of *langue* (as semiology) "has been obstructed, paradoxically, by the same instrument which created it: the sign" (Benveniste 1985: 243). Saussure himself was not unaware of an attendant problem with the word, inherited from the very linguistic tradition he sought to undermine. "As regards *sign,* if I am satisfied with it, this is simply because I do not know of any word to replace it, the ordinary language suggesting no other" (1974: 67).

Given these cautionary warnings, we will not be surprised that Saussure's initial discussion of the sign serves a propaedeutic function, gently broaching a looming maze of potential difficulties by explaining the shortcomings of the commonsense notion of language as nomenclature. This view posits the sign as a surrogate for something else, a name that represents the meaning of the thing for which it "stands in." Although this is a naïve conception according to Saussure, he will concede that it nevertheless approaches the truth inasmuch as it recognizes that "the linguistic unit is a double entity, one formed by the associating of two terms"(1974: 65).[5] The argument begins, however, with the decision over which two terms are united in the sign and exactly how they are combined.

Saussure maintained that the constitutive elements of the sign were mental and not physical. "The linguistic sign unites, not a thing and a name, but a concept and a sound image" (1974: 66). In the third Course, Saussure introduces the terms signifier *(signifiant)* and signified *(signifié)* to capture this division between the "psychological imprint of the sound, the impression that it makes on our senses," and its mental representation or meaning (66). However, Roman Jakobson disputes whether Saussure's use of these terms offers anything new, suggesting that they merely mimic the ancient Stoic tradition that figures an indissoluble unity of *sēmainon* and *sēmainomenon* as, respectively, the perceptible (signifier) and intelligible (signified) parts of the sign *(sēmeion)* (1987: 413). Yet the similarity is only apparent, and Jakobson's conflation elides some important differences. For example, the Platonic conception of the sign installs the signified, or idea, before the signifier that conjures it. Words were thus the phonic exterior of pre-existing ideas, and as a consequence the "indissoluble unity" of the Platonic signifier and signified presumed their original separation (Kristeva 1989: 109).

The Saussurean sign granted no elemental priority to either signifier or

signified. Both terms were created within the bond of the sign: they were not independent entities that were then conjoined. Saussure compared language with a sheet of paper: "thought is the front and the sound the back; one cannot cut the front without cutting the back at the same time; likewise in language, one can neither divide sound from thought nor thought from sound" (1974: 113). This analogy would appear to capture the paradox of the sign's divided unity *in time*.[6] However, there is a problem with this. If the signifier and signified are contemporary according to this comparison, they are nevertheless separated *in space* by the thickness of the paper itself. Thus thought and sound are figured as both amorphous and spatially delimited.

This conceptual difficulty also haunts the sign's diagrammatic representation (Saussure 1974: 66, 67). Saussure explains that "[t]he two elements are intimately united, and each recalls the other" (66). Yet the word "recalls," together with the directional arrows, imply that the signifier and signified are indeed differentiated both spatially and temporally. Unfortunately, the specter of nomenclature resurfaces in this representation, where every signifier would seem to evoke a particular signified that has already been assigned to it.[7]

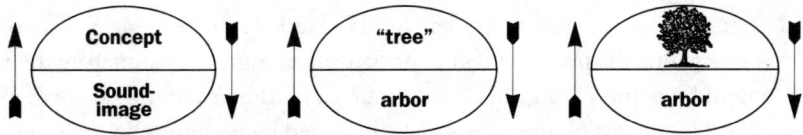

In positing the existence of a space, however small, between the signifier and signified, there follows some requirement to theorize its operation. What explains the attraction of the signifier and signified across that separating divide? Of course, it was precisely this type of question that Saussure's notion of the sign tried to displace, given that its logical conclusion presumed a causal connection between the two parts of the sign. Yet in spite of this, his argument does seem to embrace the tenets of nomenclature that he elsewhere rejected. This contradiction can be attributed, in part, to an inherent confusion over just what constitutes the basic units under discussion. As this is an instructive confusion, it deserves our careful attention.

Beginning again, we find that if we return to Saussure's opening remarks on language as a naming process, he is quite unclear about what nomenclaturists add to a signifier in order to make a sign. As Saussure attempts to elaborate his position, there is a slippage in the *Course* between the words "thing" and "idea."[8] In this account, the signified becomes something of an ambiguous entity, vacillating between the notions of "concept" and "reality." And the signifier is also caught in indecision. "To signify" can be glossed as "to

be the sign of something." Hence the signifier is commonly conflated with the entirety of the sign itself. As a consequence, the signifier is thought to incorporate both sound-image and idea, and the referent, or reality's substance, is inadvertently smuggled in as the signified to which it attaches. These textual contradictions that confuse signifier with signified by introducing a third term, namely, reality itself, beg a crucial question about what exactly we are to do with the referent in the Saussurean model of the sign.

It has already been suggested that even conventional linguistic wisdom conceded that the sign was a bipartite structure. Yet in spite of this, previous conceptualizations of the sign actually conjured with three terms: thing, word, and idea. The Saussurean sign represented a radical departure from this implied trinity, and the difference is underlined in a celebrated criticism by C. K. Ogden and I. A. Richards. In *The Meaning of Meaning*, the authors argue that the bipartite structure of the Saussurean sign is an inadequate conceptualization because it ignores the fact of reality by excluding the referent, "[u]nfortunately this theory of signs, by neglecting entirely the things for which signs stand, was from the beginning cut off from any contact with scientific methods of verification" (1956: 6). Set adrift from the sturdy stuff of reality, Saussure's position is deemed by Ogden and Richards to be necessarily absurd. After describing the peculiarities of the Saussurean sign, they anticipate their argument by commenting, "The disadvantage of this account is, as we shall see, that the process of interpretation is included by definition in the sign!" (1956: 5). Saussure's error in this assumption is considered self-evident. The exclamation mark forecloses any serious consideration of such a possibility.

Marie-Laure Ryan is another writer who exemplifies an impatience with the way "Saussure's doctrine 'frees' the sign from its ties with the world" and all its pressing political urgencies (1979: 44).[9] Ryan is clearly irritated by those who would still subscribe to this "Saussurean cult" that chooses fictions over facts. Ryan presumes that signification for Saussureans "is not the representation of thoughts and of states of affairs, but the incessant movement by which each term of the linguistic system leads back to every other term" (44). Saussurean linguistics is here understood as a turning away from the world, an indulgent abrogation of ethical and social responsibility that reveres language as "a sacred and autonomous power" (44).

In a much more informed criticism, although one that is similarly couched in the terms of an heretical skepticism against the Saussurean credo, Vincent Descombes counts himself another disbeliever. He remains unconvinced by what he describes as "the mystery of the left-hand box" (1986).[10] Descombes divides the *Course*'s original image as shown here into a four-part grid, hence his reference to boxes.

Corporeal Complexity

The mystery refers to what he regards as a semiological sleight of hand whereby these boxes that represent parts of the sign are surreptitiously filled. Although this composite representation would appear to describe an ostensive notion of language that Saussure disputes, Descombes queries how the image nevertheless "works" as a sign. For Descombes, the figurative illustration presumes precisely what needs to be explained. Descombes also suggests that Saussure's use of Latin cleverly deflects some important questions. "We know that Saussurean linguistics excludes semantic problems from its field of study. The 'referent,' to use an expression that came later, would be bracketed off" (Descombes 1986: 158).[11]

In an argument that becomes increasingly obscure, we can nevertheless glean an important question. Descombes is curious about why the figure on the left-hand side, a figure that supposedly shares an arbitrary relationship with the word on the right, should be designated by that particular image. We might extend Descombes's question further by acknowledging that both the word and the image are each already signs, not just parts of signs. Related to this, it is conventional practice to describe the sign's components in the order signifier/signified (left/right) rather than the other way around. Given this, why do we so automatically break with convention and presume that the left-hand figure is the signified? Is the reason for this that we have also merged the notion of "concept" with "reality," just as Saussure did before us? If we admit that the difference between "concept" and "reality" is indeed blurred here, we still need to explain how this confusion is produced. Why, for example, is the drawing quite naturally confused with reality? It is worth noting that the word is no less a graphic image than the drawing is. And yet we tend to regard the word as a cultural (and therefore arbitrary entity), whereas we tend to regard the drawing as deriving from nature.

Despite the difficulties in his argument, Descombes remains surprisingly unaware of many of the inherent ambiguities that attend his question. For

example, Descombes finds nothing particularly curious in the logic that installs the left-hand box as the signified. And indeed, he underwrites his own investment in this same logic by inferring from it that "the left-hand boxes were filled first" (1986: 159).

In sum, if we consider the objections to Saussurean linguistics posed by Ryan and Descombes, their respective arguments, however different, both focus on the way that Saussure dispenses with reality/the referent. For Ryan, Saussure willfully abandons the world for language. For Descombes, the opposite is the case. Despite Saussure's claims that reality's substantive presence does not witness the truth or distortion of the sign's representation, Descombes argues that the referent is nevertheless ubiquitous: it is an unacknowledged third term that is merely disavowed by Saussure's misguided disclaimer.

Ryan's misleadingly glib representation and Descombes's more complicated misgivings are not easily addressed and, unfortunately, the defense against such criticisms is often far from salutary. For example, Roy Harris's attempt to salvage something from this muddle is finally indistinguishable from its confusions. Referring again to Saussure's use of the sign "arbor" and the complication of the accompanying "tree picture," Harris argues that Saussure was actually interested in

> how, conceptually, the Latin language used the sign *arbor* to contrast with other Latin linguistic signs. And this is essentially an "internal" matter pertaining to the structure of Latin. It has to do only indirectly with the "external" botanical facts, or with such knowledge of botany as the Romans possessed. (1987: 64)

According to Harris, Saussure is quite different from the nomenclaturists because he "finds no place for the botanical 'thing' we call a tree" (64). Yet if we linger over the last sentence of the above quotation, we notice that reality, for which Saussure can apparently find no place, is nevertheless connected to language, even if "only indirectly." Harris doesn't expand on this possible concession, suggesting as it does that the relationship between language and reality is more qualified than severed. For he quickly goes on to make a firm distinction between the materiality of the tree as a botanical fact and the way that we conceptualize this extralinguistic entity. As Harris explains it:

> Thus when Saussure's diagram offers *arbre* as a conceptual "translation" of *arbor*, it implies neither that what the French mean by *arbre* the Romans meant by *arbor*, nor that botanical classifications have remained invariant for two thou-

sand years; but merely—and more basically—that the relationship between the Latin *signifiant* and *signifié* in the case of *arbor* is of the same order as that between the French *signifiant* and *signifié* in the case of *arbre*. (1987: 64)

Despite an acknowledged complexity evident in the quotation marks that accompany the words "internal" and "external" in the first quotation, implying, as previously noted, that perhaps these divisions are in some way compromised, Harris's explanation relies on their continued separation. The definite divisions that inform his clarification could reasonably be interpreted to reinforce the basis of Ryan's accusations while completely ignoring the provocations in Descombes's query. Refiguring the latter in view of Harris's insistence that Saussure has no need for "the botanical 'thing' we call a tree," we might wonder what authorizes the translation between "arbor," "arbre," and "tree." Clearly, these are not randomly associated words, even though for Saussureans signification is produced within the constraints of specific language systems *(langues)*.[12]

Saussure's criticisms of nineteenth-century comparative philology could certainly be taken to endorse Harris's claim here. Saussure argued against a genetic theory of language that presumed to study the sign as an isolated datum, separable from its historical context. He maintained that the sign's signification was not translatable in any straightforward way across history. The residue that did survive historical change was the proper object of panchronic explanation, and Saussure gave it the status of "a concrete fact." Indeed, it was precisely this ability to endure over time that provided the limiting criterion for determining what belongs to language and what does not (Saussure 1974: 95). Consequently, "concrete facts" could hold no importance for linguists because "signification" was a process entirely separable and independent of them.

This confident circumscription of language and reality is less persuasive when considered against the fact of translation. As in the aforementioned example of *arbor, arbre,* and "tree," translation is an exchange of sorts whose value must be insured against a standard. Precisely what that standard might consist of, or even what constitutes the substance of the exchange, remains quite unclear within the Saussurean judgment, repeated by Harris, that there can be no commerce between language and reality. We might note in passing that inasmuch as the two spheres seem to share in something, some uneasy interconnection, the prohibition against their intercourse is strangely reminiscent of a moral injunction.

Also acknowledging the vexed nature of translation, Jacques Derrida ponders the problematic in relation to *Glas*, a book originally written in

French and, ironically as it turns out, intended to demonstrate *un*translatability. In a preface to the English edition of the book's companion volume *GLASsary*, Derrida's questions recall something of Descombes's "mystery of the left-hand box":

> Where is the evidence for a translation to be situated? Of what does such evidence consist? Where are its entitlements [*titres*]? Who will prove, in calling on what criteria, that this book is indeed the translation, a good translation, the best English translation of *Glas*?[13] (Derrida 1986: 17)

Derrida muses over the conditions of possibility that must obtain in order for the accuracy of a translation to be decided. His questions would include the curious nature of the "diachronic identity" that etymology isolates, as well as the more obvious issue of how words from different language systems can appear to have the same meaning. The paradox whereby the process of translation presumes an equivalence in difference, or invariance in the midst of variation, encapsulates the riddle of the sign that, as Saussure noted, "is never 'the same' *(le même)* twice" (as cited in Jakobson 1987: 448).

However, if the question of translation rehearses the same complexities that define the sign, then Saussure's attempt to prove the arbitrary nature of the sign by recourse to translation evidence seems misguided. The dilemma is exemplified when Saussure illustrates the arbitrary relationship between the signifier (sound-image) and the signified (concept):

> The idea of "sister" is not linked by any inner relationship to the succession of sounds *s-ö-r* which serves as its signifier in French; that it could be represented equally by just any other sequence is proved by differences among languages and by the very existence of different languages: the signified "ox" has as its signifier *b-ö-f* on one side of the border and *o-k-s (Ochs)* on the other. (1974: 67–68)

It has already been suggested that Saussure was unable to represent a theory of language that could successfully forfeit any appeal to reality's substance, and we see this criticism justified in the above assertion. Benveniste's intervention is helpful here, as he skillfully interrogates this recurring contradiction "between the way in which Saussure defined the linguistic sign and the fundamental nature which he attributed to it" (1971: 44).

Commenting on this particular passage, Benveniste notes that the relationship between the French idea *boeuf* and its signifier *b-ö-f,* or between *soeur* and the sound sequence *s-ö-r;* or, in English, the relationship between the

concept "ox" and the signifier *o-k-s*, or sister and its phonetic expression, could only be described as an arbitrary one, "under the impassive regard of Sirius" (1971: 44). Saussure's mistake comes in the assumption that he has recourse to the substance of reality, to the "concrete and substantial particularity" of the thing itself that is outside the purview of the sign and its interpretive frame. Benveniste draws our attention to the contradiction wherein an argument that would prove contingency and dissimilarity inadvertently installs an irreducible similarity at the heart of the linguistic sign. For if any number of signifiers can be anchored in the same signified, then Saussure has reaffirmed the axiomatics of nomenclature—namely, that meaning has a given, universal pre-existence that different languages merely capture in their various vocabularies.

Saussure quite explicitly denies this reading of his work. Nevertheless, we witness a reiteration of the contradiction in his attempt at clarification:

> The choice of a given slice of sound to name a given idea is completely arbitrary. If this were not true, the notion of value would be compromised, for it would include an externally imposed element. But actually values remain entirely relative, and that is why the bond between the sound and the idea is radically arbitrary. (1974: 113)

Saussure argued that the substance of reality, or what we take to be the referent, is produced through language and is therefore not in itself a determining precursor of meaning. Saussure posits a pure, undifferentiated plenitude prior to language that language reproduces *as reality* by cutting it up in the act of re-presentation. It is therefore language that "worlds the world," inscribing boundaries and distinctions that then appear as meaningful objects and entities:

> Psychologically our thought—apart from its expression in words—is only a shapeless and indistinct mass. Philosophers and linguists have always agreed in recognizing that without the help of signs we would be unable to make a clear-cut, consistent distinction between two ideas. Without language, thought is a vague, uncharted nebula. There are no pre-existing ideas, and nothing is distinct before the appearance of language. (1974: 111–12)

And yet the notion of a "thing in itself," an objective reality in a transparently translatable world, insistently manifests itself in the previous passage about translation. Reiterating an earlier point regarding the equivocal nature of the sign's components, Benveniste explains that when speaking of "the

idea" or "the concept," "Saussure was always thinking of the representation of the *real object* (although he spoke of the 'idea') and of the evidently unnecessary and unmotivated character of the bond which united the sign to the *thing* signified" (1971: 47). Given Saussure's insistence that the signifier and signified are consubstantial, the structural unity of the sign must mean that there can be nothing arbitrary about the relationship between the sign's internal components. Benveniste elaborates this important point:

> The concept (the "signified") *boeuf* is perforce identical in my consciousness with the sound sequence (the "signifier") *böf.* How could it be otherwise? Together the two are imprinted on my mind, together they evoke each other under any circumstance. There is such a close symbiosis between them that the concept of *boeuf* is like the soul of the sound image *böf.* (1971: 45)

In view of this, Benveniste concludes that the relationship between the signifier and signified is a motivated or necessary one. More appropriately, he decides that it is the relationship between the sign and reality that should be described as arbitrary.

Via Benveniste's clarification, the otherwise errant notion of "the arbitrary" is safely located outside the extension of the sign and therefore outside Saussure's thesis. Saussure's original intention is arguably restored to his text and its awkward contradictions explained. The domain of "the arbitrary" becomes the material world of reality, that zone against which the proper object of linguistics is delimited and defined. As a consequence of this clarification, Benveniste quaintly chastens us to leave questions that ponder the possible correspondence between mind and world to philosophers and "specialists in the physical universe" (1971: 10). The result of Benveniste's curative then is that a whole battery of difficulties is neatly disposed of. Benveniste defends linguistics from the perceived need for further philosophical entanglement, justifying this somewhat convenient conclusion with the claim that it more adequately "affirm[s] the rigor of Saussure's thought" (48).

But is the riddle of the sign so felicitously unraveled? It will be remembered that when Saussure acknowledged that the arbitrary nature of the sign was a piece of wisdom with a surprisingly long history, he added that "it is often easier to discover a truth than to assign to it its proper place." Saussure warned that the principle was not easily discovered, requiring an oblique approach that entailed many detours. In view of this, can we be satisfied that Benveniste's remedial clarification takes us closer to the notion's complexity? Before attempting another approach that, while not simply rejecting Benveniste's solution will nevertheless question its conviction, we need to go back over the ground covered so far.

Throughout the *Course* Saussure persisted in conflating "the concept" (signified) with "the thing," or real object. Within the terms of Saussure's own argument, this was clearly a mistake, as he regarded reality as something of a theoretical abstraction, inaccessible to human understanding because mediated by language. It followed from this that "the referent," as it later came to be called, was not given *a priori* as speakers might instinctively assume, but engendered through language, *a posteriori*. One of the errors of the nomenclature theory was its failure to understand that the referent is a derivative rather than an originary entity.

The argument to this point seems quite straightforward. However, if we grant that language precedes the referent rather than the other way around—or, perhaps more accurately, if we think of the referent as neither preceding nor following language because it is an immanence within it—then the referent cannot be bracketed out of a Saussurean approach. Although the referent's status as the generative origin of meaning is certainly called into question, this does not imply that we can be entirely rid of the referent as a consequence. After all, the very definition of the sign, inasmuch as it incorporates a notion of semiosis, discovers the sign's identity in relentless referral.

Saussure was certainly suggesting that what appears as the unmediated fact of reality according to nomenclature is actually compromised, a compromise that today we might describe as a "reality effect" rather than reality itself. Although, in recognizing this, Saussure nevertheless remained just as convinced, or taken in, by the transparency of reality's apparent immediacy as any nomenclaturist. However the question that needs to be asked, and especially of those who would disabuse Saussure of this confusion, is how could it be otherwise? When Benveniste argued that the concept *boeuf* and the sound sequence *böf* were identical in his consciousness and therefore necessarily interconnected, he also added this same phrase—"How could it be otherwise?" Yet Benveniste balks at extending the very same argument to explain why Saussure routinely elided the difference between "the thing" and "the concept of the thing," nor does he explain how he will innoculate himself against this same "mistake." For if the thing and the concept of the thing are entirely dissimilar, then how are they made synonyms for each other? I do not want to deny that Saussure inadvertently contradicted his own argument by including within the sign the reality to which the sign refers. However, such is the complexity of his thesis that we can interpret this same contradiction as faithfully consistent with the very paradox he sought to explore and articulate.

According to the principle of noncontradiction that underpins Western metaphysics, Saussure is unable both to refute and to embrace the tenets of nomenclaturism: he must come down on either one side or the other. Yet, in a comment made in a different although not unrelated context, Samuel

Weber suggests that "[i]f the temptation to take sides, to make a choice, short-circuits the problem, it is because there are more 'sides' to the battle than first meet the eye" (1987: 4). In this struggle over the precise identity of the sign, Benveniste secures the sign's integrity by differentiating it from a reality to which the human condition is prohibited access. In other words, the notion of an "outside the sign" is made an heuristic necessity that must nevertheless remain unendorsable because unknowable. Despite this, Benveniste does presume to know what is exterior to the sign. It is the substantial world of real objects that reveals itself to Benveniste, who noted above that it was only "the impassive regard of Sirius" (1971: 44) that could witness the substantial truth of such things.

When Benveniste insists on the difference between the mentalism of linguistics and the materiality of the unmediated world, he makes a distinction that is already a conceptual one, comprehended and evaluated through language. It is somewhat ironic that Benveniste's intervention at this juncture is entirely predicated on identifying the border between discrete and separable entities, because this is an exercise whose ultimate success Saussure's thesis will profoundly contest. For Saussure, identity and difference are profoundly implicated notions.

Saussure will nevertheless authorize Benveniste's distinction here, problematizing the supposed substance of discrete linguistic data by measuring it against the fact of objects "elsewhere":

> Elsewhere there are things, certain objects, which one is free to consider afterwards from different points of view. In our case [i.e., in language] there are, primarily, points of view, right or wrong, but simply points of view, with the aid of which, secondarily, one *creates* things. . . .
>
> Here is our profession of faith regarding linguistic matter: in other fields one can speak of things *from such or such point of view*, certain that one will find oneself again on firm ground in the object itself. In linguistics, we deny in principle that there are given objects, that there are things which continue to exist when one passes from one order of ideas to another, and that one can, as a result, allow oneself to consider "things" in several orders, as if they were given by themselves. (Saussure, as cited in Benveniste 1971: 35)

If we agree that there are indeed objects that exist outside language, then we assume that our knowledge of those objects must be independent of language. Perhaps this is a somewhat misleading representation of Saussure's point here, as his concern is rather to distinguish the dissembling and elusive object of linguistics from those objects studied in other fields of knowledge.

However, the independence of thought and language surely underwrites the possibility of even drawing such a comparison.

It will be recalled that Benveniste advised that philosophers and "specialists in the physical universe" were best equipped to assess the possible adequation between language and the real world. Benveniste argued that there were two quite separate orders of phenomena that should not be confused:

> On the one hand the physiological and biological data, which present a "simple" nature (no matter what their complexity may be) because they hold entirely within the field in which they appear ... on the other side, the phenomena belonging to the interhuman milieu, which have the characteristic that they can never be taken as simple data or defined in the order of their own nature but must always be understood as double from the fact that they are connected to something else, whatever their "referent" may be. (1971: 38–39)

Following Benveniste's advice, we might use the vocabulary coined by certain philosophers who do engage these questions and describe Benveniste's position as one that presumes that objects "as such" exist "in and for themselves" in the physical world: objects can therefore have an existence that is independent of any other. The "human milieu," or what we might shorthand as "culture," however, is an entirely symbolic phenomenon in which objects are created from webs of symbolic interconnection. As did Saussure before him, Benveniste regards these culturally produced "things" as ephemeral inasmuch as their existence is only apparent within a particular perspective. Against the discrete and grounded nature of real objects, Benveniste argues that in culture "there is no natural, immediate, and direct relationship between man and the world or between man and man" (26).

We have already encountered this need to separate the physical world of science from the humanities (with the happy exemption of philosophy), as if the knowledge gained in the former were uncontaminated by "the interhuman milieu." Roy Harris's earlier comments regarding the slippery nature of the sign also discriminated between the "'external' botanical facts" of a tree and the linguistic re-presentation of a tree. And Vincent Descombes similarly installed a nature/culture split when he assumed that the drawing of a tree in the left-hand box constitutes the signified that precedes the word. What, then, is the relationship between thought and language that will justify this division of ephemeral from concrete phenomena; this division between the world that language appears to reflect and the world whose actual, or substantial reality, lies veiled behind it?

Despite the commonsense conviction that thinking and speaking are

quite distinct activities, associated only for the practical purpose of communication, we learned above that language and thought are inextricably implicated. According to Saussure, "Without language, thought is a vague, uncharted nebula," (1974: 112). Benveniste goes even further, entertaining the possibility that "one could be tempted to equate thought and language" (1971: 25). Benveniste considers that thought and language are as one, such that any metaphor that figures their implication nevertheless remains inadequate to the degree of their entanglement. He notes, "Strictly speaking, thought is not matter to which language lends form, since at no time could this 'container' be imagined as empty of its contents, nor the 'contents' as independent of their 'container'" (56). Given this, Benveniste queries whether it is possible to determine if thought can apprehend itself directly, and he examines the question more closely through an analysis of Aristotle's categories. These categories form the list of *a priori* concepts that Aristotle distilled as the organizational cipher of experience: the independent and irreducible logical categories inherent in the mind and anterior and exterior to language.

After close scrutiny, Benveniste finds that Aristotle's inventory of all the possible predications for a proposition is also a conceptual projection of specific linguistic distinctions:

> No matter how much validity Aristotle's categories have as categories of thought, they turn out to be transposed from categories of language. It is what one can *say* that delimits and organizes what one can think. Language provides the fundamental configuration of the properties of things as recognized by the mind. This table of predications informs us above all about the class structure of a particular language. (1971: 61)

Although Benveniste began this discussion by asserting that thought and language are inseparable, we see in this comment that his refutation of Aristotle rests on the separation of these categories and their inevitable hierarchization. Benveniste answers Aristotle's argument that categories of thought form the framework of predication by reversing the claim and insisting instead that "[l]anguage provides the fundamental configuration of the properties of things as recognized by the mind."

The argument about which category precedes the other and how they are conjoined is reminiscent of the earlier discussion about the nature of the sign's divided unity. Just as the relationship between signifier and signified was likened to that of a vehicle of expression and its content, the relationship between language and thought is similarly conceptualized. We noted above

that temporal priority is granted to the conduit, or vehicle of expression, in the mistaken assumption that the signifier evokes the signified. Similarly, Benveniste argues here that language, as thought's instrument, is the necessary predication of thinking, for "this content has to pass through language and conform to its framework" (1971: 56). We might note in passing that Saussure's conflation of the signified with the thing itself disrupted the terms of this origin story by conceding an even more foundational existence to the concept. And although Benveniste explained Saussure's inconsistency in asserting this, we will see that the twists and turns of his own argument will also come to rest on the transcendental existence of the concept.

This last point becomes clear if we pause to consider that although the discussion proceeds by questioning whether thought is the same as, or different from, language, we remain unsure of what precisely Benveniste intends by the word "language." For example, privileging the notion of "language in general," Benveniste excludes the specific instance of language from his conclusions about the language/thought couple:

> Chinese thought may well have invented categories as specific as the *tao*, the *yin*, and the *yang*; it is nonetheless able to assimilate the concepts of dialectical materialism or quantum mechanics without the structure of the Chinese language providing a hindrance. No type of language can by itself alone foster or hamper the activity of the mind. The advance of thought is linked much more closely to the capacities of men, to general conditions of culture, and to the organization of society than to the particular nature of language. (1971: 63–64)

If the structure of the Chinese language can provide no hindrance to the assimilation of otherwise foreign concepts, however, then the mutuality of thought and language (likened to the in-forming of content within container) can have no specific reliability. And if this is so, why then should Aristotle's categories necessarily repeat the particular grammatical structure of the Greek language?

Even if we move over this hesitation, granting that language and thought are inseparable, the difficulty stubbornly persists. For surely we are forced to admit a degree of skepticism regarding the possible status that can consequently be accorded the concrete fact of Saussure's "elsewhere." ("Elsewhere there are things, certain objects, which one is free to consider afterwards from different points of view" [Saussure, as cited in Benveniste 1971: 35].) It will be remembered that in this place, supposed to exist outside language, Saussure believes that "one will find oneself again on firm ground in the object itself" (Saussure, as cited in Benveniste 1971:35). This is the very same place

in which the objective facts of Benveniste's "physiological and biological data" can also be discovered; the "proper place" to which Saussure seems content to assign the vexed notion of "the arbitrary."

But if thought is always formed in the habit of language, then we are left with some difficult questions about the ontological nature of these physical objects that are supposedly known by Saussure and Benveniste and adjudicated by "experts" such as physicists and philosophers. If the problematic identity of the sign cannot be measured and explained by reference to the stable and solid substance of an anterior reality, then the enigma of the sign can be generalized to include that reality. After all, what can words such as "arbitrary" or "reality" finally claim to denote, in any positive sense, when the terms can only be understood within already determined frames of reference that constitute the "human milieu"?

Benveniste explains that we are only able to make sense of something because, in a way, it has already been made sense of within the webs of signification through which it necessarily appears. We could add to this that even when we might regard a thing as unintelligible, we are interpreting it, evaluating and categorizing it, according to familiar conventions. Consequently, unintelligibility is an intelligible notion. Similarly, a concept such as "arbitrary" cannot present itself as the true opposite of "necessary," that is, as something purely random and capricious, for the notion of restriction is essential to the identification of arbitrariness.

The uncanny result of this economy is that the only proper account of the sign, the one that can finally decide its identity or limit, is ultimately purchased from a perspective *within* the sign's own labyrinthine structure—an outside that is also strangely at home with/in itself. Is it possible then to draw a definite conclusion about the existence or nonexistence of discrete objects in a reality that pre-exists the human condition? The maze of the matter is such that, even if we were to concede that we can know nothing of "reality," that we cannot know the unmediated substance of "objects-in-themselves," we are surely caught by the simple force of Georges Bataille's comment, "Who will ever know what it is to know nothing?" (as cited in Taylor 1986: 1). This admission that identity is ultimately undecidable because the vagaries of the limit cannot be secured concedes that interpretive closure is impossible. Much contemporary criticism that continues to draw on the Saussurean legacy is content to leave it at that.

There is another question here, however, a question whose dimensions extend well beyond concessions to hermeneutic undecidability. If language is indeed the irreducible *sine qua non* in all analytical categories, then the

complexity of the sign is inseparable from the riddle of the copula. Any answer that could presume to resolve whether objects do or do not exist outside language must first settle a preliminary question about existence, or "Being itself." In what functions as a postscript to his previous discussion, Benveniste recognizes this quandary:

> Beyond the Aristotelian terms, above that categorization, there is the notion of "being" which envelops everything. Without being a predicate itself, "being" is the condition of all predicates. All the varieties of "being-such," of "state," all the possible views of "time," etc., depend on the notion of "being." Now here again, this concept reflects a very specific linguistic quality. (1971: 61)

Curiously, however, this comment takes us well beyond Benveniste's original brief. "Being" is the transcategorical condition of any category: it will not appear on any table of categories, whether grammatical or philosophical. As the notion that makes possible the category "language," it also opens the possibility of an outside of language. Similarly, as the "condition of all predicates," "Being" cannot be defined and analyzed by philosophical thought, as Being "envelops everything."

However, we have been down this path before. Perhaps we are even becoming a little more comfortable with its tortuous circuit, for the topography of the landscape remains, to some degree, always familiar—even when we sense ourselves to have "gone astray." If there is more to language than we acknowledge, an elusive "something" that confounds its representation, then the "outside" of language, thought, and representation, may be caught within the folds of its own expression, inhabiting "the being-language-of-language" that entirely exceeds the word/concept, "Being" or "to be."[14] The confusions of Saussure's text map the contours of a landscape to which we will relentlessly return. This is not to say that a certain leave-taking is impossible whenever we begin again. Indeed, we will discover that, however faithfully we retrace our steps, we will always be "elsewhere" or "other" than the place where we think ourselves to be.

And so to Saussure again. The struggle to determine the essential reality of language, to discover the minimal unit of its identity in the sign, is valiantly sustained for almost half the volume of the *Course*. Such was the burden of the linguistic tradition inherited by Saussure that he could do little else, bound as he was by a legacy of thought whose commitments he both shared and disputed. But the measure of the sign, its enclosure as a definite entity, was not Saussure's primary concern. Although he was clearly involved in

debate over the chameleon nature of the sign, by the third and final Course of lectures Saussure had shifted his attention. Intrigued by the insistent evidence of something wayward about the sign, an errant quality that inevitably flouted its various definitions, the question, "What is the sign?" could no longer capture the complexity of his project. The same question is now more subtly engaged in the query, "How is the sign?" In other words, "How is the sign's identity produced?" or, more broadly, "How are we able to conceptualize the very notion of 'identity' at all?"

Reconceptualizing the sign's identity as a dynamic process of differentiation Saussure's argument shifts register, and the shape of the discussion to this point is entirely refigured as a consequence. The classical conceptuality that both underpins the durable institution of the sign and encloses "the integral and concrete object of linguistics" is suddenly made vulnerable by Saussure's introduction of the term "value."

"tout est rapport"
(Saussure, as cited in Koerner 1973: 365)

We are now familiar with the way that apparently oppositional notions such as "the conventional" and "the arbitrary" are routinely conflated by Saussure, along with their analogues, the signified and "reality." And perhaps we are no longer surprised by the consistency with which various attempts to correct the confusion inevitably repeat it. But conceding that these terms do occur in the same collocation doesn't quite explain why they do. Without discounting the relevance of the earlier discussion, Saussure broaches its seeming impasse in his elaboration of linguistic value, a term that negotiates the mystifying operations of exchange and equivalence that make up the economy of the sign:

> the idea of value ... shows that to consider a term as simply the union of a certain sound with a certain concept is grossly misleading. To define it in this way would isolate the term from its system; it would mean assuming that one can start from the terms and construct the system by adding them together when, on the contrary, it is from the interdependent whole that one must start and through analysis obtain its elements. (1974: 113)

The circulation of values can be likened to an economic or commercial transaction because, just as with money, price is reckoned within a larger system of interdependent fluctuations. "Value" is therefore a corollary of "system." And it is in this system, or reflex of necessity to which language is

subject, that Saussure discovers the proper object of linguistics. Saussure states that "[l]anguage [*langue*] is a system that has its own arrangement" and this "interdependent whole" (or "internal linguistic organism," as he calls it) is self-referential and autonomous (1974: 22). Saussure's previous attempt to separate the sign from reality by marking the difference with the term "arbitrary" is surely echoed in this description. Yet the term "arbitrary" will prove so fundamental to Saussure's analysis of the internal order of *langue* that it is finally inseparable from the notion of systematicity itself (*arbitraire relatif*). Hence, Saussure's analysis of "value" and "system" will again return us to the vexed notion of "the arbitrary."

Saussure opens his discussion of value by distinguishing it from what is commonly called "signification." Explaining why the two terms should not be regarded as synonyms, Saussure argues that although the French *mouton* has the same signification as the English "sheep," they do not share the same value. In part, their difference derives from the fact that English has a second word, "mutton," to describe the meat in its culinary state. Consequently, use of the word "sheep" will be limited by the existence of this other word "beside it," whereas the French word *mouton* will not be similarly qualified.

Signification describes the internal workings of the sign that conjure its semantic or denotational sense "when we look upon the word as independent and self-contained" (Saussure 1974: 114). We might think of it as a sort of use value that is distilled from the general exchange of language. But, the heuristic necessity that posits the sign's integrity is, paradoxically, dependent upon "a system of interdependent terms in which the value of each term results solely from the simultaneous presence of the others" (114). With the introduction of value, the sign's closure can no longer be maintained. As the sign is open to the system that informs it, signification is also pregnable to the infinite vagaries of semiosis. In which case, words from different language systems are never equivalent, not even within the supposed circumscription of signification. It would be more accurate to say that the process of translation's "making equivalent," a process that effects a denial of difference by "decontextualizing" the sign, actually engenders the sense of universal signification and reference. Value, then, is the relationship of mutuality that obtains between signs, represented in the *Course* by another diagram (115).

Value is produced along two interconnecting axes of equivalence. One axis involves a relationship of dissimilarity and contrast, while the other expresses similarity through comparison and association. Again, this conceptualization of two distinct axes is an heuristic device, an analytic orientation that helps us to understand the process through which value is figured. But what exactly is being compared and contrasted within this system of exchange? Does this model quietly return us to the comfortable wisdom of nomenclaturism in a different guise? If we think of the question as it might apply to a word, Saussure states that "[i]ts content is really fixed only by the concurrence of everything that exists outside it" (1974: 115). As suggested above, a word is not a self-enclosed unit, anchored by the stability of its semantic, denotational function. Rather, the signification of a word and the sense we might have of its representational accuracy—that is, how well it measures up to what presents itself as an extralinguistic referent—is actually generated from within the system of language itself *(langue)*:

> Instead of pre-existing ideas then, we find . . . *values* emanating from the system. When they are said to correspond to concepts, it is understood that the concepts are purely differential and defined not by their positive content but negatively by their relations with the other terms of the system. Their most precise characteristic is in being what the others are not. (Saussure 1974: 117)

Saussure further illuminates the peculiar contents of the language system in the *Cahiers*:

> All our distinctions, all our terminology, all our ways of speaking are molded according to that involuntary supposition that there is a substance; one cannot refuse, above all, to recognize that the theory of language will have as its most essential task the disentangling of the real nature of our primary distinctions. (as cited in Benveniste 1971: 36)

Saussure reiterates that there can be no aspect of language that can exist without the others, no property that can be isolated as primordial and anterior:

> The more one delves into the material proposed for linguistic study, the more one becomes convinced of this truth, which most particularly—it would be useless to conceal it—makes one pause: that the bond established among things is preexistent, in this area, to *the things themselves*, and serves to determine them. (as cited in Benveniste 1971: 37)

For Saussure, signification is both distinct from value and determined or comprehended by it. And it is in the intimacy of this coupling that we discover why referential explanations of language that essentialize the sign cannot be disengaged by their critics. To argue that it is the system that confers signification and delineates identity, or that identity is constituted rather than given, is not to say that we can abandon notions of reference, signification, or identity. After all, although we may forfeit the comfortable fact of the sign's identifiable integrity, the larger abstraction of "the system" surely recuperates the notions of unity and identity. Consequently, the radical import of the Saussurean project is to understand these concepts of reference, signification, and identity and the assumptions that ordinarily derive from them, in another way. If "in language there are only differences *without positive terms*" (Saussure 1974: 120), if "differences carry signification" and "signs function ... not through their intrinsic value but through their relative position" (118), then it may be granted that language involves something more than the concept "representation" normally implies.

Representation traverses the space between two or more discrete identities. It involves the notion of reference and denomination and it legislates borders and what is determined as proper to them. Similarly, as an instrument of communication, language is traditionally conceptualized as an operation *between* things, as a vehicle or medium through which meanings (identifiable concepts) are conveyed. We circled around this more conventional approach to language with Saussure's attempt to define the sign, isolate its parts, and delimit its extension. With the notion of value, however, Saussure finally takes his departure from his antecedents and introduces his most provocative intervention.

This time, the material we begin with involves differential relations within a system of value. Consequently, the sign and its heterogeneous components, as well as the fact of the referent in/and reality, are only identifiable as such because they are "fixed in place" by relational differences from other signs. Identity then, of whatever sort, is negatively delimited, produced within the diacritical play of language. As a productive force with constitutive power, language does more than provide a passive and neutral medium through which matter passes. Language is now a process of "making matter."

This notion of process in which a sign embodies its own becoming, its "sense" giving witness to its contextual and reciprocal relationships with other (absent) signs, displaces our previous discussion of "the arbitrary nature of the sign." We recall that there was something almost smug in the way Saussure conceded that the sign's arbitrary nature was disputed by no one. How-

ever, his challenge to the term's conventional interpretation came in the clue, "but it is often easier to discover a truth than to assign to it its proper place." Was "the arbitrary" to be located between the signifier and the signified or between the sign and reality, as Saussure's later commentators would argue?

The question's unhappy resolution derives from its conceptual containment. The assumption that "the arbitrary" is ultimately locatable ignores the fact that the very notions of place and location are also in question. For if we understand "the arbitrary" as an "in between" one thing and another, we will fail to recognize that "the proper" is also given the apparent wholeness and independence of its identity through a system of relational dependencies that both surround *and* inhabit it. Whether we focus upon the identity of a meaning, a person, or a thing, "the arbitrary" resides within these very terms. Identity is, therefore, always divided from itself, constituted from a difference within (in between) itself; a difference that at the same time determines its difference from another, supposedly outside itself. There is a perverse connection here, diacritically inflected, and caught in an involution in which identity and difference inevitably cleave to each other.

Saussure acknowledges this "somewhat mysterious" intricacy with the insight that "*[a]rbitrary* and *differential* are two correlative qualities" (1974: 118). Yet many provocations within this deceptively simple statement may continue to elude us, just as they tantalized the grasp of Saussure himself. The important point here is that "the arbitrary" marries the notion of mediation *with* constitution. We witness the inseparablity of these terms in Saussure's comment, "It is a characteristic of the language, as of any semiological system in general, that it can admit no difference between what distinguishes a certain thing and what constitutes that thing" (as cited in Barthes 1968: 72). Articulated from a force field of constraints and flows, identity is an expression of the system's own specificity, a differentiated moment within the mechanism of *la langue*. From this, Saussure concludes that *"the true and unique object of linguistics is language [la langue] studied in and for itself"* (1974: 232).

Following Saussure's perception that distinctiveness and solidarity are related conditions, the integrity of *la langue* is unfortunately rendered just as problematic as its smallest concrete particle, the sign. When Saussure determined that the foundational essence of the organism or system of *la langue* is differential, he undermined the confidence with which we can assume separability of any sort—here, the existence of a separate domain deemed proper to linguistics. If there is no unalienated origin before signifying production, no definite beginning that grounds the system, then it follows logically that there can be no limiting membrane that ends or encloses the

system's identity, as language, either. This important point requires some explanation via yet another detour.

The arbitrary nature of the sign, at least in the various and contradictory ways that Saussure deployed the term, marks the linguist's attempt to recognize the mutability of language and its profoundly historical nature. We should not confuse this argument with the historicism of nineteenth-century philology, which posited a rational basis to words as derived from their resemblance to a primitive sign. Saussure's thesis offered a decided intervention against this causal, or teleological, understanding of language, based on stability. According to Saussure, language is an "object" that is negatively founded, such that *la langue* is the expression of an historical contingency. Indeed, as there is no necessary connection between signifier and signified or between one sign and another that can make ultimate appeal to a transcendental signified, the sign is wholly constrained by its historical articulation. In other words, the force that does bind the signifier with/in the signified is that of history itself.

Perhaps we are now better positioned to understand the apparent paradox wherein the arbitrary nature of the sign is meant to explain why language is a convention, a structured institution entirely bound by social constraints (Saussure 1974: 10). By blurring the difference between arbitrariness and systematicity Saussure also linked the concept of mutability with immutability:

> To say that language is a product of social forces does not suffice to show clearly that it is unfree; remembering that it is always the heritage of the preceding period, we must add that these social forces are linked with time. Language is checked not only by the weight of the collectivity but also by time. These two are inseparable. At every moment solidarity with the past checks freedom of choice. We say *man* and *dog* because our predecessors said *man* and *dog*. This does not prevent the existence in the total phenomenon of a bond between the two antithetical forces—arbitrary convention by virtue of which choice is free and time which causes choice to be fixed. Because the sign is arbitrary, it follows no law other than that of tradition, and because it is based on tradition it is arbitrary. (74)

This is a difficult complication to juggle, and we see Saussure's effort to retain some conceptual consistency in the awkward qualification of "relative arbitrariness" and "absolute arbitrariness." Saussure insists that, "[t]he fundamental principle of the arbitrariness of the sign does not prevent our singling out in each language what is radically arbitrary, i.e. unmotivated, and what is only

relatively arbitrary" (1974: 131). Via the notion of motivation, Saussure introduces the idea that arbitrariness is more a matter of degree.

The sign's motivation can only be decided relative to other signs. As Saussure explains:

> For instance, both *vingt* "twenty" and *dix-neuf* "nineteen" are unmotivated in French, but not in the same degree, for *dix-neuf* suggests its own terms and other terms associated with it (e.g. *dix* "ten," *neuf* "nine," *vingt-neuf* "twenty-nine"' *dix-huit* "eighteen," *soixante-dix* "seventy," etc.). Taken separately, *dix* and *neuf* are in the same class as *vingt*, but *dix-neuf* is an example of relative motivation. (1974: 131)

Similarly, for segmental discriminations:

> The same is true of *poirier* "pear-tree," which recalls the simple word *poire* "pear" and, through its suffix, *cerisier* "cherry-tree," *pommier* "apple-tree," etc. For *frêne* "ash," *chêne* "oak," etc. there is nothing comparable. (131)

It seems that these restrictions on arbitrariness witness the internal structures of *langue*; identifiable constituents on what Saussure calls the associative axis of language. Saussure notes that "[i]n language everything boils down to differences *but also to groupings*" (1974: 128; emphasis added), and he describes these associational constellations as "units living underneath the word" (as cited in Gadet 1989: 85). The existence of these solid formations is evident, quite simply, in the fact that they are alive for the speakers who discern and use them. It is through these intuitively perceived connections that access to the grammatical is afforded, and the possibility of isolating the manageable, or analyzable, "units" that constitute linguistics proper is also determined. Yet it is precisely here, in Saussure's pragmatic and entirely understandable desire to secure linguistics and the specificity of its particular operations as an autonomous science, that we see him straining to resolve and, indeed, to avoid the provocative ramifications of his own intellectual inquiry. Saussure could not have been unaware of an uneasy tension in his assertions on this point. Elsewhere, for example, he insists that the task of definitively isolating *any* unit or identity is an impossible one:

> The linguistic mechanism is geared to differences and identities, the former being only the counterpart of the latter. Everywhere then, the problem of identities appears; moreover, it blends partially with the problem of entities and units and is only a complication—illuminating at some points—of the larger problem. (Saussure 1974: 108)

By "the larger problem" Saussure is referring to "the notion of value [that] envelopes the notions of unit, concrete entity, and reality" (110).

The relevance of this to the previous discussion lies in the suggestion that the interconnections that are said to motivate only a particular, isolatable set of words or linguistic structures and, correlatively, to sever their connection with other words is not so much a fact of language as it is an heuristic requirement for linguistics—an effect of the necessity to form categories for the purpose of analysis. Saussure acknowledges this when he says, "Linguistics accordingly works continuously with concepts forged by grammarians without knowing whether or not the concepts actually correspond to the constituents of the system of language" (1974: 110).

Anticipating the rejoinder that linguistic entities are somehow accurate because they correspond to categories of logic, Saussure cautions, as would Benveniste, against such teleological thinking which "forget[s] that there are no linguistic facts apart from the phonic substance cut into significant elements" (1974: 110). If this sounds a little like a more abstract reiteration of the problem, the radical import of this comment becomes apparent if we recall that, for Saussure, "[p]honemes are characterized not, as one might think, by their own positive quality but simply by the fact that they are distinct. Phonemes are above all else opposing, relative, and negative entities" (119).

If we turn to the figure in the *Course* that illustrates the network of these associational chains, we see something of the way that Saussure conceptualized the structure of such a constellation (1974: 126).

```
                    enseignement
              /    /    |    \    \
       enseigner              clement
    enseignons                  justement
       etc.                       etc.
  etc.   apprentissage  changement   etc.
         education       armement
            etc.           etc.
           etc.             etc.
```

Harris, however, remains critical of what he perceives as the diagram's misleading restriction. He argues that Saussure's elaboration of the value of the word *enseignement* fails to acknowledge the sorts of associations that J. Firth, for example, draws from the English word "time"—namely, "*saved, spent, wasted, frittered away, presses, flies* and *no*" (Harris 1987: 125).

There seems no reason to assume that Saussure would disagree with Firth's seemingly wild collocation, since Saussure maintained that associations

"outside discourse" are not constrained by linearity. In the text that immediately precedes the diagram, he comments:

> Mental association creates other groups besides those based on the comparing of terms that have something in common; through its grasp of the nature of the relations that bind the terms together, the mind creates as many associative series as there are diverse relations. (Saussure 1974: 125)

In Engler's critical edition of the *Course*, this sense of a word's unending implication with other words, the nature of whose connection would, eventually, prove recalcitrant to linguistic analysis, is even further emphasized:

> [a] word will summon up in an unconscious fashion ... the idea of a crowd of other words which, *in one way or another*, have something in common with it. Maybe in very different ways ... the number of associative groups is infinite. (Saussure, as cited in Gadet 1989: 79–80)

Although it might not be immediately apparent from Saussure's figure that an infinite run of free associations must also support the word *enseignement*, the fourth leg of associative links does at least suggest this possibility. We notice that the editors of the *Course* who, it seems, are also responsible for the addition of this fourth series, nevertheless felt themselves compelled to describe it as "rare" and "abnormal," "for the mind naturally discards associations that becloud the intelligibility of discourse" (Bally and Sechehaye 1974: 126–27).[15] This same editorial intrusion quite irritates the linguist Robert Godel, who chastens the editors for having "added to the diagram of associative relations the spurious series *enseignement, clément, justement*, etc., which has no right to be there" (as cited in Gadet 1989: 100).

The reason for such apology and disapproval derives from the fact that these words do not conform to grammatical categories. For example, *clément* is not segmentable and so does not share a formal suffix with *enseignement*. And although *justement* looks as though it should satisfy this particular requirement, and indeed would happily be accommodated into the third branch of associations, it is not a substitutable syntagm for *enseignement*. The latter is a noun and the former an adverb. The nonspecialist reader may well be wondering what all the fuss is about. But, it is in this abnormal series that the linguist perceives a potentially threatening suggestion; namely, that the descriptive categories of grammar are ultimately inadequate to explain the labyrinthine involvement of the language system.

In spite of Saussure's iconoclasm in so much of the *Course*—the sustained challenge he mounts against the received linguistic conventions of his time—he too becomes strangely squeamish when confronted with data that elude grammar. For example, when discussing the innovations of folk etymology, an apparent confusion whereby "interpetations of misunderstood forms [are made] in terms of known forms," Saussure's language becomes decidedly moralistic (1974: 175). He describes folk etymology in terms of "corruption" and "deformation," and when comparing the peculiarities of this form of innovation against the analyzable evidence of analogical construction, he judges the latter "rational" whereas folk etymology "works somewhat haphazardly and results only in absurdities" (174).

This sense of indignation, as if there is something improper or even scandalous in the process (or "goings-on") of folk etymology, is quaintly in evidence in Saussure's summation of the problem. "There is something in it [folk etymology] which may be regarded as perverted, pathological, albeit that it is a very particular instance of analogy" (as cited in Gadet 1989: 101). We are reminded of Godel's similar appeal to the proper when he condemned the waywardness of the fourth associative branch (as cited in Gadet 1989: 100). And we may wonder if perhaps Louis Hjelmslev's reformulation of Saussure's somewhat loose and psychologistic "associative axis," with the much more formal and axiomatized notion of the "paradigmatic," doesn't also derive from a similar anxiety about the need for closure (Hjelmslev: 1961).

The suggestion that there is an inevitable surplus value generated along the associative axis is, however, surely a truism among literary critics. Poetics deliberately exploits the polysemous character of words, perplexes the efforts of analytic containment, and reflects upon language's most intimate resources of meaning and style. The business of literary studies celebrates the wealth and complexity of this verbal implication, demarking a disciplinary domain by its peculiar richness and ambiguity. "The literary" is regarded as a privileged field of expression whose intricacy of meaning is irreducible to "ordinary" language and plain prose statement: the *modus operandi* of "the literary" part of language has nevertheless been provided.

One of the modern pioneers in this field was the Russian linguist Roman Jakobson who insisted that linguistic methods could certainly be applied to the study of literature. Jakobson regarded the poetic function of language, the focal point of literary studies, as just one of six possible categories,[16] and each of these was determined by a particular orientation within any speech event.[17] Jakobson made a definite distinction between "the work of poetry" and "the poetic function":

Novalis and Mallarmé regarded the alphabet as the greatest work of poetry. Russian poets have admired the poetic qualities of a wine list (Vjazemskij), an inventory of the tsar's clothes (Gogol'), a timetable (Pasternak), and even a laundry bill (Kručenyx). (1987: 369–70)

Jakobson also argues that "the content of the concept of *poetry* is unstable and temporally conditioned. But the poetic function, *poeticity,* is, as the 'formalists' stressed, an element sui generis, one that cannot be mechanically reduced to other elements" (1987: 378).

Jakobson elaborates Saussure's oppositional planes of language—association and syntagm—through another terminology, namely, the axes of metaphor (similarity) and metonymy (contiguity). This division is repeated again in Hjelmslev's axes of selection (paradigmatic) and combination (syntagmatic). The consequence of this is an analytical method whose efficiency is such that the intricate patterns of *poeticity* are inevitably rendered up as legible to linguistics:

> Any unbiased, attentive, exhaustive, total description of the selection, distribution and interrelation of diverse morphological classes and syntactic constructions in a given poem surprises the examiner himself by unexpected, striking symmetries and antisymmetries, balanced structures, efficient accumulation of equivalent forms and salient contrasts, finally by rigid restrictions in the repertory of morphological and syntactic constituents used in the poem, eliminations which, on the other hand, permit us to follow the masterly interplay of the actualized constituents. (Jakobson 1987: 127)

Not wanting to denigrate the usefulness of Jakobson's work for literary studies, Jonathan Culler nevertheless draws our attention to some of the difficulties that emerge from this approach. Culler questions the claim that the science of linguistics can truly provide an algorithm for the workings of a text—a "determinate procedure" for an objective and exhaustive description of the poetic patterns through which a poem is organized. Although Jakobson's search for the numerical symmetry in a poem, the balanced unity that defines the "poeticality" of a text, can certainly be shown to deliver up an organizational structure, Culler queries the relevance of this discovery. Since different methods of approach uncover different motivational patterns, these results, inasmuch as they are various, do not locate the poem's distinguishing elemental characteristics. Given the plastic nature of linguistic categories, together with their considerable number, Culler's provocation here is that "one can use them to find evidence for practically any form of organization" (Culler 1975: 62).

Culler concedes his uncertainty regarding the claims that Jakobson might make for his analytical method, and so proceeds to evaluate the relevance of the linguist's approach against two possible aims:

> If he is maintaining that linguistic analysis enables one to discover precisely which forms of organization, out of all possible structures, are actualized in a given poem, then one may contest his claim by showing that there is no type of organization which could not be found in a particular poem. On the other hand—and this is perhaps more likely, given the fact that he tends to find the same organizational symmetries in the different poems he analyses—his position may be rather that since the poetic function makes equivalence the constitutive device of the sequence, one will be able to find innumerable symmetries in any poem, and that it is precisely this fact which distinguishes poetry from prose. (1975: 63)

Against this, however, Culler argues that the battery of symmetries deemed peculiar to the poetic function are readily discovered in all forms of writing. By way of illustration he takes the opening page of Jakobson's "Postscriptum" to *Questions de poétique* and submits the first couple of sentences to the linguist's analytical method. Under close examination, it seems that even these quite ordinary lines of prose are possessed of the defining characteristics of the poetic function. Culler concludes from this that *poeticity* is not comprehended by categories of linguistic analysis.

Indeed, the untidy ubiquity of the poetic function undercuts the possibility that an efficient regime of distinct subdivisions can properly be distilled from the associative axis or system of *langue*. We should also note that, even if it is unstated, this appeal to a functional operation presumes a teleological reference to the speaker's intentional or intuitive consciousness. This appeal, whose basis is arguably quite foreign to the Saussurean project, privileges the semantic over the semiotic.[18]

Regarding the suggestion that language possesses a motivational fulcrum in the speaking subject, Saussure explains why this assumption is misguided. Drawing an analogy between language and a deck of cards, he compares the agency of the speaker to the skill of a card player. Within the random play of possibilities that the cards represent, Saussure discovers the play of language and the infinite potential of its expression. And yet, just as there are obvious restrictions—in the rules of a specific card game, the inevitable limitations in any one deal, the measured timing through which the play unfolds, and so on—we might assume that a similar field of constraints must also qualify the speaker's degree of agency.

Saussure's point here is that although the speaking subject may feel entirely

possessed of free and individual choice regarding language decisions, this apparent agency is the determined articulation of language itself. We might extrapolate from this that what is perceived as creatively innovative and uniquely individual in its expression will also imply the "coming to voice" of an elaborate inheritance of constraints and potentialities. Ironically, perhaps, what is heard as the self-present immediacy of voice is, in the final instance, the articulation of history, informed by the living burden of infinite mediation.

The ramifications of this argument are considerable. The opposition, for example, so confidently assumed to divide event from system, to separate individual from community, *parole* from *langue*, and even the speaking subject from language—these differences become vulnerable to a "force" that somehow involves and entangles each of these categories within the other. It follows from this that if language use is effectively to be compared with playing cards, then the analogy is more accurately captured by imagining that the unwitting player has entered the game with a stacked deck. In other words, the player remains ignorant of the fact that her choice of moves is also enacted or played by the "will" of the cards.

Agency is, of course, another way of talking about "arbitrariness" by imputing to the speaking subject an entirely random and infinite range of options. Arguing against the self-evidence of this assumption, Saussure notes:

> The masses have no voice in the matter, and the signifier chosen by language could be replaced by no other. This fact, which seems to embody a contradiction, might be called colloquially "the stacked deck" [*la carte forcée*]. We say to language: "Choose!" but we add: "It must be this sign and no other." No individual, even if he willed it, could modify in any way at all the choice that has been made; and what is more, the community itself cannot control so much as a single word; it is bound to the existing language.
>
> No longer can language be identified with a contract pure and simple ... language furnishes the best proof that a law accepted by a community is a thing that is tolerated and not a rule to which all freely consent. (1974: 71)

According to this view, the player's (speaker's) instrumental manipulation of the cards (words) may well realize intended results. Yet this result is always a realization in which intention, conventionally conceived as the causal origin of any maneuver (or speech act), is already a determination, thrown up within the play of another game whose "chance" operation comprehends and indeed, engenders it.

It would be a mistake to conclude that this argument denies the efficacy or existence of what is commonly understood as the motor of intention. More accurately, the argument strives to complicate the conventional understanding of this notion, since there can be no structural limit to *vouloir-dire* in either the speaker (as the guarantor and origin of meaning) or in reception (as the final fulfillment of intention's destination). If we return to the card game in order to understand this point, the player/intention might be conceived of as a sort of nodal moment within a larger "system"; as an instance, or as an ensemble, of differences that plays across a generalized force field and whose specific emergence in/as the speaking subject articulates individuality.

We are caught within a complicitous circuit of production here, but one whose motivation is, importantly, quite different from the lineal unfolding of dialectical causality, conceived of as a chain of interrelated entities. Consequently, the actualization of identity, as this notion might refer to that of the individual speaking subject, or again, to a particular concept, becomes the embodiment of concrete universality—in this case, the specific incorporation of community and of language.

Given the above discussion and with all due caution to the claim that intention is ever at one with itself/the author, or with the reader who interprets it, it seems safe to suggest that the above exegesis of agency far exceeds Saussure's own purpose, however faithful it may be to the ironic letter of his text. Although Saussure offers us a way to think this circuit of exchange *as* a circuit of production, we see the linguist stall before the challenge of his own insights. For example, Saussure's thesis undermines to some extent, our notion of the individual as a separate and self-possessed entity whose integrity is secured by personal will. In which case, we might query why Saussure insists above that "[n]o individual, even if he willed it, could modify in any way at all the choice that has been made . . . [T]he community itself cannot control so much as a single word." Strictly speaking, this is surely not the case. The individual can indeed express a choice, invent a word, and even create a private language should she wish. Because after Saussure, and as with "agency," the words "individual," "choice," "invention," and "private" have taken on an entirely different complexion. To insist that the individual has no creative influence over language is just as erroneous as its opposite assertion, namely, that the individual is the originary site that explains its metamorphosis.

We can better understand why the complexity of this matter might lie somewhere inside this curious oscillation between claim and counterclaim if we remember the difficulty that surrounded the sign's definition. Just as Saussure argued against the essentialism of the sign in nomenclaturism, we saw that he nevertheless remained caught in its cloying vocabulary, returning to

a conceptual regime that he seemed to reject. However, as the earlier part of the chapter attempted to explain, this recuperation was not simply mistaken. It is important to note that although Saussure's reiteration of the problem suggests that his recourse to essentialism was inescapable, the itinerary of this return raises a question about the very identity of essentialism—the immutability of its location and its separation from anti-essentialism.

It is worth emphasizing that this is not a more roundabout way of reasserting Saussure's anti-essentialism, an argument that would require essentialism as its transcendental reference point. Rather, it is the relational in-habiting between these two terms that is witnessed in Saussure's work; the implicated nature of their difference. We see this same bind in the linguist's discussion of agency as he tries to resolve the problem of how to account for the mutability of language. The surreptitious return to the province of individual will and creativity as the origin of this process is an awkward qualification of the earlier discussion. Saussure now suggests, "It is in speaking that the germ of all change is found. Each change is launched by a certain number of individuals before it is accepted for general use" (1974: 98).[19] An attention to Saussure's notion of "the stacked deck," read as the play of production, can usefully be deployed to analyze this division between society and the individual, *langue* and *parole*. The way in which Saussure understands the separation between system and speech also affords us another insight into why Saussure seemed determined to defend himself against aspects of his own thesis.

According to the linguist, *langue* was the opposite of *parole* because, "[i]n separating language from speaking we are at the same time separating: (1) what is social from what is individual; and (2) what is essential from what is accessory and more or less accidental" (Saussure 1974: 14). Earlier, Saussure rendered the notion of agency a more difficult and complex one, rejecting the speaker's ability to change elements within a language. Yet, he reclaims the concept to some degree in his definition of *parole*. Although the speaker was thought to have no efficacy within the system of *langue*, speaking itself was quite another matter. Saussure considered speech to be the executive side of language where meanings are actively designed and negotiated by an individual will. The speaker can exercise her own intelligence and realize her particular intentions through the arrangement and combination of language. In other words, the terms of language remain resistant to individual innovation, but the speaker can choose how those terms are to be organized.

Parole is therefore the instantiation of *langue* as individual selection. However, Saussure regarded the heterogeneous and contingent nature of speech acts and their contextual realization as far too messy for linguistics. As Culler explains it:

> If we tried to study everything related to the phenomenon of speech we would enter a realm of confusion where relevance and irrelevance were extremely difficult to determine; but if we concentrate on *la langue*, then various aspects of language and speech fall into place within or around it. Once we put forward this notion of the linguistic system, then we can ask of every phenomenon whether it belongs to the system itself or is simply a feature of the performance or realization of linguistic units, and we thus succeed in classifying speech facts into groups in which they can profitably be studied. (1986: 41)

Culler's rationale for the exclusion of speech assumes that the object of linguistic analysis must be a manageable one, obedient to the desire of the analyst who demands "profitable" rewards. The disciplinarization of knowledge into convenient frames of reference certainly involves such interested judgments, and a pragmatic instrumentalism inevitably informs most critical inquiry.

If we are not satisfied with the methodological justification for the *langue/parole* split, however, then Saussure's isolation of *langue* as essential and homogeneous, "the integral and concrete object of linguistics,"[20] "a self-contained whole and a principle of classification" (1974: 9), becomes something of a theoretical puzzle. *Langue* is also described as "a social product of the faculty of speech [*langage*] and a collection of necessary conventions that have been adopted by a social body to permit individuals to exercise that faculty" (9). In order to manage the contradiction that emerges regarding the discrete nature of *langue*, given the apparent inclusion of *parole*, this definition juggles with an awkward third term, *langage*. How should we understand the nature of *parole*, or more precisely the nature of the connection between the different categories, given that the *Course* tells us very little about the specifics of *parole*?

Saussure is quite consistent in his various descriptions of the speech/system division. He represents this difference through a series of oppositions, an ensemble of traits that are finally reducible to activity and passivity, the speaking subject versus the object of analysis. Although the word "system" would seem to connote some sort of dynamic involvement, its operation is figured in terms of static metaphors. *Langue* is "a storehouse filled by the members of a given community through their active use of speaking [*parole*], a grammatical system that has a potential existence in each brain, or, more specifically, in the brains of a group of individuals" (1974: 13–14). *Langue* becomes a reservoir for potential use, "exist[ing] in the form of a sum of impressions deposited in the brain of each member of a community, almost like a dictionary of which identical copies have been distributed to each indi-

vidual" (19). According to this analogy, the inventory of *langue* is "a product that is passively assimilated by the individual" (14), a memory bank of socially shared conventions that the speaking subject then manipulates and deploys. Hence, speaking is a creative act, the realization of intention.

We can scrutinize the speech/system division further by way of Anne Freadman's convenient summation of Saussure's project and the importance she attributes to it. Freadman evaluates the Saussurean approach to linguistics against that of Charles Sanders Peirce, an American philosopher and contemporary of Saussure's. As Freadman explains Saussure's *langue/parole* split, "*Langue* is the opposite of *parole* as the virtual is the opposite of the actual. *Langue* is the system *in virtu*: not the system in use, but the system available for use" (Freadman 1981: 143). We are again reminded that speech and system are organized around activity and passivity, or movement and inertia: a division that in turn interprets "use" as the realization of intention in the context of a "here and now." Measured against the presence of speech and its immediate efficacy, the system of language has only latent potential, and until this potential is actualized, it remains absent.

For Freadman, the difficulty can't be overcome by simply including *parole*, because Saussure regards speaking as an instance of *langue* rather than as a language event in its own right—that is, as an act whereby language is employed to do something. Against the apparent stasis of Saussure's "programmatic" theory of language, Peirce offers a theory of interpretation that attends to the functional dynamism of language. Freadman endorses the necessity for this attention in the comment, "a theory of language cannot exclude what language does" (1981: 144).

Drawn from an internal description of Saussure's theory, the active/passive split is now used to epitomize the essential difference between the two thinkers, with Saussure's system of signs *available for use* made the complement of Peirce's theory of signs *in use*. Freadman summarizes the oppositional differences between the theorists:

> the sign is for Saussure an item of a code, whereas for Peirce it is an event in the production of knowledge, and ... the object for Saussure is the system of signs prior to use, where meaning as such is non-problematic, while for Peirce the object is meaning as use, where the code as such is non-problematic. (1981: 147)

Whereas Peirce has no way of acknowledging the difference between language systems such as English and French, or accounting for the differences

among representational modes such as portraiture, geometry, and architecture, Freadman notes that in Saussure

> we have the foundation for a theory of codes, and therefore of the diversity and the specificity of signifiers. But there is no way of generating from it a theory of meaning as process, no way—because of the principle of synchronicity and the object of *langue*—of talking about what happens between one text and the next, and no way—because of the absence of reference—of talking about the relation of meaning and knowledge, of speaking and the world. (149)

A Peircean pragmatics attempts to explain how meanings and knowledges are attributed to the world and how they are then evaluated. Consequently, the focus of an approach that involves notions of intention and extension, sense, reference, and inferential semantics, is the context of speaking. We know that this is the area of *parole* that Saussure neglects, but should we infer, along with Freadman, that at this point we must turn to Peirce to redress this omission?[21] In order to answer this we need to determine the relationship between system and *parole* at the precise moment of speaking. However, if this truly is a relationship of absence and passivity versus immediacy and process, then the nature of the relationship, if indeed it is reasonable to continue to describe it as such, requires further explanation.

We can surely understand why the "being present" of speech (*parole*), the process of actualizing signification with a spatial and temporal existence, commands the attention of linguists. Something of the elusive nature of this speech/system division is captured in the fascinating work of Benveniste. He quite successfully combines Saussure's primacy of the system as the object of linguistics with the pragmatic necessity of studying its concrete contextualization.[22]

Through an analysis of pronominal forms, Benveniste reclaims the study of speech by arguing for a "fundamental division" within *langue*. He makes a separation between "language as a repertory of signs and a system for combining them and . . . language as an activity manifested in instances of discourse which are characterized as such by particular signs" (1971: 222). The distinctive shift here is to argue that discourse is not the strict equivalent of speech, for it also involves the variety of written genres that reproduce oral expression. This is why discourse remains a part of *langue*, the unique instance of *énonciation* wherein the frame of speech becomes the referential organization of linguistic signs.

The notion of reference here is quite different from the conventional model of denotation, because it is delimited by the "reality of discourse" and entirely defined within terms of locution. The determinations of space and time ("here," "there," "now," "yesterday") that are generated between interlocutors (deixis) become the contemporary and specific conditions of speech that are validated through the grammatical category of person—a frame of referencing that generates the referent.

Benveniste describes this division within *langue* as a difference between the semiotic and the semantic.[23] If the semiotic recognizes the complexity of intralinguistic relations, the semantic delivers the analytical possibility of interpreting the relationship of signs within a frame of reference. It is an endeavor that strives to account for the particular meanings and propositional functions that language enacts in any utterance-based reference.

The methodological usefulness of such discriminations is not in dispute. However, it needs to be remembered that the instrumental success of a particular analytical approach is often judged against a body of intellectual commitments and requirements that are not subjected to scrutiny. In this case, it is important to stress the all-too-obvious point that Benveniste is a linguist and one whose analytical enterprise answers the particular intellectual demands of that discipline. We should not be surprised, then, that Benveniste will ultimately subsume the heterogeneity of language data to semantics. As he insists:

> *Meaning* is indeed the fundamental condition that any unit on any level must fulfill in order to obtain linguistic status. We repeat: on any level. The phoneme has value only as a discriminator of linguistic signs, and the distinctive feature, in its turn, as a discriminator of phonemes. The language could not function otherwise. (1971: 103)

We might add into the mix the complication that Benveniste describes as a "Medusa's head" for linguists, namely, the difference between form and meaning. Inasmuch as form is a meaningful discrimination because it satisfies a certain functional operation, it will inevitably return us to a generalized notion of meaning. Indeed, the notions of "meaning," "use," and "function" are sufficiently implicated that they are almost interchangeable.

To harken back to Culler, when the dividends of linguistic analysis are not profitable a line is drawn. For Benveniste "a boundary is crossed" with the sentence. He puts the problem quite bluntly: "An inventory of the uses of a word might have no end; an inventory of the uses of a sentence could not even be begun. The sentence, [is] an undefined creation of limitless variety."

(Benveniste 1971: 110). Faced with its gross nature, Benveniste resolves, as Saussure had before him, that the sentence is not itself a sign.[24] As it is free from the constitutive involvement of language as a system of signs, the sentence is defined as the unit of discourse, "the manifestation of language in living communication." And unlike a sign, the sentence is self-sufficient:

> a complete unit that conveys both meaning and reference; meaning because it is informed by signification, and reference because it refers to a given situation. Those who communicate have precisely this in common: a certain situational reference, in the absence of which communication as such does not operate. (110)

This curtailment of the sentence within discourse locates the frame of analysis in the shared, spatio-temporal context of speech. And this becomes the manageable horizon that makes possible the general enterprise of hermeneutics in which notions of reference and time are conjoined. If it were to be conceded that the sentence is a sign, then the "context" of its production could not be delimited in this way. Consequently, such a concession would entirely undermine the stability of deictic location and thus fracture the presence (or unity) of the analytical moment. Although Benveniste's discussion of enunciation and discourse elaborates "context" and "subjectivity" as production effects of language, we see that he is never far away from a presence beyond language—a resolution of the sign in the nonsign—the reassuring world to which language ultimately refers.

Notwithstanding internal disputes, Benveniste's intervention remains enclosed within the classical conceptuality of modern linguistics that equates representation with derivation: the signifier means "derived from," just as the sign means "a substitute for." The result of this is that Benveniste's definition and elaboration of the sign depends upon the metaphysics of self-presence. Yet in the earlier part of this chapter the identity of the sign seemed much more elusive. Saussure's various attempts to define the sign involved a tangle of contradictions, a confusion of claims that inadvertently embraced what they refuted. The limit of the sign, that selvage where the textile of language folds back upon itself to secure its identity, threads a strange fabric. For within the particularity of the language textile we discovered the incontrovertible trace of what is purportedly an extralinguistic reality. As the autonomy of language cannot be discriminated from what supposedly is external to it, the paradox of the sign's identity is symptomatic of the paradox of identity *as such*.

We can put this another way by saying that if the sign is "purely differ-

ential" then it is never sufficient to itself: it is always pregnant with otherness, full with expressing its peculiar "indebtedness." Saussure explained that the content of a sign "is really fixed only by the concurrence of everything that exists outside it" (1974: 115). But if the context of the sign's existence is already incorporated in/as the sign, then the body of the sign is never not engorged with the whole of the language system. This is the notion of value that interrupts any normative definition of the sign.

Keeping this in mind, we should now be aware that Benveniste's ruling that the sentence is not a sign was required by the interpretive demands of linguistics and the discipline's will to mastery. This same point is pertinent to Freadman's earlier comments. Although her account of the sign draws from Saussure's own descriptions, it does not acknowledge the irreducible breach in his definition that is brought about through the elaboration of "value." Freadman notes that the very fact that *la langue* is the dictionary "accounts for the absence of reference in Saussure: only language in use refers, dictionaries don't. Saussure's dictum, that everything happens within the confines of the sign, follows strictly from the postulate of *la langue* as a repertoire" (1981: 143). According to this analogy, meaning slides from one word to another in a polysemous chain of referral. This is a lineal metaphor that locates difference outside a particular sign, between one sign and the next, one word leading to another in an endless unfolding of different contextualities. Yet, if a sign is constituted *within* differential relations, then these relations must also inhabit the sign.

The problem here is that a conventional understanding of identity and difference takes these categories as oppositional, assuming that there is a distinct inside and an outside (the sign), a presence and an absence—an actual versus a potential. With the notion of "value," however, Saussure undermines the separability of these oppositions and provokes us to question whether this involvement is inevitably, or simply, legible to hermeneutics/linguistics. The metaphor of the dictionary, even as it concedes the contextual ambiguity of polysemy, comprehends difference/referral within the regime of sense, meaning, or semantics. The unity of meaning is inevitably recuperable in this analogy, even as it remains something of a promise postponed.[25]

Yet the disquiet that accompanies Saussure's elaboration of "value" is the apprehension that difference is not, finally, comprehensible in any straightforward way. For difference exceeds even the contextual multiplication of polysemy and, indeed, the regime of meaning itself. Difference is never in itself a discrete, sensible plenitude. Difference marks the impossibility of the unity of a sign, complete within the fullness of an absolute presence. The "stuff" that is considered absent (because in the storehouse of the system) *is*

the process of the sign's "becoming sign." It is not simply absent any more than the sign is simply present.

The attempt to circumscribe the sign through an appeal to its use—that is, an appeal that would presume to finally resolve what the sign does or how it means—must make recourse to an originary plenitude in intuitive consciousness, the speaking (intending) subject and/or the contextual time frame of an utterance. This gesture allows the analyst to invest in the possibility of disclosure, where meaning will ultimately be returned to itself.

We see its logical foundation in Saussure's second principle of language: the linearity of the signifier. The principle is so obvious that Saussure suggests "linguists have always neglected to state it, doubtless because they found it too simple" (1974: 70). But, it is precisely in the self-evidence of temporal essence as the unfolding of presence along a line—in this case, in the fact that discourse is conceived as "a succession of sounds in time"—that Martin Heidegger locates its vulgar understanding. This conception of time as a string of discrete and autonomous moments whose tangible immediacy is present to experience *and then* absent from it, has dominated "all philosophy from Aristotle's *Physics* to Hegel's *Logic*" (Derrida: 1984: 72).[26] It is presumed in Freadman's earlier comments about reference, process, and use—notions that are only meaningful within the full presence (even when deferred) of the speech act. It is the companion concept that explains the impatience of linguists with the "wrong tempo" of the fourth associational chain mentioned above. And it is why linguists, or literary theorists for that matter, have a good deal of trouble explaining the ubiquity of "poeticity" as "that certain something" that both exceeds meaning and contingently makes it possible.

In what has been described as *la folie de Saussure*, we see the linguist caught by a fascination with this ungraspable "something" in language. The objects of his sustained obsession were the anagrams or "hypograms" unaccountably hidden within Latin verse. At first Saussure sought proof of the reality of these cryptic signs in the author's conscious intention, presuming they were evidence of a poetic convention within Latin that had since been lost to history. But Saussure was soon discovering a "stream" of anagrams everywhere he looked, even in the most banal of prose fragments. Hoping that "the great gain will be knowing the starting point of the anagram" (Saussure, as cited in Starobinski 1979: 93), he nevertheless conceded that the phenomenon might prove a retrospective illusion projected there by the reader—a product, then, of his own desire.

The linguist's compulsion to discover the anagram of a proper name within a text inevitably leads him to seek proof from the author, who could

attest to its existence. But when finally convinced that the anagram was not the result of a conscious process Saussure abandoned his studies. He now had clear evidence of an operation within language that could not be comprehended by linguistics; an operation whose "motivation" was not simply linear, and whose manifestations were strangely phantasmatic. The vagaries of this operation's temporal spacing involved a vertigo of infinite connections and disjunctions that together articulate writing *and* speech. Sylvère Lotringer summarizes the crisis that Saussure's perception implied:

> Here we can glimpse briefly the infinity of language, "the sacred mystery," a textual process without origin since it is caught in a ceaseless play of referral and reverberations, and without end inasmuch as it unfolds in a self-referential space, a perpetual refraction in a hall of mirrors where every site is a citation and every citation an *incitation* (a setting into motion).[27] (1973: 4)

In the desire to restore meaning through an appeal to the author's intention, Saussure hoped to preserve the unity of the word and the unity of the subject. He could not allow that the will and intention of the subject are also fractured by the same "anagrammatism" that subverts the unity of the sign. As we have seen, Saussure likened individual agency in language to the skill of a card player whose chances were determined by a stacked deck. But he retained an unqualified investment in agency and intention nevertheless. If the ordinary speaker is unwittingly played by the dictates of language, it still remains somewhat heretical to suggest that the linguist is similarly duped.

Saussure discovers a system that is regulated by the exigencies of its own internal necessity, but a system whose frontiers cannot be defended against an exteriority that involves something more than the science of linguistics is prepared to embrace. And yet it is this desire to define the system of language for the discipline of linguistics that, according to Derrida, "prevents Saussure and the majority of his successors from determining fully and explicitly that which is called 'the integral and concrete object of linguistics'" (1984: 33).[28] Nevertheless, the challenge that Saussure brings to linguistics, a rupture that heralds the opening of a question that will not be answered by any classical concept of the *epistémè*, remains sufficiently compelling for Derrida to advise, "it is not a question of 'going beyond' the master's teaching but of following it and extending it" (1984: 55), and in such a way that "we definitely have to oppose Saussure to himself" (1984: 52).

Reading Saussure against himself, we find that one of the enduring signatures of his work is legible in the perverse way that he subverts the unity of identity—perhaps even his own. We have seen how the assumption that

an entity can be determined in any final way as the proper unit of analysis has been displaced by the force field of "value." Consequently, the smallest atomic particle of the language system, its larger analytical agglomerations, and even the sense-certainty of the speaking subject, have now all been put into question. But where does this leave us regarding what can only be a theoretical *non sequitur*, namely, a persistent belief in the unity of the language system itself? Further to this, how is the autonomy of the language system dissected out from the operations of other social systems? And finally, how does the unity of "the social," or "the cultural," secure its particular identity against "an outside," namely, the natural order?

two

Corpus Delicti

The Body *as* the Scene of Writing

> [W]riting, the letter, the sensible inscription, has always been considered by Western tradition as the body and matter external to the spirit, to breath, to speech, and to the logos. And the problem of soul and body is no doubt derived from the problem of writing from which it seems—conversely—to borrow its metaphors.
> —Derrida, *Of Grammatology*

> "[A] psychology of consciousness and of intuitive consciousness," of truth as the circuit of self-speaking, self-hearing, and self-understanding . . . this is made possible by the repression of writing, of the body of the signifier, and of the economy of language.
> —Jay, "Values and Deconstructions"

Signifying Matter

The excessive identity of the sign swells like an illicit pregnancy that witnesses an improper breaching of borders. This moral stain of disrespect is at the very heart of the sign, its irreducible essence. The perceptible and intelligible parts of the sign (signifier and signified) entirely betray their defining difference, incorporating what the bar that separates them would legislate as "other." Yet in the delirium of this copulation difference is not undone but rather reinvested with itself, fissured through with an involvement that transforms and complicates its original identity.

There is no inside or outside the sign whose integrity is untouched by these implications. For this reason, one should not take the critique of the classical notion of the sign in the previous chapter as merely an extended metaphor whose complexities rehearse the problematic of the body. It is our conventional understanding of the difference between the literal and the metaphorical, between the body and the sign that represents it, glossed as the

distance between real and representation, matter and language, that the previous chapter contests. Indeed, the ramifications of Saussure's notion of "value" leave us in something of a quandary regarding the meaning of "betweenness," dependent as this word is upon notions of discreteness and identity and upon linear concepts of time and space that are now called into question. The provocation is this: with no "outside the sign" there can be no "outside the system" that gives it value. Consequently, language bursts the boundaries of its conventional articulation, engendering a reality whose inscriptive production implicates the ideological with/in the physical.

But these extraordinary claims have become somewhat trite within the identifying axiomatics of postmodern and poststructuralist theorizing. As we saw in the previous chapter, the force of such assertions commonly draws its conviction from an appeal to "the arbitrary nature of the sign." Yet, if left unproblematized this notion entirely qualifies the most radical implications of this blurring of divisions. We should remember that it is through the notion of "the arbitrary" that the aporia of reference is both conceded *and* refused. And yet, although it may be allowed that the precise break between nature and culture, or reality and representation, is now undecidable, we are left with a sense that these realities are "in fact" discrete. The meaning of "undecidability" is conventionally circumscribed within hermeneutics, a concession to the encultured nature of the human condition that prevents the division's final arbitration.

Questions of sexual and cultural difference have also been confined within the parameters of this classical comprehension of the sign as something separable from the extralinguistic reality of matter. The curtailment of these questions is insufficiently perceived, perhaps because the conservative presumptions of positivism and empiricism, with their abdication of theoretical complexity, become the essentializing and politically suspect practices against which a self-proclaimed anti-essentialism approves itself. Yet, as the question of essentialism remains an irreducible part of any practice, our attempts to think the body differently will unfold within its necessity.

We have already seen that the principles of nomenclature endure within Saussurean linguistics despite attempts to shake off any essentialist appeal to the real world, to reference and denotation. What Saussure would exclude from his own practice as its defining essence is, ultimately, an irrepressible and necessary part of it: Saussure's anti-essentialism relies upon and includes its avowed opposite. But if the relationship between signifier/signified and sign/real cannot be adjudicated by the word "arbitrary," then there can be no final limits to language. It is this insight, captured in Derrida's now infamous

phrase, "there is nothing outside of the text" (1984: 158),[1] that inspires anxiety among critics of poststructuralism.

Derrida is routinely admonished for presuming to reduce the extraordinary complexity of the world to "the prison-house of language." But this judgment entirely misses the point, reinvesting in the logocentrism of linguistics (considered the proper purview of the sign) that Derrida would unsettle. Unlike Saussure and Benveniste before him, Derrida does not argue that language (as speech and its annotation) is an enclosed entity that can be separated from all that we take to be its "other." In his hesitant speculations about a future science of signs, even Saussure himself came close to disrupting the enclosure of language:

> *A science that studies the life of signs within society is conceivable* . . . I shall call it semiology. . . . Since the science does not yet exist, no one can say what it would be; but it has a right to existence, a place staked out in advance. Linguistics is only a part of the general science of semiology; the laws discovered by semiology will be applicable to linguistics. (Saussure 1974: 16)

Saussure's musings are sufficiently akin to Derrida's expanded notion of language ("language in the general sense") for Derrida to substitute his own word, "grammatology," for Saussure's "semiology." The suggestion here is that the sign is informed by a context that is more than linguistic, an "intertext" in which the very concept of linguistics is placed under erasure. This reading is very different from Roland Barthes' correction of Saussure's semiology, a correction whose inversion of the relationship between linguistic part and semiological whole supposedly "carries out the profoundest intention of the *Course.*" Barthes restores what he deems is the proper order of dependence between linguistics and semiology: "From now on we must admit the possibility of reversing Saussure's proposition some day: linguistics is not a part, even if privileged, of the general science of signs, it is semiology that is a part of linguistics" (Barthes, as cited in Derrida 1984: 51).

Barthes' corrective continues to invest in the discreteness of "sign" and "system," as if the closure that surrounds the categorization of signs as entities within systems of knowledge was not a *process* of closing, a process of identifying and delimiting that can never be finished. It is this process that precedes, constitutes, and subverts the integrity of sense and meaning, and the identities of sign, system, linguistics, and its "other," that grammatology tries to acknowledge in the words "trace," "inscription," "arche-writing," and "text." The consequence is that the morphology of the grammatological textile cannot be contained *within society*, as Saussure remarks of semiol-

ogy, for the identity of society as such becomes a question within the sign's rewriting as "trace."

The classical understanding of signification grants the absence of a transcendental signified, together with the accompanying implication that the play of the signifier is limitless. Indeed, this is the explanatory basis of anti-essentialism that discovers in essentialism's putative facts the sedimentation of cultural and political values. A genealogy of French theorists from Saussure through Benveniste, Lévi-Strauss, Barthes, and on to many of today's postmodern and cultural critics, would surely accede to this view, captured in the structuralist aphorism "language speaks us." Yet if we read this aphorism grammatologically rather than, as Barthes would have it, through a notion of language where linguistics mainframes all other data, what difference does it make? Put simply, does it really matter? In this chapter I explore "the matter of difference" as "the difference of matter." I argue that anti-essentialism disavows its own investment in an essentialist conceptualization of matter. And I endeavor to suggest why "essence" rests upon an unacknowledged complexity that should be engaged by cultural critics rather than simply diagnosed and condemned.

If we begin this interrogation with a reconsideration of "the play of semiosis" as the absence of a transcendental signified, we soon discover that the signifier's slide, said to be infinite, is actually quite restricted. Derrida comments that this "play" is understood to take place "within regional limits," that is, it unfolds "*in the world*." But Derrida argues that "it is . . . *the game of the world* that must be first thought; before attempting to understand all the forms of play in the world" (1984: 50). This gaming metaphor recalls Saussure's own attempt to complicate our notions of agency and causality through the image of "the stacked deck." Derrida attends to Saussure's intervention, yet tries to acknowledge what the implications might be if they were not confined "within regional limits."

The stable ground presumed to be outside signification is of course matter itself—the real physical substance that, ultimately, resists all attempts to penetrate and to know it. We should not be surprised at this metaphor of carnal knowledge, where the feminine allure of nature taunts and counters the will of culture gendered masculine. Saussure was quite precise about what was inappropriate to the sign. Its identity was determined through the play of form, not substance: "The linguistic signifier . . . is not phonic but *incorporeal*—constituted *not* by its material substance but by the differences that separate its sound-image from all others" (1974: 118–19; emphasis added).

Saussure's active repression of the body of the signifier reiterates the

somatophobia (phallocentrism) of Western metaphysics that renders matter immaterial. Saussure was certainly careful to exclude "the material sound, a purely physical thing," from "the psychological imprint of the sound, the impression that it makes on our senses." It was only after this clarification that Saussure could risk describing the signifier as the material part of the sign. As he explains, "The sound-image is sensory, and if I happen to call it 'material,' it is only in that sense, and by way of opposing it to the other term of the association, the concept, which is generally more abstract" (1974: 66).

What predicates the assertion that difference can be localized as the formation of form, a diacritical play said to be without positive terms, is the grounding predication that the world, conceived as the sensible plenitude of substance, is already *present* to itself, both independent of, and anterior to, those signs that would designate it. Consequently, the anti-essentialism of the sign is guaranteed by an essence now deferred. It is this difference, interpreted as an oppositional relationship between two separable spheres, that founds the Saussurean sign and recuperates it for Western metaphysics. But as the previous chapter suggested, Saussure's notion of "value" is not captured in the concept of difference as "in betweenness": difference already inhabits the identity it would discriminate.

If we extend the play of the signifier "in the world" to "the game of the world," then the generative substance of matter, the body of feminized nature, is no longer a solid ground as immutable essence and origin. If difference motivates matter, incorporating transformations thought to be incorporeal, knitting signification within representation within substance, then the body as nature as woman as other involves a *différance* for which oppositional logic can give little account. What is required here is a sense that ideality and materiality are enmeshed and empowered by what Derrida might call an inscriptive efficacy, a "writing together of traces." This productive entanglement is so entire that ideality and materiality, as they are commonly conceived, are profoundly altered.

"and the word was made flesh"

As my argument involves an exploration of the supposed difference between material objects and immaterial signs, a difference about which Saussure was quite definite, the linguist's own assertion on this subject is worth noting. Saussure insisted:

> The object that serves as sign is never "the same" *(le même)* twice: one immediately needs an examination or an initial convention to know within what limits and in the name of what we have the right to call it the same; therein

lies its fundamental difference from an ordinary object. (as cited in Jakobson 1987: 448)

Again we witness how the nature of signification's dynamic flux is identified against the mute reality of stable objects. But if the critique of the sign is to be taken seriously, if materiality is a type of "writing" wherein difference is its defining force, then we would have to concede that objects are entirely permeable to what we describe as culture, and that the transformational plasticity that identifies the latter must also inhabit the former.

This is not an easy concession to make. And I suspect that the reason why deconstructive criticism has remained so comfortably confined within literary studies is that it is politically unthinkable that the grammatological "textile" could really be as strange as all that. Evidence of this extraordinary "weave" is not spectacularly present, and the business of proving its existence, when it is existence itself that must be rethought, underlines the question's labyrinthine dimensions. We should also remember that the logic of proof, wherein reason proceeds through an analysis of contradiction or negation, deploys an oppositional notion of difference that forecloses its complexity in the presence/absence binary.

The following phenomenon is especially provocative in view of these difficulties, for we witness the sense of the corpo*real* differently and in a way that includes the tissue of the body in the sensible textile of an "arche-writing." It is an illustration whose provocations extend far beyond its historical moment, relaying a script which is still very much alive.[2] For what is writing when it is more than writing—when the familiar meaning of the word assumes such monstrous elasticity that it surrounds and invades everything, when it is everything, when there is no getting outside this ubiquitous text? And how is the body itself a scene of writing, subject to a sentence that is never quite legible, because to read it is to write it, again, yet differently?

A dangerously dilapidated wing of the Satpêtrière hospital is forced to release its unfortunate inmates into the care of its senior physician. We are in the Paris of the 1870s, in the company of Charcot and his medical colleagues and among the many patients who exhibit a range of behaviors then attributed to hysteria. Separating the hysterics from those suffering from mania, melancholia, schizophrenia, or nonpsychotic epilepsy was, at least at first, a confusing task, because the hysteric is a consummate mimic who can impersonate all of these afflictions. Most often a woman, her bizarre symptoms are displayed with an ostentatious enthusiasm that is worthy of the professional actor. Indeed, the hysteric is so devoted to her performance that she

takes on its script in a quite remarkable way. The hysteric's talent for mimicry is so entirely persuasive that the difference between reality and theater, disease and its imitation, is difficult to determine.

The physician, Barthélémy, is spared such a decision as he makes his daily rounds through this Parisian bedlam. Among his observations is a patient whose skin is alive with smallpox, and yet this alarming spectacle rouses only interest, not concern. Barthélémy is well aware of the hysteric's ability to mime these mortal signs, to fabricate this dermal counterfeit of contagion and disease. We might imagine that some inattention to detail alerts the physician to the symptom's forgery, but the patient's capacity for simulation approaches the perfect copy. Barthélémy can only discriminate fake from real because his patient's chameleon display is well rehearsed: the doctor has witnessed it several times before.

But even as a repeat performance, who could not be captivated by these hysterical histrionics? It is as if the hysteric is a mirror of her surroundings, incorporating the signs from an other's body as the reflection of her own. Interestingly, these ruptures in the skin that witness the desire to figure will transform over time; today's smallpox becomes next week's scarlet fever, or last month's measles, or dermatitis (Didi-Huberman 1984: 11).

One of the most curious manifestations of hysteria in the late nineteenth century, and one that would seem to support Freud's suggestion that this is a disease of representation, is the phenomenon of dermagraphism. The autographic capacity of the skin was a regular part of the "show" in the Salpêtrière, where Charcot encouraged his hypnotized patients to perform their symptomatology before a fascinated medical gaze. Barthélémy gives an account of one of these events:

> a patient is hypnotized; the doctor writes his own name on the patient's forearms with a rubber stylet and issues the following suggestion: "This evening, at 4 pm, after falling asleep, you will bleed from the lines that I have drawn on your arms." At the appointed time, the patient obliges. The characters appear in bright relief upon his skin, and droplets of blood rise in several spots. The words persist for more than three months (as cited in Didi-Huberman 1987a: 69).

Scriptural markings could also be commanded without the aid of a stylet, as we might presume from the delay in this example and from its peculiar endurance.

The uncanny impressionability of these impersonators earned for them the nickname *femme-cliché*, a term that compares the hysteric's skin to a photographic or typographic recording plate. The graphic images of these der-

mal inscriptions behaved like a sort of negative relief: the markings could rise up to six millimeters, and there was usually a significant color contrast between the writing and its ground, or even between one word and another on the same patient—a red or white dermagraphism.

Charcot likened the parade of "exhibits" at his weekly séances to "a living museum of pathology," and the relationship between medical observation and art appreciation is made quite explicit in Bourneville and Régnard's three-volume *Iconographie photographique de la Salpêtrière* (1878). Choosing only female hysterics, Charcot acts as *répétiteur*, drilling his leading ladies in a nineteenth-century version of vogueing that blurs the difference between pose and possession. Charcot's fascination with the demonic, the ecstatic, and with sickness and deformity in ancient statuary provoked him to publish articles and books on the subject. According to Georges Didi-Huberman, Charcot was convinced that the hysterical symptom should be observed and analyzed in much the same way as one would study an art work (1984:8).

Fixed before the camera of clinical voyeurism, the symptom was effectively aestheticized by Charcot in a *tableau vivant* of sculptural compliance. There could be no doubt that the hysteric was part of the artist's *oeuvre*.[3] Many doctors inscribed fantastic markings on the bodies of their patients such as the name or hand of Satan, an image from the face of a coin, or a cryptic doodle meant to evoke some cabalistic significance. Often, as with Barthélémy's example, the "work" would then be signed and even dated in preparation for the photograph, as if the physician was the author of the subject, the artist of an embodied icon. The photographic symptom could perhaps be considered a contractual effect of the photographic pose. And this is a strange contract indeed, whose signature is secured when the tactility of the look and the cutting edge of the voice are rendered visible. For if dermagraphism is an effect of some sort, then what precisely are we to understand as its cause?

As it is commonly conceptualized, the notion of cause and effect presumes two independent moments, separated by a medium through which information passes. The medium in this communication model is nothing more than a cipher, a thing of no constitutive consequence, the vehicle through which the message is conveyed from sender to receiver. In other words, the difference between the author/sender and the reader/receiver is a difference in identity and location that must be bridged. It is this same gap that also separates the origin from its aim or end, the supposed difference between creation and reception.

The hysteric's inscripted body quietly subverts all of these divisions with its simple autograph. Who wrote this text? Where do we locate its begin-

nings, the act through which it is figured, the intention that sees it realized? How is this dumb, intoxicated body able to illustrate its subject position, enact its passivity, and sentence itself? How is the desire of the other incarnated and stigmatized as tattoo? And how is this swelling and engorging of cells traced through the rhythm of an interval of time—"at 4 pm, after falling asleep"?

Any discussion of Charcot's clinic and the theater of its curiosities is now overdetermined by the discourse and vocabulary of psychoanalysis. Freud studied with Charcot, and Freud's interest in hysteria, which began there, was foundational to his later practice. However, the haunting image of the autographic skin is surely provocative even for those who may be unfamiliar with psychoanalytic theory. The sheer wonder of the phenomenon gives pause for thought. What is perhaps most shocking about the hysteric who poses herself as the malleable plastic of figuration, making herself a work of art—an artifice that declares its own deceit—is that within the strangeness of her embodied scripture we read something of ourselves. Reluctantly perhaps, we find ourselves inhabiting the flesh of this text and sharing the same corporeal stuff of its writing. For what is posed is the awful evidence that perhaps we are not what or where we think ourselves to be. If thinking is something that fastens upon a body—"coming to grips" with a body of questions, "taking" an object for speculation—then what does it mean when the body that is written upon signs itself, when a symptom "speaks," or when an object possesses us?

It is by now a commonplace that the subject/object split that underpins the mind/body division is one that is politically inflected. Although the Cartesian schema grants that man has a body, it is merely as an object that he grasps, penetrates, comprehends, and ultimately transcends. As man's companion and complement, woman *is* the body. She remains stuck in the primeval ooze of nature's sticky immanence, a victim of the vagaries of her emotions, a creature who can't think straight as a consequence. To engage the political asymmetry of this binary opposition it is not enough to try to overturn it, if by such a gesture we mean to celebrate, or at least to reassess the value of what has previously been denigrated (although this strategy is always a useful start!). Nor is it sufficient to condemn the division itself, as if the mistake of Cartesianism could be corrected by the unremarkable observation that mind and body are, surely, irreducibly inseparable. Descartes himself was painstakingly insistent on this last point.

The political complexity of binary divisions is inadequately engaged by such responses because the question of identity is foreclosed, rather than posed, by these interventions. They inevitably propel themselves through

unacknowledged binary divisions that attempt to replace errors with truths in the simple presumption that knowledge is either present or absent. However, if we begin by analyzing the in-habiting of oppositional terms, taking leverage from the negative side of the binary, then we are inevitably faced with the specter of something more, something that, because it embraces and confounds both terms, destabilizes their division and refigures their meanings. Dermagraphism is just such a troubling phenomenon because it suggests that mind and body, subject and object, even Charcot and his patient for that matter, are none of them either autonomous notions or simply separable as subjects. The corruption of integrity here involves more than a surface contamination, for the identity of each is produced within a complicitous intertext, a "writing," as Jacques Derrida calls it, that is all-encompassing.

Concepts such as "writing in the general sense," *écriture*, "trace," "text," and so on, are commonly interpreted within the conventional literary context that would normally define them. As a consequence, the radical purchase in these neologisms is often lost in the ease of this recuperation. Derrida explains that

> strategic reasons . . . have motivated the choice of this word [writing] to designate "something" which is no longer tied to writing in the traditional sense any more than it is to speech or to any other type of mark . . . [W]hat is at stake is precisely the attempt to put this concept into question and to transform it. (1977: 191).

Within this transformation, "writing" is no longer just a literary notion because its purview extends to cinematography, choreography, the pictorial, the musical, the sculptural, the athletic, the military, the political, and "the entire field covered by the cybernetic *program*" (Derrida 1984: 9). Despite Derrida's description, which is no more than a suggestive opening onto this enlarged scene of writing, we might still be under the misapprehension that this is just another way of talking about representation in its conventional sense, about the complexity of the cultural text that, in its different guises, mediates the world of real objects and natural processes. There are, then, at least two ways to interpret this insistence that "there is no outside of text."

This claim is most commonly taken to mean that we are caught in an endless slide of referral that leads from one signifier to another signifier, one meaning to yet another meaning, in a vertiginous spiral of implication that never quite arrives at its destination. As a consequence, we can never retreat or advance to some natural, prediscursive, or extratextual space in order to test the truth or adequacy of our representations because, as we have seen,

intelligibility itself is reckoned through such systems. However, one can insist that there is no getting outside representation while still holding to the view that there is indeed an "outside," but one to which the human condition prohibits access. This "outside" is assumed to be the reality that culture mediates, the substance to which our discourses give form and shape, the ultimate ground of Being.

This idealist stance measures the artifice of a representational reality against the material stability and endurance of some unreachable ur-form, or, more accurately here, ur-substance. According to this view, what we take to be reality is more accurately understood as a "reality effect," a dissembling "construct" that evidences culture's own hystericized imposture as nature. Certainly, the word "construct" bears quite an interpretive load here, and one whose theoretical and political ambiguities are seldom and insufficiently elaborated.

The above approach concedes that "the worlding of the world" is different through time and space. And it is the shifting nature of these different representational guises that provides proof against foundationalist or essentialist claims that knowledge is finally grounded. The assumption seems to be that if the ground isn't solid and fixed, then it isn't a ground—if it moves and changes, then it must be the mere representation of a ground. Ironically, the unspoken foundation for this anti-essentialist assertion of groundlessness is a notion of groundedness whose immutability is never in question.

But there is another approach to the dictum "there is no outside of text," and it comes in the suggestion that "the worlding of the world" as "writing in the general sense" articulates a *différential* of space/time, an inseparability between representation and substance that rewrites causality. It is as if the very tissue of substance, the ground of Being, is this mutable intertext—a "writing" that both circumscribes and exceeds the conventional divisions of nature and culture. If we translate this into what is normally regarded as the matter of the body, then, following Derrida, "the most elementary processes within the living cell" are also a "writing" and one whose "system" is never closed (1984:9). This would mean that the body is unstable—a shifting scene of inscription that both writes and is written—a scenario where the subject takes itself as its own object, and where, for example, an image could be said to rewrite the image-maker in a movement of production that disrupts the temporal determination of what comes first. The common understanding of materiality as a rock-solid "something," that is, as the absolute exteriority that qualifies or limits the efficacy of representational practices, is called into question through such an approach.

The example of the autographic skin witnesses an outside becoming an

inside, an image real-ized, a body *as* its own historical and cultural context. But why call this "writing"? Put simply, writing in the narrow sense articulates its status as representation, as something encoded, structured, and never immediate because fractured by an inevitable delay of time. Writing is never granted an originary or foundational status because we tend to think of it as something parasitic. We think of writing as something that originates in the writer/author; as something that reports what originally happened in a speech act; as something that re-presents a distant reality. If, however, whatever writing measures itself against is also a scripture—and this will include the assumed substance and solidity of nature as ultimate cause, the self-presence of the subject, intention as an originary explanation, truth as stable and unified, and so on—then the phallocentrism and ethnocentrism that is endorsed within such notions might be more effectively engaged. In sum, we might consider that, in every possible sense, representation matters.

Corporeal Habits: Addressing Essentialism Differently

> Writing, sensible matter and artificial exteriority: a "clothing." It has sometimes been contested that speech clothed thought.... But has it ever been doubted that writing was the clothing of speech? For Saussure it is even a garment of perversion and debauchery, a dress of corruption and disguise, a festival mask that must be exorcised, that is to say warded off, by the good word: "Writing veils the appearance of language; it is not a guise for language but a disguise" ([*Course,*] p. 30). Strange "image." One already suspects that if writing is "image" and exterior "figuration," this "representation" is not innocent. The outside bears with the inside a relationship that is, as usual, anything but simple exteriority. The meaning of the outside was always present within the inside, imprisoned outside the outside, and vice versa. (Derrida 1984: 35)

Dermagraphism incarnates as cutting edge the play of impersonation that enmeshes the tissue of the visual, the auditory, and the tactile. Here, the semiotic integrity of a particular perceptual mode is corrupted by what is considered foreign to it, that is, information that hails from another sense system. This "inscripting" refigures the arithmetic that comprehends sense data as an aggregate of separable realms.[4]

In trying to convey something of the wonder and complexity of this inscription I am reminded of the Scottish percussionist, Evelyn Glennie. Achieving international recognition as "The Royal Philharmonic Society's Soloist of the Year" in 1991, and currently among the more pre-eminent soloist percussionists in classical music, the success of this virtuoso performer is particularly remarkable: Glennie has been profoundly deaf since the

age of twelve. Strangely, in interviews, it is apparent that her world is in fact full of sound: a Brazilian *batteria* is described as "deafening," wrong notes are "heard," and kettle drums promptly adjusted and retuned. If for most of us hearing is the legibility of vibration on the tympanum of the ear, then Glennie's entire body has become sound's instrument. For example, Glennie explains that she hears certain notes through her jaw, while others sound through parts of her face or certain parts of her feet and so on. Sound is thus intricately scored and played through the staff of her body, recorded and performed in the very tissue of skin, blood, and bone. What remains then of the notion of sound itself in the suggestion that bone produces this silent music? If the vibrations of skin and blood constitute a mode of listening, a mode of reading and rewriting sound, then sound itself is a text, a differential reflex. Here, touch impersonates sound because both modalities are underscored by the rhythm of a *différance* in which the body is never not musical. The body is the spacing of this game, the ma(r)king of an uncanny interlude.

What enables Glennie to completely redefine our notion of audibility is clearly something that extends well beyond her own individual achievement. If Glennie is her music, then even those of us who are apparently deaf to sounds such as these must hear them nevertheless. To suggest that we "hear" this cacophony and that we make "sense" of it does not return us to hermeneutics in any conventional way. When Derrida insists that "the most elementary processes within the living cell" are also a writing (and we could put this another way and describe this complexity as a form of reading), it is to this script that Glennie's music is attuned.

This notion of the ludic body as the play of the sign is not comfortably reconciled with Benveniste's assertion that "[t]here is no sign that bridges several systems, that is transsystemic" (1985: 235). In questioning "the intersemiotic validity of the notion of 'sign,'" Benveniste describes music and the plastic arts as syntactic but not semiotic (237). In these instances, Benveniste considers that the analytical unit cannot be deemed a sign because there is simply too much going on. Unlike "the great semiotic matrix" of linguistics (241), with its "univocal" sign and fixed repertory, music and the plastic arts involve a veritable din of signifying possibilities:

> Musical sounds can occur in monophony or in polyphony; they function in an isolated state or simultaneously (chords), whatever the intervals separating them into their respective scales. There is no limit to the multiplicity of sounds produced simultaneously by a group of instruments, nor to the order, to the frequency, or to the scope of combinations. (236)

The axes of selection and combination that organize language are certainly confounded in this example.

Yet if not in this particular case, Benveniste nevertheless assumes that the notion of the sign is *somewhere* sufficient to itself, and that in this privileged place its functional operation can be determined and contained. This same belief motivates the work of Christian Metz and Peter Wollen, who are among the many writers who have explored the applicability of the apparatus of the sign to the visual arts.[5] Such endeavors have been important in questioning the nature and limits of structuralism. Yet, these theorists begin by assuming that the identity of the sign, as a unit with a delimitable integrity, can indeed be isolated in linguistics.

In the previous chapter we saw that every attempt to delineate the nature of the sign (and difference) was founded on a maze of confusions and contradictions. Saussure's notion of the signifier, for example, couples the visual with the auditory in his *image acoustique*, not as one mode *with* another so much as the intermodality of perception itself. Vincent Descombes's "mystery of the left-hand box" illustrates the ease with which we separate one sign's perceptual validity, or expressive modality, from another. Like Descombes, most of us will assume that the left-hand box (in Saussure's diagram of the signs for "arbor" and "equus") is a visual representation, and we may need to be reminded that a word is also a visual figure.

What I am trying to get at here is rehearsed in the previous chapter's discussion of *langue* as a repertoire—a storehouse full of latent usefulness. It is the passivity of this figure that deserves attention, with its reliance on a model of difference that is synonymous with separation and opposition. Descombes remains unconvinced that, for a word, "all its various potential meanings are latent in each one of its uses" (1986: 181).

His skepticism is surely warranted by the conventional conceptualization of the sign within the presence/absence binary. It seems reasonable to wonder about the nature of a relationship that is capable of "working" across a gap, or an absence, when the connecting "current" is apparently turned off. What does it mean to insist that difference is the relational force of production in the language "system" when difference is equated with the lack, or absence, of identity? How is an absence, or lack, possessed of a generative capacity. How is an absence communicative?

If we read "difference" through the complexity of Saussure's notion of "value," the force of the grammatological "textile" and its *différant* "trace" presents itself. But this is no ordinary presentation. Perhaps the working of a hologram might prove helpful in suggesting the extraordinary implications of this textile. A hologram (literally "whole writing") has the peculiar "prop-

erty" of distributing information through the entirety of an image, such that any fragment contains the whole image, albeit differently. Theoretically then, if we smash a hologram into pieces, each tiny fragment retains the imprint of the "original" image, the tracery of this "whole writing" still alive in its smallest particle. The hologrammatic difference between part and whole, or original and copy, is no longer the difference of conjunction—a spatial join between separate fragments, or a temporal join between a later copy and its earlier original. Rather, difference is a "becoming entity": it is not a name for the gap of supposedly dead space and time between pregiven entities.

This hologrammatic sense of difference, wherein an "absent" part nevertheless remains in transformative dialogue with what is "present," is reminiscent of Saussure's evocative description of *langue* as "units living underneath the word" (as cited in Gadet 1989: 85). Perhaps Saussure's phrase was an attempt to give life to a notion of difference that, if equated with absence, would stop the pulse of that vital inter-connection. Interestingly, the productive differential of the hologrammatic structure does not return us to the binary of a unified whole versus its diminished part. For even the "fragment's perspective" is, in its turn, another differentiated whole, but one that is no simple repetitition of the "original." The "original" is itself a fragment of a fragment: every appeal to the specificity of a unified perspective returns us to a fractured differential that is at once a particularity that again involves "the whole" differently. The separation of part from whole, or the hierarchical subsumption of difference to unity, is not simply made. It follows from this that universalizing discourses are never monolithic or unified, any more than a so-called situated, or particular, perspective is singular in either its focus or location.

And so to the curious pulse of the body whose tissue is rendered a little more strange after the above discussion. A comment made by Paul Valéry about the paradoxical nature of embodiment serves as introduction. He observed that the unease that confronts us in reconciling our sense of self with embodied existence lies in the contradiction between the stability that we feel about who we are, and the flux of that identity's incorporation:

> We speak of [the body] to others as of a thing that belongs to us; but for us it is not entirely a thing; and it belongs to us a little less than we belong to it. . . . This thing that is so much mine and yet so mysteriously and sometimes—always, in the end—our most redoubtable antagonist, is the most urgent, the most constant and the most variable thing imaginable: for it carries with it all constancy and all variation. (1989: 398–99)

"All constancy and all variation" recalls another phrase that we have had cause to mention. This time it is Saussure's attempt to comprehend the body of the sign, another paradoxical identity that "is never 'the same' *(le même)* twice." As already noted, because Saussure splits signification from reality in the form/substance opposition, he is forced to conclude that the contradiction at the heart of the sign is peculiar to the sign's identity and not to identity in general. What insists in the sign is flux, and this mutability marks the sign's "fundamental difference from an ordinary object." Clearly, Saussure was unable to entertain the possibility that the stuff of ordinary objects is also a volatile text whose variations are not indifferent to the regime of the sign.

After faithfully following the vagaries of the sign's peculiar identity it seems that signification and reality are not so much laminated together as two conjoined realms, as they are holographically emergent within their implication. This last assertion might seem to dismiss any robust return to dualism. Yet the difference that is supposed to obtain between even these two apparently discrete claims also entails an irreducible involvement *(différance)* that cannot be severed by declaring dualism either inadequate or wrong. The deconstruction of Western metaphysics and the oppositional logic that reasons through an undeclared phallogocentric and ethnocentric violence emerges from a space within this same logic. As Derrida describes it in this section's opening citation, "The outside bears with the inside a relationship that is, as usual, anything but simple exteriority. The meaning of the outside was always present within the inside, imprisoned outside the outside, and vice versa." Ironically, the discriminatory violence of binary oppositions engenders its own critique, because the trace of essence is everywhere indelible in what is considered outside or exterior to it.

The attempt to come to grips with the paradox of essence has an ancient history, one whose illusiveness is referenced through sexual difference. Diana Fuss locates one of the dominant legacies of patriarchal thought since Aristotle in the assumption that "woman has an essence and it is matter." But, if the essence of matter is the density of its irreducible passivity, its dumb inertness, its lack of differentiation, then matter can possess nothing but itself. It can't even differentiate itself within the fold of its own self-possession. As Fuss points out, if "woman has an essence and it is matter," then we are left with the paradoxical conclusion that "it is the essence of woman to have no essence" (1989a: 72).[6]

I want to move into this discussion by way of the metaphoric slide that confuses woman with matter and nature. And I want to do this in such a way that the passage through this confusion will again attempt to acknowledge the uncanny interiority of the classical concept of "language." My contention

is that even theoretically sophisticated discussions of essentialism take place within an unexamined anthropocentrism that is itself a form of essentializing. In other words, the question of sexual difference has been staged *within* the frame of Man, a frame that presumes that the identity of species-being is not itself the subject of this interrogation. Perhaps it is the sheer weightlessness of our essential humanness, of what for most of us is the banality of simply living it, that makes us immune to consideration of the question's anthropological implications. It is toward this enlarged horizon of what might begin to render the question of essence quite unmanageable that my argument will try to move.

The identity of woman has traditionally been associated with the essential stuff of the body and nature, just as man's identity has been located in their transcendence and aligned with mind and culture. Woman is thereby positioned as man's attenuated inversion, as a mere specular reflection through which his identity is grounded. The brute matter of woman's embodiment and the immediacy of her lived experience provide the corporeal substratum upon which man erects himself and from which he keeps a safe distance. And it is precisely through the difference that this distance secures that the man of reason, the *cogito*, is able to locate himself as a proper subject.[7]

Humanism might be glossed as the discourse of Man, propped up by an unacknowledged debt to woman that is figured through these binary attributions. Modernism's crisis of legitimation, a crisis signaled in the term "postmodernism," registers the faltering recognition that this complicitous kinship of gendered binary divisions cannot be accepted complacently. If meaning is produced rather than simply given, then sexual identity, like any other identity, is a relational, processual entity that emerges through language and its peculiar economy. It follows from this that the hesitations that now interrupt orthodox accounts of truth and subjectivity have inevitably returned us to the perplexing question of woman's identity. The question's purchase condenses in the fact that if the natural world of humanism is to be denaturalized of its most comfortable wisdoms, then woman's "place" in this story, her "in-corporation" into its narrative, assumes critical importance.

It would be misleading to suggest that woman's uncertain identity is a recent discovery. If second-wave feminism were to risk conceiving its own conception, then perhaps one significant moment in its rebirthing would be identified with the emergence of *The Second Sex* in 1949 and the shock of Beauvoir's curious question, "Are there women really?" (1953: 13). The question remains powerful because her argument was able to sustain the scandal of its asking by delaying any easy answer. According to Beauvoir and

despite all claims to the contrary, woman is not a natural subject but a cultural artifice *par excellence*. In the now-famous opening lines of Book Two, she asserts, "One is not born, but rather becomes, a woman . . . this creature, intermediate between male and eunuch" (1953: 273).[8]

Almost half a century after Beauvoir, how are we to understand this embodied "ground" that is "woman?" Feminists have tirelessly sought to interrogate the odd couple of nature and culture in order to broaden women's horizon of possibility.[9] Just as Beauvoir suggested, upon investigation there seems to be nothing very natural about the nature of woman. It is not surprising then that patriarchal attempts to justify woman's subordination as the destined effect of nature's prescriptions have had to adopt various guises.

In "Conclusion: A Note on Essentialism and Difference," Elizabeth Grosz (1990) explores the broad terms within which essentialism is commonly negotiated, offering a helpful summary of its legitimizing strategies. Grosz divides the prevailing arguments into four kindred, although subtly differentiated, categories: essentialism, biologism, naturalism, and universalism.[10] The terms are easily confused and, as Grosz suggests, each one is often made to serve as a shorthand formula for another. In its earliest and most urgent claims, feminism tended to embrace essentialism as the evidence of sexual difference, and many feminists have retained an allegiance to the political efficacy of such arguments. However, in more recent years, academic feminists in particular have become skilled diagnosticians in recognizing the conservative commitments invested in this syndrome of questionable attributions, and a sense of contamination is now associated with their pathology. Grosz notes:

> It is not surprising that these terms have become labels for danger zones or theoretical pitfalls in feminist assessments of patriarchal theory. . . . They are the critical touchstones of assessment, self-evident guidelines for evaluating patriarchal theories and the patriarchal residues or adherences of feminist theories. These terms seem unquestionably problematic. (1990: 335)

Feminism is usually quick to distance itself from the dubious investments of such terms and to judge the worth of its practice by the success of this distancing. However, Grosz goes on to query the advantage of such an automatic reaction to these categories by cautioning that "their value as criteria of critical evaluation for feminist as well as patriarchal theory is not as clear as it might seem" (335).

This qualification is pause for thought, an appeal to linger a little longer over feminism's own version of doing what comes naturally. An interesting

detail that emerges once we step into this "danger zone" is that these conservative doxa do not themselves respect the nature/culture divide. It seems that "the nature of things," or more specifically here, "the nature of woman," is also discovered in cultural data. Grosz explains, for example, that universalism can be conceived in purely social terms, with no necessary recourse to biological arguments. In this case, cross-cultural data that show women consigned to invariant social categories and roles in the sexual division of labor can be offered as proof of essential and therefore unarguable human requirements.

It appears that the originary cause of what is interpreted as woman's inevitable oppression is ultimately a shifting determination that can variously be secured in either nature or culture. Its equivocal and therefore questionable location is made stable by patriarchy's own investment in the continuing truth of its existence. In other words, man's desire that "the nature of things" (namely, his privilege) might be justified and even demanded by some causal essence in woman, displaces the need for this essential predication from the necessity for his existence to the explanation of hers.

It is surely a tribute to the effectiveness of feminism's intellectual persistence and to its rereading of patriarchal truths that both "the nature of woman" as well as "nature itself" have still to be reckoned. Yet, given the continued instability of the culture/nature division, maintaining anti-essentialism versus essentialism as the respectively good and bad sides of any argument can install a dubious moral agenda that merely condemns what requires further exploration. The troubled contradictions within feminism's own identity have generated important contributions to political change. What may hold true in one context will inevitably dissolve in another. My question follows from this rather obvious point. If we concede that the field of political negotiation is historically and culturally inflected and therefore always transforming, how might the continuation of Beauvoir's enterprise be more effectively realized today? Is it possible that, at least within a certain academic feminism, a reversal of the apparent direction of its original critique is now needed? By refiguring feminism so that it maintains its critical tenacity and relevance, we might venture a different set of questions. For example, is it possible that our vigilant opposition to arguments that associate woman and nature has become so automatic and prescriptive that it risks intellectual complacency? To put it bluntly, can we always be sure of just what it is that our vigilance would defend or deny?

My conviction that such awkward questions need to be asked was dramatically illustrated at a philosophy conference I attended some years ago. The particular session that drew my interest addressed the work of Luce Iri-

garay. In anticipation of the charge of essentialism that is commonly leveled at this particular french feminist, the speaker offered a preliminary clarification in Irigaray's defense. We were told that corporeality in Irigaray's writing should be understood as a decidedly literary evocation. Those now notorious "two lips" were a figurative strategy, a metaphor through which the significance of woman's embodiment could be reinterpreted as morphology.[11] To extinguish any lingering doubt that this argument might still harbor a naturalizing impulse, the anatomical or biological body was safely located outside the concerns of Irigaray's interventionist project.

However, if the audience was meant to be reassured by these remarks, requiring this explanatory caveat before the paper could be taken seriously, I was left wondering what danger had been averted by the exclusion of biology. What does the nominative "biological or anatomical body" actually refer to? And what secures the separation of its inadmissible matter from the proper purview of Irigaray's textual interventions? When I asked a question to this effect it was met with a certain nervous incomprehension. Deciding, perhaps, that I must still be immersed in a precritical understanding of the body, the speaker dismissed me with a revealing theatrical gesture. As if to emphasize the sheer absurdity of my question she pinched herself and commented, "Well, I certainly don't mean *this* body." And so it seemed that with a gesture so matter of fact that it required no further comment, the fact of (the) matter was both decided and dispatched. Yet where do we suppose that other body might be located? And how is it so quickly dissociated from "the real life of these existences 'of flesh and bone?'"[12]

This anecdote illustrates the pervasive yet unpalatable belief that the anatomical body locates the unarguably real body, the literal body, the body whose immovable and immobilizing substance must be secured outside the discussion. This improper body is quarantined for fear that its ineluctable immediacy will leave us no space for change, no chance to be otherwise, no place from which to engender a different future. According to this view, the politics of representation remain separable from what are commonly understood as the biological facts of the body's existence. Inevitably, the sex/gender, real/representation, nature/culture distinction will reassert its comfortable wisdom because it reiterates the most adequate conceptualization of materiality as something fundamentally other than its interpretation.[13]

Yet, various forms of contemporary critical theory about the nature of representation have attracted attention precisely because they disrupt this base/superstructure model, suggesting different possibilities for rethinking the question of *how* reality means. Of course, feminism has actively participated in this radical enterprise. Yet even in feminisms that are informed and

empowered by this same critique of a restricted notion of materiality, an accompanying maneuver can "naturally" exclude the biological body from critical attention. If pinching oneself is indeed a reality test, albeit within the ironized quotation marks of a certain theoretical savvy, then the announcement that reality's substance is of no matter is hardly a persuasive one. What is discovered in this gesture is essentialism's superlative—the thing believed to be most essential, most incontrovertibly real, and most decidedly significant. The anatomical body emerges as reality's harshest truth in the very attempt to dissolve its substance and the accompanying notions of "reality" and "reference" through which it is made manifest.

Nevertheless, over the last several years there have been increasing signs that essentialism, as it is commonly understood, is not necessarily "something" from which we could, or should, dissociate ourselves.[14] Nor is this view bought by any failure to recognize that essentialism is a subject that involves considerable difficulties for feminism. In the aforementioned article by Elizabeth Grosz, for example, she acknowledges that, "[a]ny theory of femininity, any definition of woman in general, any description that abstracts from the particular, historical, cultural, ethnic, and class positions of particular women verges perilously close to essentialism" (1990: 341).

Grosz goes on to cite Toril Moi, who also insists that "to define 'woman' is necessarily to essentialize her." Yet Grosz is alert to an attendant irony in this assertion that Moi tries to sidestep. Moi's description of essentialism, especially when she describes it as the defining attribute of Luce Irigaray's work, represents an unequivocal judgment against such definitions, a condemnation of their fixed investments, a casting out of their error. Moi witnesses something unholy in Irigaray's work and censures her for "fall[ing] for the temptation to produce her own positive theory of femininity" (1988: 139). Moi rightly understands that "any attempt to formulate a general theory of femininity will be metaphysical" (as cited in Grosz 1990: 341). Grosz, however elaborates the paradox that this criticism enacts:

> if women cannot be characterised in any general way ... then how can feminism be taken seriously? What justifies the assumption that women are oppressed as a sex? What, indeed, does it mean to talk about women as a category? If we are not justified in taking women as a category, then what political grounding does feminism have? (1990: 341)

In her fervid desire to remain unsullied by essentialism, Moi forgets that essentialism is the condition of possibility for any political axiology: the minimal consensual stuff through which political action is engendered is already

essentialism's effect. If there is no outside this entanglement, then the task is not to dream of deliverance, as if our arguments could eventually be redeemed by transcending their contamination with/in essentialism. Rather, the challenge is to real-ize the ways in which we are inextricably immersed within the strange weave of essentialism's identity, and to acknowledge that this bind is one that is not merely prohibitive, but also enabling.

Rethinking essentialism then is not a dispute about its meaning, at least not within the order of its commonplace understanding. The weight of that understanding as the burden of its lived reality is not in contention here. If anything, what is being questioned is how we can pretend to bear this burden so lightly. It is not so much the meaning of essentialism that requires further consideration, but "the how" of that meaning. How is "essence" entailed, made proper, installed "as such" and naturalized within our thought and our being? How does it congeal into a corporeal reality? We may assume that when we locate essentialism we identify it and corral its dangers, thereby securing the virtue of our own practice. But we have merely embraced another of essentialism's many mutations and one that finds us right inside the belly of the beast.[15]

The stuff of essentialism is not an entity that can be identified and dissolved by merely saying yes or no to it. When Toril Moi says no to the category "woman," to "the minefield of femininity and femaleness" (1988: 148), she imagines herself a witness to the truth of (the) matter, or more precisely, to truth's essence (assuming that there could be such a thing), to the nontruth of phallocentrism's truth, namely, to the truth of its error. Yet if we grant that essentialism is unarguably wrong—morally, politically, and even logically—we still haven't addressed the ways in which its errors work; that is, how essentialism's scriptures "come to matter," how they come to write/right themselves.

To put this in a way that better suggests that we are always/already in the grip of essentialism's reflex, we might ask, where is the evidence for either essentialism's error or anti-essentialism's truth to be situated, and in what does it consist? Or, against what criteria or with what "matter" is the category "woman" considered incommensurable? Surely the "place" from which both essentialism and anti-essentialism make their claims is "something" of a "shared accommodation," a strange abode which their contradictions cohabit. And this abode recalls a body that demonstrates its anti-essentialism by pinching its essentialism, a body that denies the violence of identity on the one hand by violently grasping its identity with the other.

Essentialism has always been of interest to feminism, but only recently has this interest been thought to pay dividends. Emerging discussions of essen-

tialism are attempting to confront feminism's anxieties in order to exorcise the somatophobia that underpins the legacy of phallocentrism's mind/body split. Nevertheless, the subject still provokes fear as well as fascination, even—or perhaps especially—among critical theorists. In her important contribution to the subject of essentialism, Diana Fuss suggests that "[p]erhaps more than any other notion in the vocabulary of recent feminist poststructuralist theory, 'essentialism' has come to represent both our greatest fear and our greatest temptation . . . essentialism is the issue which simply refuses to die (1989b: 62).[16] Accordingly, the subject is commonly approached with a certain sense of hesitation or even guilt. Fuss notes the apologetic tone that accompanies the question's reconsideration, with critics consistently describing their enterprise as one of "risking" or "daring" to consider essentialism's revaluation.

Although rethinking essentialism marks an avowed return to the body, the reunion is always be-ing deferred. It is certainly not an easy homecoming. Perhaps commerce with the body is considered risky business because the split between mind and body, the border across which interpretations of the body might be negotiated, just cannot be secured. This fear of being discovered unwittingly behind enemy lines, caught in the suffocating embrace of that carnal envelope, menaces all conciliatory efforts. It seems that feminism needs courage to mount even quite small and furtive reconnaissance missions. Any exchange between the mind and the body demands explanation; a minimal reassurance that incursions into the body's foreign spaces will be temporary and provisional—a "tactical" or "strategic" necessity that justifies the risks. Paul Valéry's earlier comment illustrates this sense that the body is a dangerous supplement that we possess, or are possessed by. It is as if we are held hostage *within* the body, *em*bodied, such that the site of self, the stuff of thinking and consciousness, is an isolate made of quite different matter.

The body of Luce Irigaray's work has become a synecdoche for these larger threats.[17] To involve oneself in her "writing (of) the body" is a venture that has come to require justification. Routinely, these justifications will stress Irigaray's theoretical and philosophical sophistication and the ways in which the pleasures of her texts are enabled by the crisis of confidence in orthodox understandings of referentiality and materiality. The question, however, is what to do with what Jane Gallop describes as Irigaray's apparent "referential naïveté," the seduction that Irigaray enacts by way of thinking through anatomical reference. The speaker in my earlier anecdote decided to solve this apparent problem by discarding the tissue of anatomy as something outside the play of textual writing. As a result, Irigaray's "two lips" were interpreted as figuration, as a representational provocation that should not be taken literally.[18]

Jane Gallop is of a different persuasion. In "Quand Nos Lèvres S'Écrivent:

Irigaray's Body Politic," Gallop argues that anatomy is inextricably caught up in its interpretation:

> Discourse about the body seems to represent a point of unusually suggestive tension about the referent. Yet perhaps the most far-reaching effect of her [Irigaray's] *invraisemblable* stand on the labia is to force the reader to reconsider the status of anatomical referentiality.[19] (1983: 82–83)

Gallop goes on to conclude that "the gesture of a troubled but nonetheless insistent referentiality is essential" (1983: 83). She defends this opinion by way of a slippery rhetorical gambit that demonstrates that the referent is a necessary anchor for any argument, even as it remains elusive and ambiguous.

Gallop begins by remembering Freud's famous dictum, "Anatomy is destiny." She notes that Irigaray "seems" to endorse what she describes as Freud's folly in this assumption but advises, "let us beware too literal a reading of Irigarayan anatomy" (1983: 78).[20] Gallop answers this too literal reading by reminding us that Irigaray's object is not genital anatomy but the symbolic interpretation of that anatomy—the ways in which a phallomorphic logic reconstructs anatomy in its own image. Having put this corrective into place, however, Gallop openly admits that her argument entails some sticky dealings with an extratextual referent, a male anatomy that somehow informs phallomorphism.

Although the body is always understood through its interpretation, the power of this interpretation is such that it induces an *"effet de réel"* (Gallop 1983: 79). Gallop reminds us that "this is only a texture of signifiers, as slippery as any," however "the effect of this illusion is to point the reader outside the text" (80). It is the persuasiveness of the resulting "referential illusion" that insists as anatomy. As Gallop explains it, "Belief in simple referentiality is not only unpoetic but also ultimately politically conservative, because it cannot recognize that the reality to which it appeals is a traditional ideological construction ... taken for the 'real'" (83).

An illustration of this misrecognition might be feminism's own participation in the either/or sexology of vagina or clitoris. Gallop discovers in this debate an unwitting commitment to a phallo-logic whose sense of choice (between clitoris as phallic-same or vagina as phallic-opposite) is, consequently, quite mistaken. According to Gallop, Irigaray's genius is that she is not seduced by the hidden phallocentrism that a single answer would entail:

> Irigaray seems to be advocating a female sexuality that replaces the anxious either-or with a pleasurable both: vagina *and* clitoris. But Irigaray ultimately

chooses *not both but neither*, and the spark of her genital poetics rather comes to light on the lips. (Gallop 1983: 81)

As Gallop would have it, the empirical appeal of clitoris and/or vagina is rejected because "Irigaray is interested in a plurality that is not reducible to a series of singular elements. In the list of female genital parts, only the lips are already plural" (82).

On a closer look, however, Gallop's reading of the body in Irigaray's writing is itself a dissection of female genital parts, for in order to secure the valued plurality of "the two lips," she identifies them in terms of what they are not—namely, the "singular elements" of vagina and clitoris. As a consequence, the revaluation of female specificity is purchased through a presence/absence, have/lack split, that endorses the logic of phallocentrism's excisions. Instead of reversing this binary valuation, perhaps a vulvo-logic could explore the ways in which the lips () touch not only "themselves" but also the other, apparently different and "singular elements." This mode of touching would involve a tissue of implications that would refigure both vagina and clitoris as never not plural. Indeed, no*thing* could be bracketed out.

Within the fold of this affection, even the unity of the penis would be divided by a labial embrace. As the ritual importance of circumcision attests, the prepuce of the penis is no small matter. We might also note that the divided *out*line of the penis also splits the organ internally, joining and dividing outside with/in inside along the length of a fold. Gallop is obviously alert to the need to rethink masculinity in this way, and comments that Irigaray's interpretation of male anatomy as the unity of phallomorphism is made by ignoring *les couilles*, the balls. "Male genital anatomy does not determine phallomorphic logic, but rather phallomorphic logic determines a certain unitary perception of male genitalia" (Gallop 1983: 78). It is precisely in the fact that Irigarayan anatomy is an anatomy of language, a textual site of paradox and possibility, that Gallop situates the value of modernist writing strategies and the extraordinary surgeries that they perform. The resulting reinterpretations negotiate an *"effet de réel,"* a *"poétique du corps,"* that recreates embodiment and thereby re-views the status normally accorded to an immutable, anatomical referentiality.

If we translate this re-formation into the familiar terms of the nature/culture, essentialism/anti-essentialism division, then it appears that Gallop dissipates a certain anxiety about what to do with anatomy (nature, essence) by arguing that what we take to be anatomy is just another moment in culture's refiguring of itself. In other words, anatomy is an illusion of sorts, albeit a very powerful one, and one that Gallop imbues with a certain political effi-

cacy. Understandably then, it is this belief in anatomy's political efficacy that motivates its reinterpretation. Importantly, Gallop's assumption that the essential substance of the body "as such" is always/already deferred relies on "the absence of any certain access to the referent" (Gallop 1983: 80). Gallop nevertheless counters modernism's "absurd" assertion that language is nonreferential because it is polyvalent, or polysemous, by arguing that reference is irreducible: it is an ideological manifestation whose persistence cannot be denied. It follows from this, however, that the anxieties that accompanied the mind/body border crossing were largely unfounded. There was no enemy waiting in ambush. Indeed, in essence, it seems that there was no-body there at all.

Can anything more be ventured about the question of biology? Does, for example, Gallop's interpretation of Irigaray's virtuoso rewriting (of) the body include in its textual adventure the peristaltic movements of the viscera, the mitosis of cells, the electrical activity that plays across a synapse, the itinerary of a virus, and so on? In other words, is this a "text" and a "writing" whose tissue includes all the oozings and pulsings that literally and figuratively make up the differential stuff of the body's extra-ordinary circuitry? Apparently not—certainly Gallop is careful never to say as much.[21] But, given the political ramifications that derive from conflating essence with biology as an outside of cultural intervention, don't we repeat the problem on another register if we remain obedient to this inside/outside schema? And is our reluctance to address the question of "flesh and bone" a silent acknowledgment that the sense of "risk" is warranted, that the substance of biology will inevitably thwart our puny efforts with the force of its reality?

It should be said unequivocally that Gallop's interpretation of Irigaray represented a welcome relief from the largely uninformed and ungenerous commentaries that had previously advised against the complexities of her work.[22] Gallop's writing scintillates. It playfully and provocatively explores the resonances between female sexuality and modernist textuality in Irigaray's corporeal *poiésis,* and its value is not in dispute here. Rather, my argument concerns the way in which Gallop and other of Irigaray's more subtle and careful interpreters have actually underestimated the creative and productive force of Irigaray's writing, and indeed of their own.

Gallop acknowledges the confounded nature of any argument that claims to separate the brute matter of anatomy from its interpretation. Yet the purchase of Gallop's corrective against those who would confuse Irigaray's *"effet de réel"* with reality, or conflate "referential illusion" with "referential naïveté," is predicated on the necessity for just such a separation. Gallop is

able to resolve this contradiction because she reads "anatomy" in a restricted sense, as the body's surface—the forms that are to be re-formed; the text that is to be re-inscribed. Consequently, morphology is accorded its narrowest interpretation as the metaphorization of sexual difference, the unity of phallomorphism or the split-that-is-not-one of vulvomorphism. Within this reading, Irigaray's writing traces its artistry over the surface of the body as writing pad, beating a tattoo that suggests different patterns of meaning through which the body's substance may be ciphered. Gallop offers a concise annotation to the inflection that motivates this performance: "Irigarayan *poétique du corps* is not an expression of the body but a *poiésis*, a creating of the body" (1983: 79). But how does Gallop determine the difference between "a creating of the body" and "an expression of the body," and why is this division necessary?

Gallop appears to conceive writing, or *poéisis*, through its phenomenal analogue, that is, as an activity whose effects are passively received and recorded upon a surface. Yet in other arenas, feminism is wise to the dubious sexual economy that informs this notion of writing. The model of a *tabula rasa* whose inert matter merely receives and then bears an inscription without in any way rewriting its significance is surely a familiar story. Within patriarchal thought the body/woman, as that specular surface, is routinely denied any efficacy in the reproduction of value.

Gallop's hermeneutic secludes biology behind anatomy's dermal veil, a veil that mediates between substance and form. Perhaps the substance of the referent is also hidden behind that veil, deep within the body's opaque depths, for it will be remembered that Gallop describes the complexities of the referent in terms of accessibility. This closure that installs an inaccessible "before" or "behind" is consistent with Gallop's reliance on a psychoanalytic explanatory narrative that traditionally posits the body before language. Psychoanalysis does not engage the problematic of the body as always/already a field of language, but rather posits it as something that precedes and *then* enters the field of language.[23] Gallop also draws on contemporary literary theory that has preferred to read the notion of "textuality" or "writing" within the confines of a convenient horizon, as if to preserve and to contain "context" within the covers of books.[24] The consistency with which literary critics continue to equate Derrida's notion of "writing in the general sense" with writing in the phenomenal sense is surely evidence of this.[25]

Rethinking essentialism is a thinking through the body, and this is a thinking through of closure. But how do we think this "corporeal place," this envelope of immanence that our disembodied speculations would render "separable" and "other?" Again we are reminded of a body that pinches itself

within the reflex of a Möbius loop. Enacting the circuit of a contradiction, anatomy grasps its own excess, the neither/nor of essentialism and anti-essentialism that nevertheless, and at once, embraces them both, the literal and figural tissue of their mutual implication. Biology's scriptures cannot be left out of this account. Biology is volatile, a mutable intertexture, the stuff that informs our interventions. And such is the implication of biology, the intelligence of its performativity, that Irigaray's *poétique du corps* might also be thought as biology rewriting itself.

The intricacies of such a circuitry conjures Derrida's provocative discussion of the writing machine in Freud's "neurological fable"—the mystic writing pad. An analogy for the workings of the psyche, the pad's mystery was embodied in the receptive innocence of its writing surface, a surface whose virginity was infinitely recuperable as the marks of violation were erased and forgotten. The underlying wax surface, however, continued to bear the permanent mnemonic traces of these previous inscriptions such that the pad's "memory" provided an infinite reserve. From this child's toy, Freud found a way to reconceptualize causality by questioning the apparent autonomy and temporal spacing between such divisions as stimulus/response, surface/depth, present/past, passivity/activity, and conscious/unconscious. He hypothesized that perception is made possible by the discontinuous distribution of previous perceptions (writings). Yet, the temporal fabric of these "previous" spacings is not an archaeological layering of past historical strata, for this is a past that was never simply present. Derrida elaborates this important point:

> Let us note that the *depth* of the Mystic Pad is simultaneously a depth without bottom, an infinite allusion, and a perfectly superficial exteriority: a stratification of surfaces each of whose relation to itself, each of whose interior, is but the implication of another similarly exposed surface. It joins the two empirical certainties by which we are constituted: infinite depth in the implication of meaning, in the unlimited envelopment of the present, and, simultaneously, the pellicular essence of being, the absolute absence of any foundation.[26] (Derrida 1985b: 224)

Derrida's "infinite allusion" is more generous in its implications than Gallop's "referential illusion" or *"effet de réel."* Derrida attempts to interrupt and to reinscribe the economy that underpins Gallop's interpretive limit, with its reliance on an original/simulacrum, real/representation, substance/form split. Following Derrida, if we think the body *as* the scene of writing/reading, then propriation is indeterminate for the notion of a causal essence, or

explanatory ground is "constituted only in being divided from itself, in becoming space, in temporizing, in deferral" (Derrida 1985a: 29). Consequently, the difference that is supposed to separate essentialism from anti-essentialism, or reality from its interpretation, is not the dividing interval of a third term (that separates identities and thereby also establishes its own) but an efficacious spacing within which identity is continually emergent.

Derrida calls this *différantial* process a political economy because it operates through a force field of hierarchical oppositions whose presumed separability denies the ongoing mode of their production. The invariable denigration, and even the complete erasure, of the value of maintenance work in all its forms is surely the motor of political intervention in any and every context. And Derrida's engagement with "the metaphysics of presence" is consistent with this history. "Presence," or what is considered proper to identity, is established and maintained by an involved support "system." This explains why the irreducible tension or difference that inhabits this "system" of "writing in the general sense" is inflected through a sexual diacritics, or what Sarah Kofman has called "a sexualization of the text" and "a textualization of sex" (1989: 127). As nothing precedes the *différance* of spacing, man/woman emerge within the force field of this differentiation, inscribed through the textual play of presence/absence, value/lack. Yet, there is more to sexual difference than this oppositional logic can give account; more to its inheritance than the burden of phallogocentrism's logic of the same.

As woman is ceaselessly refigured as an absence such that man can be rendered present in every account, the very repetition of this mode of reckoning is itself differentiating and transformational: it is never identical with itself. If "woman" is the corporeal "play" of essentialism's difference from and within itself in the mode of production of man, then "woman" realizes phallocentrism's many essentialisms: she is the tissue of their complicitous interlacings. Within the space of this intertexture and contexture, between and within the interstices of essentialism's textile, a persistent and radical singularity insists. And this singularity or radical difference always remains essentialism's accomplice: the "constant variable" that allows essentialism to play the imposture of "invariant constancy."

If we think of the complexity of essentialism's textile as morphology, we may begin to appreciate why morphology cannot be reduced to the external outline of an anatomy that discriminates vulvomorphism from phallomorphism.[27] Morphology is a splitting through of every membrane that would protect (itself against) an interiority. Morpho-logy is also a bio-logy where the "infinite allusion" of one membrane *within* another real-izes a corporeography whose substance is never not generative.

What happens to the question of reference as it pertains to woman's corporeality and to the notion of morphology in this broader sense? In this context, Gallop's earlier discussion of the referent's inaccessibility presumes an interiority that is untouched by an outside. Yet, the identity of the referent isn't so much hidden, or out of reach behind the adumbration of an *effet de réel*, as it is something that unfolds as an immanence, a grammatological complicity or binding together of traces that is real-izing. The fact of the referent is not located in the truth of biological substance, a truth that must remain inaccessible behind the skin of cultural interpretation. It is the very tissue of their interweaving. Reference, then, is not so much a veiling or a mediation of the substantive realm from the formal as it is a partitioning—an intricate and infinite fabric-ation.[28]

The matter at issue is very much the issue, the bodying forth, of matter. If we attend to the question of sexual difference that resonates in this problematic, then can *"this-sex-which-is-not-one"* be properly unified under *one* name—"woman?" Doesn't this assumption return us to the logic of phallocentrism? We could begin to counter the violence of this single designation by stressing that woman's unity is fractured by the infinite differences of the women who are named "woman." And we could list the differences of race, class, ethnicity, sexuality, cultural difference, and so on in order to fracture the category further. However, Elizabeth Spelman is just one theorist among many who alerts us to this "ampersand problem" within feminism: to the additive analysis of identity that reads different forms of oppression as separable supplements of the more fundamental category "woman" (1988). Given the discussion of difference earlier in this and the previous chapter, how is differentiation held *within* the corporeal membrane of "woman," a membrane whose morphology is split by an interiority that is now exposed? And where is man in this exposition that splits his name open within hers?

Within the context of the above discussion, Beauvoir's "woman question" continues to have political efficacy precisely because it broaches the possibility that man is also implicated within the question's explanatory difficulties. Gayatri Spivak also engages the entangled production of sexual difference when she opens the question of woman by asking, "What is man that the itinerary of his desire creates such a text?" (1983: 191).

Approaching the question of sexual difference in this more oblique way, we could venture that "becoming woman" is written in the spacing of a corporeography from which nothing is exempted. This may sound as if the scene of writing is consequently undifferentiated, as if the essence of identity and the identity of essence were now dissolved by the "pure permeability to breaching." However, the gravity of identity is not immaterial to the acci-

dent of writing. Derrida argues that "writing is unthinkable without repression," without the resistance of a closing and identifying. The mystic writing pad, for example, required the differential of two hands to make the apparatus function: one to write and one to lift the page and to erase the markings. However, the process of page lifting was not just an erasure of the mark, the closing of a period of writing *within* a membrane or an envelope of time. For this gesture of enclosure is also a breaching, a rewriting, that makes legibility possible. Thus, the accident of writing is an involvement in which essentialism's identifying closures mark an indebtedness to limits that is limitless. Derrida notes that "we are written only as we write," "constituted by the double force of repetition and erasure" in this "two-handed machine" (1985b: 226).[29] If the issue of corporeographies is generated through the labor of the trace, then the substance of "the woman question" embraces all of the essentialisms through which the matter—of nature, of woman, of the body, and indeed, of man—is decided.

three
Poststructuralist Feminisms

Part 1: Accommodating Matter: Drucilla Cornell

In the previous chapter we saw that the matter of the body is often referred to as a "text" within postmodern and poststructural criticism.[1] As a consequence, the intricacies of textual production become sites of political engagement, sites where the limitations of corporeal possibility are interpreted, contested, and renegotiated. Yet, the perceived efficacy of these interpretive strategies that engage the body of the text as the text of the body is predicated upon a quite complex understanding of "text" and "language." In the introduction to *Feminists Theorize the Political*, Judith Butler and Joan W. Scott elaborate this assumption, noting that the provocative implications that inform a poststructural understanding of language are seldom understood. Their concern is that "[t]he emphasis of poststructuralist positions on language or signifying practices is often taken to be an emphasis on written documents, particular utterances, or other empirically restrictive 'examples' of language (1992: xv). Acknowledging the rancor that this confusion can generate, they ask, "How are language, signification and discourse *misread*, and what are the political consequences of this misreading?" (1992: xv). For Butler and Scott, who encourage "poststructuralist refigurations of 'the material'" (1992: xvi), the need to pay particular attention to the redeployment of words such as "language" and "text" is crucial to this enterprise.

My own project is in close alliance with any attempt to open "empirically restrictive 'examples' of language" to the scene of their production, and I endeavored to do this in previous chapters by reading language and matter as "textuality." My aim was to try to wrest the term "textuality" from its conventional interpretation in literary criticism by evoking Derrida's notion of "the scene of writing," a generalized writing that might be termed a *corporeography*. My interest here (and in other chapters) is therefore quite close to Scott and Butler's concerns. I want to consider the claim that re-thinking

"language" and "textuality" can materially effect/rewrite the notions "essence," "origin," and "body." In sum, have feminist writers who seek to reinscribe the concept "language" with the complexities of postmodern and poststructural insights effectively challenged the classical constraints of the sign/language and its conceptual legacy?

In this and the next chapter, I want to address the work of two writers whose work specifically explores the relationship between language and the body. Both Drucilla Cornell and Judith Butler argue that the politics of corporeality can be read as a politics of textuality and discursivity. To this end, although to different degrees, they find a useful resource in the contributions of Jacques Derrida. This general approach also describes the direction of my own efforts. Yet inasmuch as our respective interpretations of textuality and discourse open the matter of corporeality very differently, I want to explore what I regard as an unnecessary foreclosure of "textuality" by these writers, paying particular attention to the significance of this containment for feminism.

Drucilla Cornell is committed to proving the usefulness of deconstruction. Her interest in the intricacies of textual production focuses upon the political significance of closure, and as a consequence she renames deconstruction "the philosophy of the limit." This gesture is meant to remove the negative preconceptions that have come to surround the word "deconstruction" and to locate the specific site of deconstruction's intervention.[2] The term deconstruction has quite wrongly been elided with destruction, as if deconstruction is intent on reducing the philosophical tradition to "an 'unreconstructable' litter" (Cornell 1992: 1). Given this misconception, Cornell's goal is to explain the critical relevance of deconstruction as an approach that can sustain questions of ethics, justice, and legal representation in interestingly new ways. Cornell also argues that deconstructive strategies have particular significance in the vexed field of feminist jurisprudence.

A clear explication of deconstruction's value is therefore required, and Cornell elaborates those parts of deconstructive theory that might bring contemporary philosophical practice into productive association with legal studies. In the introduction to *The Philosophy of the Limit*, deconstruction is described as an analytical form of intervention that "exposes the quasi-transcendental conditions that establish any system, including a legal system as a system" (Cornell 1992: 1). According to Cornell, the law enforces and strengthens itself by determining what is proper to its jurisdiction and what must and should remain outside or beyond it. Yet, the philosophy of the limit discovers that the reach of the law is greater than it is prepared to acknowl-

edge, extending well beyond the boundary of its declared authority. This work of breaching, which Derrida has called "the logic of parergonality" (1987), demonstrates that the law exerts authority outside the frame of its avowed circumscription. Put simply, if the law continues to operate beyond its jurisdiction, then our conception of justice needs to be reassessed.

Drawing heavily on the insight that, "the very definition of a system as a system implies a beyond to it" (Cornell 1992: 1), Cornell interrogates this notion of an "outside." If the "outside" remains subject to the covert expression of the law, then the difference between what is considered either inside or outside the law is only an apparent difference. What is posited as "outside" is actually a reflection, or a negative version, of the system itself. It is important to note here that the exemplary system for Cornell is Hegelian, a system that sublates difference and contradiction in the very gesture of recognition (as specular reflection). Within the restricted economy of Hegelian dialectics, difference is figured as a negative projection of otherness—as what the system is not. The resulting contradiction is that the specificity of difference, the otherness of the Other, must be made familiar if it is to be recognized at all. Cornell interprets this confusion as the paradox of knowledge itself. Narcissistically caught in reflection, knowledge is incapable of knowing the extent of its own self-capture: it cannot acknowledge its limitations because the limit is always *within* knowledge. Maurice Blanchot succinctly captures the riddle that Cornell uncovers:

> There is an "I do not know" that is at the limit of knowledge but that belongs to knowledge. We always pronounce it too early, still knowing all—or too late, when I no longer know that I do not know. (Blanchot, as cited in Taylor 1986: 1)

Cornell focuses upon this seeming impasse wherein the outside surreptitiously inhabits the inside, and finds that the philosophy of the limit has some suggestive insights regarding this paradox. Cornell explains that Derridean *différance* is a force that "prevents any system . . . from encompassing its other or its excess. The Other for Derrida remains other to the system" (1992: 2). Derrida demonstrates why and how the system will ultimately fail to recognize the other as Other, a demonstration that uncovers a process whereby otherness is routinely constituted through projection and misrecognition. By exploring the way in which a radical sense of difference that is truly "outside" and "Other" to the system cannot be grasped, deconstruction promises a different understanding of both justice and ethical responsibility.

This rereading of Otherness is by implication also a reconsideration of the negative side of any binary opposition, the side aligned with woman, native,

nature, matter, and the body. For this reason, I want to explicate what I understand as the philosophy of the limit because it offers another approach to the question of corporeality and its battery of associations. Although my argument will challenge several of Cornell's assumptions, I do not regard our differences as oppositional, as if one body of writing could simply be dismissed and replaced with another. Our differences might be regarded as "involvements": they are *conceived together* and forged from the indebted tissue of a corporeography that entangles us both.

Taking up the provocations in Derrida's work, Cornell reiterates that, although we cannot escape systems of representation we are nevertheless able to acknowledge that there are limits to our understanding and that what lies beyond knowledge will remain unrepresentable. Less cautious than Blanchot perhaps, Cornell proceeds to lay out what properly belongs to knowledge and what does not. For Cornell, the system of knowledge is the realm of the ideal, hence her insistence that "[v]ery simply, reality is not interpretation all the way down" (1992: 1). Making use of an expression coined by Charles Sanders Peirce in his critique of Hegelian idealism, Cornell explains that the philosophy of the limit is an acknowledgement of "secondness," or, as she puts it, "the materiality that persists *beyond* any attempt to conceptualize it" (1992: 1). In other words, the material facticity of things can only be grasped indirectly, as one might experience death, for example, secondhand via the death of another. Materiality, then, is what resists knowledge.

Deconstruction, reconceived as the philosophy of the limit, "continually points to the failure of idealism to capture the real" (Cornell 1992: 1). It is this vigilant recording of failure that engages Cornell's attentions. She emphasizes that deconstruction guards the difference between idealism and its Other, acknowledging a *différance* that must be protected and secured against encroachment. Yet, this need to respect the otherness of the Other is erased by the metaphysics of presence that elides difference by founding justice on the possibility of mutual recognition—"Hegel's 'we' in a common present" (1992: 98). Cornell argues that deconstruction traces the political asymmetry in this forced relationship showing that, despite every effort to accommodate difference, the recognition of Otherness is inevitably disappointed. Strangely, it is only by conceding that our grasp of the Other is a pretension to conceptual mastery, that there are limits to intelligibility, and that representation is therefore compromised and contingent, that the possibility of an ethical relation with the alterity of the other becomes possible.

Cornell attributes considerable value to the shortcomings or limitations of idealism as a consequence. If the complexities of justice always resist, or exceed, the positive representations of the law, then resistance to the law

should not be seen as mere lawlessness. The philosophy of the limit reminds us that, in the attempt to masquerade as the true arbiter of justice, the law violates itself. The value of deconstruction is that it "keeps open the 'beyond' of currently unimaginable transformative possibilities precisely in the name of Justice" (Cornell 1992: 182).

The intricacies of Cornell's argument connect "Otherness," matter, and corporeality with the problematic of sexual difference. Cornell illustrates how the notions of "difference" and "alterity" are politicized and sexualized, and she suggests that our understanding of sexual difference will be challenged and rearticulated as these new and different ethical configurations of Otherness emerge:

> Simply put, this intersection, now figured as an ethical configuration, makes the question of *sexual difference* crucial to how we even dare to dream of the enactment of the ethical relation, even if we realize that its full enactment is impossible if we are to remain faithful to the ethical asymmetry that inheres in the respect for the Other as Other. (Cornell 1992: 170–71)

I particularly want to address this reading of sexual difference. How is Cornell's understanding of Otherness as "something" *beyond* the limits of knowledge accommodated *within* the body *as* the scene of writing? Or, to put this another way, how should we understand the *substance* of Cornell's intervention?

Published a year before *The Philosophy of the Limit*, Cornell's *Beyond Accommodation* (1991) can be read as a companion volume that offers an instructive exegesis of deconstruction and its usefulness for feminism:

> Derridean deconstruction exposes the limit of any system of ideality established as reality, whether that limit be evoked as the supplement, the margin, the logic of parergonality, or indeed as *Woman*. Crucial for this book is Derrida's undermining of the hierarchization of gender identity which has become "second nature" to us. The idea that we are hostage to the way things are now, to a human matrix constructed through gender hierarchy, is belied as an illusion that fails to understand the full significance of the Derridean insight that reality is only "there" as textual effect. (1991: 18)

Cornell argues that if the prescriptive and ascriptive force of gender is textually inscribed rather than naturally inherited, then its meanings are contestable. However, these meanings are no less real for being socially constructed, for inasmuch as the difference between the natural order and its

cultural interpretation cannot be known, as Blanchot explained earlier, then the power of representation is an absolute one.

Cornell is nevertheless optimistic. Although language is a system of regulatory norms, she emphasizes that these norms are unstable precisely because they lack the grounded solidity that might be accorded by an extratextual referent. As meaning is neither fixed nor self-evident, it needs to be maintained by continual restatement. This repetition means that rigid designations of gender and other normative stereotypes are changed every time they are reaffirmed: the potential to realize different futures emerges from within the slippage of meaning that this re-presentation involves. Cornell believes that the constitutive power of language is so all-encompassing that, inasmuch as it *gives* reality, it can also change it.

Cornell's contribution to feminist jurisprudence takes its leverage from this insight, namely, that the stuff of ethical and political intervention is the surprisingly fluid structuration of *cultural* representation. As a consequence, writers such as Robin West and Catharine MacKinnon are taken to task for their defining assumptions about the nature of woman. West is chastened for assuming that "there is a connection between a woman's identity, her experience, and her biology" as well as for defending "the need to root feminist theory in a theory of female *nature* that cannot be completely severed from an account of how biology functions in the acquisition of female identity" (1991: 25). Cornell finds this appeal to biology and nature dangerously misguided, because an originary explanation can be made into a prescriptive rationalization whereby political inequities seem inevitable and incontestable.

MacKinnon shares Cornell's wary mistrust of foundational explanations of the female condition and rejects the reductionism of biological explanation. Yet MacKinnon understands femaleness as something objectified and entirely subordinate to the male gaze, and so femaleness becomes synonymous with compliance and receptivity—an obedient capitulation to a sexualized representation of power relations. This bleak view leads MacKinnon to conclude that the struggle against sexism must involve a complete repudiation of femaleness and the feminine as it is currently lived, a repudiation whose result will be that real women, unburdened by these false and oppressive representations, will then be free to stand up.

Cornell rejects the positions of both West and MacKinnon because, in their different ways, they defer to an essential truth of a pregiven body. She insists that "we cannot simply reach back to an origin universally present for all women to find Woman, because we are always staging our reality *from within a cultural context*" (1991: 117; emphasis added). Cornell argues that the body is given by language through the fictions and fantasies, the myths and

fabulous projections, of metaphoric transference. She concludes from this that "we do not return to essentialism" because "[w]e are imagining, not describing" (1991: 179).

Although I have made only brief mention of Cornell's criticisms of West and MacKinnon, we can nevertheless gain a sense of what motivates her criticisms and why they are important. They are examples of a feminist deconstructive reading, and rest on the belief that the essential truth of reality is inaccessible to us. What we perceive as reality is more accurately understood as a reality effect, produced in and by language. Cornell posits that even though we are unable to discern its outline, there can never be an outside of text because we are language bound. Reality is therefore subject to mediation. Indeed, somewhat like Midas who could never feel the true texture of reality because everything he touched turned to gold, our perception of reality is not just subject to language—it is language. For Cornell, our determinations of truth and objectivity are ruptured because, along with everything else, they are open to the mutability of language.

A question emerges here, however, that is not easily accommodated within this reading. If we grant that both truth and identity, in all its forms, are constituted in language and therefore are irremediably fractured by difference, then how does the limit of language escape this identity crisis? In other words, why is the self-presence or unified truth of *the* limit, conceived as an unperforated *out*line of language, not itself prone to this same rupture? Why is there only *one* limit, a limit whose job it is to differentiate ideality from materiality while itself remaining undifferentiated? And how does the identity of the limit—or, by extension, the identities of ideality and materiality—*precede* the *différantial* process of limit*ing*? Put simply, how does identity already precede the conditions of its emergence?

Cornell uncritically repeats the Saussurean understanding of language as an interiority closed in upon itself in this reading of difference as the other of identity. We are now familiar with the temporal priority through which Saussure posited the world before language, the thing (or referent) before the sign, matter before the idea, and the sensible before the intelligible—a decidedly sexual and racial diacritics whose evolutionary logic works to naturalize political asymmetries. This temporal distinction also enacts a spatial separation such that reality, or what is regarded as the substance of the world, is assumed to be outside, or beyond, representation because it precedes it. And yet despite this, one can argue that the motif of difference in Saussure is sufficiently ambiguous that its complexity ruins these fundamental distinctions even as it installs them.

Saussure argues that in language every element of the system emerges in and through its difference from every other element, such that every element must bear the trace of the entire system within it. This sense of difference as infection undoes the identities of "element," "sign," and "system," underlining their provisional status as heuristic "moments" in the explication of language. The integrity of these entities must dissolve as the analysis proceeds. Yet the trace of this metamorphosis is not the mark of an absent element, the residue of a presence whose existence is now compromised. Rather, the differential within difference is an entangling of traces within traces so that the being of the entity "sign," and by extension, the being of the entity "language," are placed under erasure. Thus language is not an entity surrounded by a limit, for the differ*ing* of limit*ing* is also a travers*ing*—a making and unmaking of identity. Derrida refuses the linguisticism that confines the play of difference to language in the narrow sense, that is, to a notion of "text" surrounded by an unknowable exteriority outside representation. The provocation in this refusal resonates in the following remark by Geoffrey Bennington, a translator and commentator on Derrida's work:

> we receive language like the law, which fact casts doubt on the very coherence of the question about the origin of language, and reminds us among other things that language is not essentially human (for if language is *always* received, the "first man" must have received it from some nonhuman agency . . .) the refusal to think of language as in some way a separate domain over against the world . . . implies the consequence of an essential inhumanity of language. (Bennington 1993: 231–32)

One could read this another way and suggest that Derrida's reinscriptions—"writing," "language," and "textuality"—render the identity of humanity *as such* pregnable to the monstrosity of a knowing outside that, in as much, as it does not lack language, must be articulate. The way in which binarisms are conventionally organized through an oppositional logic that is sexually inflected is undone in this conversation between inside and outside. If we grant that "the outside" of language and culture, aligned with nature/woman, is neither passive nor simply receptive because actively engaged in convers(at)ion, then the phallocentric reading of sexual difference just doesn't make sense. The opposition between production and its instrument, or the difference between the complexity of writing and the mere ability to support its mark, cannot be sustained in this example. The babble of this generalized conversation is the strange stuff of Derridean "textuality," the same

"textuality" whose subversive possibilities Drucilla Cornell would encourage us to consider. Unfortunately, however, by confining "textuality" to language in the linguistic sense, that is, to speaking and writing, Cornell inevitably dismantles the radical purchase in the very reinscription she seeks to enable.

The current representation of woman within the binary economy of our conceptual system is one of denigrated matter, the originary substance transcended by man through self-awareness and cognition, the dark and mysterious enigma of lost and irretrievable corporeal affections. Although Cornell's work certainly questions the normative violence of these and other sexualized divisions, her reading also surreptitiously reinforces them. The zones of prohibition that frame Cornell's argument are, however, in no way peculiar to her particular approach, and this is what interests me here, for they illustrate what happens when the problematic of language is understood as an interpretive question, confined within the horizon of hermeneutics.

Cornell reads Derrida's provocation "there is no outside of text" as a prohibition against commonsense assumptions that confuse the representation of reality with the actual body of reality itself. For example, we saw that MacKinnon was taken to task for her "implicit confusion ... a failure to distinguish the feminine from actual women," just as West was criticized for assuming that female biology might have something to do with female identity (Cornell 1991: 134). For Cornell, the ethical challenge is to acknowledge the limit of the imagination and its inability to accommodate the material difference that lies beyond it. By text and language then, Cornell means the encodings and significations of the ideal, a realm "which *undoubtedly* establishes the intelligible" (185; emphasis added). Interestingly, Cornell doesn't question the givenness of the ideal, the complexity of this particular identity, or the autogenesis of intelligibility that occurs in apparent isolation from the matter of the body. She simply assumes that the substance of reality "is only 'reachable' in metaphor, and therefore, in the traditional sense, not reachable at all" (168).

For Cornell, the literary aspiration of metaphor to realize the ideal, to cross the incommensurable gap *between* ideality and matter, is a sisyphean striving that is never achieved. She notes:

> If we cannot escape language or render it a transparent medium, we are forced to attribute properties through the "de-tour" of metaphor.... [P]hilosophy needs metaphor to reach the real, and yet metaphor always takes us away from "it" by performing on "it." Metaphorical transference, in other words, is a mechanism by which we attempt to reach the literal, understood as the

necessary or essential properties of things.... The point is that without "direct" access to the essence of the thing, we reach that "essence" only through the metaphorical transference of properties. (1991: 30 and 31)

With "the essential or necessary properties of things" beyond our grasp, Cornell presumes to rid herself of the issue of essence. Consequently, it seems that the infection of metaphor that works through *the body of language*, contaminating everything with its perverse associations, can have no intercourse with *the language of the body*. And here we see quite clearly Cornell's attempt to stop the spread of infection within a scene of writing that cannot be returned to an enclosed domain—the ideal.

In her apparently innocuous assumption that language is an inviolable domain, the proper preserve of "the concept" and "the sign," Cornell shows a reluctance to admit that Derridean textuality is about violation, breaching, and opening, about the nature of copula-tion itself, and the way in which sexual difference is constantly "be-ing wrought." Cornell does recognize that the metaphysics of presence involves a logic that is sexualized and racialized through and through, conceived and reproduced by a separation of presence from absence, ideality from materiality, mind from body, identity from lack, and so on. Yet despite the political agenda that inhabits such divisions, Cornell seems intent on shackling feminism's hopes to the limitations of this same logic. In her defense, Cornell believes that these determinations are not factual but fictional, the powerful illusions that are nevertheless laid down and lived as reality. However, she casts doubt on the enduring truth of this reality by deploying another set of binary configurations (fiction versus fact, lived illusion versus ungraspable reality) that reaffirms its irreducibility. Ironically, Cornell's philosophy of the limit unwittingly reinstates these binary determinations much more concretely by insisting that, in the end, they are beyond question.

The Cartesian economy in Cornell's calculations, an economy that reinvests a mind/body split, should now be apparent. Language is made synonymous with the realm of intelligibility, with the mutability of thought, and with the creative possibilities of the imagination. By cordoning off the space within which language happens and by identifying this scene of creation as mind, the Cartesian subject splits himself into two quite separate parts. He *is* his mind (I think therefore I am), he *has* a body. In this sexualized division between being and having, we are reminded that the body is passive matter, the mere support and instrument of the will. Cornell doesn't question this familiar domestication of sexuality wherein the feminine is made naturally receptive, or subject to, the active gift of masculinity/culture.

Rather she endorses the direction of the donation. It seems that the body of reality and the reality of the body cannot give (of) itself other than through an act of receptivity driven by lack. The gift of re-writing the scene of political possibility must therefore be maintained as a decidedly "cultural construction," indebted to the performative possibilities that are circumscribed in/as language. By acceding to the phallocentric conflation of the body with woman, Cornell discovers woman outside the action in a limbo of anticipation, caught in a spatio-temporal hiatus: "She remains veiled" (1991: 83). As a consequence, Cornell's strategy for future and fruitful intercourse turns around an understanding of the body in/as "threshold." "As receptivity, the body gives access. To welcome accessibility is to affirm *openness* to the Other" (1991: 154).

This scene of copula-tion, where the account of difference is figured through the give-and-take arithmetic of masculine *to* feminine, is engendered through the metaphysics of presence, the logic that legitimates both sexism and heterosexism. Respectful of its terms and, indeed, taking them at their word, Cornell approves their sexualized prohibitions in the very metaphorics of her argument. Identity is assumed to be self-present to itself such that difference is figured as an "outside identity." Thus, difference is itself identified as a spatial and temporal entity, an enclosed interval that falls in between two quite separate things. The important point here is that difference cannot be conceived as an active, constitutive force when it is delimited in this way.

This static reading of difference underpins conventional understandings of representation that conflate difference with distance, with a gap that marks an inevitable corruption from the purity of a now lost origin. Endorsing this reading, Cornell reminds us that "[t]he origin that is lost is resurrected as fantasy, not as an actual account of the origin" (1991: 78). For Cornell, the essential fact of an originary moment is not in dispute; "temporalization keeps us from recovering the origin" (117). The origin is therefore irretrievably absent from the present—and it is this absence or loss, its "not hereness," that affirms that we are now left with only residual reflections and distortions, the fraudulent impostures of its re-presentation.

By returning Derrida's generalized notion of language into a synonym for literature and, at a stretch, into a metaphor for the interplay of different systems of representation within the cultural order, Cornell is forced to conclude that the promise of a deconstructive politics will necessarily be a utopian gesture. Accordingly, Cornell interprets Derrida to be offering a "redemptive perspective" because he reminds us of "the productive power of poetic signification" (1991: 117). Through the performative power of lan-

guage, we can envisage different possibilities—other worlds that are not yet here. This poetic creativity becomes a resource for feminism because "this performance is affirmed as performance, not as a mere description of what woman is." This reminder that we are not dealing with the fact of woman allows Cornell to conclude that "as performance, its evocation is explicitly utopian" (205). In an elaboration of this same point, she remarks:

> Utopian thinking demands the continual exploration and re-exploration of the possible and yet also the unrepresentable. Deconstruction reminds us of the limits of the imagination, but to recognize the limit is not to deny the imagination. It is just that: the recognition of the limit. (1991: 169)

Cornell's argument leaves us with hope for the future—hope that in another time and another place, which is not this time and this place, sexual difference will be lived differently. However, Cornell's notion of temporality actually precludes this possibility. If we think temporality as textuality in the Derridean sense, we are reminded that the grammatological textile does not wait in anticipation of time's coming (a coming into presence) through the promise of the punctum, a lineal unfolding through an evolutionary march of different, separate, self-present moments. Time is not so much a thing—divisible into moments, that is, moments *in* time. Rather we might think of a moment *of* time, a moment *as* the body of time, the marking of an anterior future, what will have been in the already not yet of the present. Opening itself to the *différantial* pulse of otherness within itself, the fold of temporality differentiates itself by touching itself. This temporal re-membering is not reducible to Cornell's prohibitive reading wherein "temporalization *keeps us from recovering the origin*" (1991:117, emphasis added).

Cornell understands any representation of the origin to be false because there can be no truly faithful representation and no differentiation at/within the origin. There is just *one* generative moment, sealed in the past, whose essential identity anchors the commonsense doxa that the origin is an entity that pre-exists its repetition. Yet Derrida argues that the origin is an inscripting *process* that continues to give (of) "itself." Perhaps Cornell does appreciate the wonder of this implicated script, and her testimony to its sheer extraordinariness is that such an involved efficacy could not possibly be generalized. Cornell assumes that the implications she witnesses are generated from the fascinating complexity of human language, a complexity that demarcates the domain of culture and is therefore the rightful property of consciousness (with concessions to its inverse) and thought. It follows from this that the material carnality of originary nature is quite incapable of such

eloquence: it lacks intelligence and must remain deaf and dumb to the gift of language. But who gives this gift?[3]

The point I want to underline is that when Cornell reads the substance of materiality, corporeality, and radical alterity together, and places them outside or beyond representation, the absolute cut of this division actually severs the possibility of an ethical relation with the Other. By understanding the notion of a relation as something that operates between two quite separate categories, the One *and* the Other, Cornell reinvests the cognizing subject with an unassailable unity that innoculates him, *and* her, against the corrupting touch of radical alterity. Remember that Cornell only concedes that identity is inhabited by difference in the realm of the ideal—the realm of "myth, metaphor ... fantasy and fable" (1991: 118). Consistent with the metaphysics of presence, Cornell assumes that if something is really different and therefore radically other, then it is spatially and temporally outside the here and now. Cornell's notion of ethical responsibility to the Other therefore becomes an act of conscious humility and benevolent obligation to an Other who is not me, an Other whose difference is so foreign that it cannot be known. Yet a Derridean reading would surely discover that the breach in the identity and being of the sovereign subject, and in the very notion of cognition itself, is not merely nostalgic loss nor anticipated threat or promise. It is a constitutive breaching, a recalling and differentiating within the subject, that hails it into presence. As impossible as it may seem, the ethical relation to radical alterity is to an other that is, also, me.

By arguing that the Derridean notion of "textuality" and "language" is an intervention that works through "delegitimization" in the manner of "ideology critique" (1992: 177), Cornell has no way to acknowledge the political *différential* in what I have called the body *as* the scene of writing. By glossing the question of difference as one that asks how we negotiate the passage or gap between things—between mind and body, between language and reality, between ideality and materiality, or between men and women—Cornell binds us within familiar regimes of intercourse and reproduction. Although Cornell argues for the constitutive efficacy of systems of representation wherein prescriptive assignments of sexual identity are confounded through iteration, she does not concede that this real-izing repetition includes the very matter that she exempts from this movement.

Against Cornell's reading, I want to suggest instead that radical otherness cannot be confined to an elsewhere. It is what opens identity and the metaphysics of presence to a force field of differences in which the binary divisions between here and elsewhere are impossibly implicated. Within this field of infection it no longer makes sense to insist that the body, reality,

death, woman, and so on, secure an irreducible originariness whose matter is unrepresentable because its substantive facticity is absolutely exterior to representation. If there is no outside representation, then the closeness, the presence-to-self of matter and substance as it is conventionally conceived, also hears a rhythm of *différance* that is the scene of writing. Mutability is therefore generalizable. This doesn't mean, however, that we can simply add what we conventionally regard as the stuff of matter and substance to the soup of textual dissolution. The difficulty here is that we are bound to work at the interfacings of these binary borders in order to question the very notions of identity and separability that they maintain. Nevertheless, the displacement of matter from its oppositional stance over and against form opens the question of matter, as indeed it must also open the question of ideality.

Broaching these questions differently always carries the attendant risk of being judged irrational and just a little peculiar, as though one has perhaps lost the plot as well as oneself along the way. An apparently nonsensical question, then, might concern whether death is indeed absolutely other to me because I haven't experienced it myself—a perfect instance of Peircean "secondness" as Cornell explained it. According to the metaphysics of presence—also known as commonsense, in this instance—this assertion is irrefutably true. However, a corporeography would find the scene of production of "me-ness" to be large indeed, and not simply because in strange ways history has conspired to produce my particularity in a here and now. What could be described as the very me-ness of me, the distillation of my own personal identity, is not closed in upon itself like an inherited possession from time past or histories received, for I am still taking (my) place within a dispersal and deferral, a generative reproducibility, whose tracings allow us radically to reread the text of identity formation. To be specific, I might ask whether my mother is, even now, truly absent from my body, as if dead and gone from the moment of my birth/breach from her, as Cornell's position assumes? Or is "s/he," differently and still, articulating herself/me *here* in the tissue of a becoming that exceeds us both? Still *my* body, *here*? Where? And my father's body? Here too? And are not both parenting bodies each already full to brimming over with a *différance* through which they are re-lating, copula-ting, before they ever meet, even as they are being born? In a way, "I" am never not dying for "I" have always been becoming other—even before my birth. Absolute closure of a beginning or end has yet to take place. What imperative insists that I am, or I am not—dead or alive?[4] What mean calculation denies the complexity of engendering, of indebtedness, in order to return us to just *one* interface across which the difference between life and death will properly be given account? The perversity of interfacing

does not obey these strictures, and indeed, in its waywardness, offers another way to think the ethical relation in its extraordinary complexity.

Deconstruction involves risk. It is not easily enlisted into a pragmatic agenda, for its waywardness reroutes the very aim of our stated intentions. An illustration of this rerouting is evident in Cornell's disagreement with Gayatri Spivak over the question of essentialism. Spivak reads essentialism to be an irreducible bind to which a political axiology will always make recourse and about which it should always be aware. Given that the taking up of definitive categories such as "woman" or "worker" is unavoidable, Spivak argues that the strategic deployment of these categories is necessary in any argument that tries to acknowledge particularity (1989). Similarly, Diana Fuss defends the active claiming of essentialism as an effective political strategy that allows feminists to question the whole Aristotelian inheritance of woman as essence. Fuss notes that "[a] woman who lays claim to an essence of her own undoes the conventional binarisms of essence/accident, form/matter, and actuality/potentiality. In this specific historical context, to essentialize 'woman' can be a politically strategic gesture of displacement" (1989b: 76).

Despite their nuanced hesitations, Cornell disagrees with both of these positions, arguing instead that deconstruction can actually rid us of this bind by attesting to the limit of essentialism. Deconstruction can show us that at the heart of essence there is contradiction, a contradiction that belongs to the realm of language. In a specific reference to Spivak's position, Cornell notes:

> Her mistake is that we should even adopt the word "essence" when we are indicating specificity. It is precisely the confusion of essentialism with any writing of the specificity of feminine difference that leads to the belief that we risk either "essentialism" or indifference to the suffering of women. The solution is precisely the one of deconstruction: to show the limit of essentialism through—at least in the case of Husserl—its self-contradictory positioning within language. (1991: 181)

In other words, Cornell insists that since the representation of essence is confined within the limits of language, then we are never in any real danger of either reverting to, or of imposing, essence. However, when Cornell cautions that we should not confuse the literary performance of woman with her description, she assumes that there is writing that constitutes and differentiates, and then there is an undifferentiated "something" that, in essence, is outside the scene of writing and outside its productive force. Yet if descrip-

tion is not the anchoring opposition to performative possibility, then the tissue of essence remains in play. Vulnerable to the accident of rewriting itself, essence undoes itself in the very expression of itself.

It should be apparent by now that a deconstructive approach to things is not very useful for clearing things up. But perhaps this inability to keep within borders and limits embodies a different style of maintenance, a different genre of usefulness—a way of keeping a question moving despite the pragmatic necessity to call a halt and to take a stand. The way in which Derrida re-marks the origin, aligned with the conceptualization of essence as outside and prior to the scene of writing, provides some insight into how we might attend to the question of essence otherwise:

> The enterprise of returning "strategically," ideally, to an origin or to a "priority" held to be simple, intact, normal, pure, standard, self-identical, in order *then* to think in terms of derivation, complication, deterioration, accident, etc. All metaphysicians, from Plato to Rousseau, Descartes to Husserl, have proceeded in this way, conceiving good to be before evil, the positive before the negative, the pure before the impure, the simple before the complex, the essential before the accidental, the imitated before the imitation, etc. And this is not just *one* metaphysical gesture among others, it is *the* metaphysical exigency, that which has been the most constant, most profound and most potent. (1988: 93)

Rather than take our distance from an originary essence, as if we could, we can acknowledge something of the process of essence becoming unmotivated within the grammatological textile. Importantly, this complexity would allow us, indeed would compel us, to reconsider what is conventionally understood as the ground of essentialism. One curious result of this would be that we could embrace even biology, with all its entailments, within the scene of writing—not as a closed origin, its identity secure, but as an integral expression of the performativity of language in the general sense.[5] To prohibit any mention of biology as inappropriate to critical theory, a stance that permeates much contemporary discourse in cultural studies, is a frightened reflex that only reinvests in the prescriptive determinisms that we now have the means to contest. For example, Robin West's claim that "there is a connection between a woman's identity, her experience, and her biology" (West, as cited in Cornell 1991: 25) could be engaged and complicated rather than dismissed for its essentialism. For how, within the infection of a corporeography, is biology thought to be entirely severed from its understanding?

Keeping within this contamination, then, it might be more politically provocative to reread the agonistic face-off between Cornell and MacKinnon quite differently. MacKinnon offered a fearful representation of the body as besieged and vulnerable to violation, arguing that women need to maintain a fortress-like barrier against "being fucked" by the assaults of masculinity (as cited in Cornell: 1991 119ff). Cornell's rejoinder to this was that this terror only makes sense "if one accepts a masculine view of the self, of the body and of carnality" (1991: 154). Cornell posits that "reality is constructed through the metaphors in which it is given body," and that these masculinist determinations of femininity are bad fictions that must, and indeed can, be rewritten (129). But, by insisting that carnality is *in reality* closed in upon itself and that it is outside the performativity of the scene of writing, Cornell inadvertently reinvests in a masculinist determination of the feminine all over again. Thus, Catharine MacKinnon's need to discover an in-itself of woman *before, underneath,* or *outside* its patriarchal overlay resurfaces in Cornell's assumption that the inscriptive force of language is bounded, and that this boundary mediates the ungraspable difference of woman.

The irony that writers whose positions are violently opposed can be shown to share the same theoretical investments should alert us to the variety and subtle expression of phallocentrism that binds "woman" and the general category of "Otherness" to a beyond that is excluded from the scene of production. If alterity is not the other of representation, if it is not radically outside knowledge and understanding, then the imperializing gesture of benevolent humility to an Other who is not me, a gesture that permeates much postmodern criticism in new forms of identity politics, can be called into question. The extraordinary difficulty of this task and the ethical challenge of its undertaking involves learning how to pose such a question in the face of institutional demands that it remain unrepresentable.

four
Poststructuralist Feminisms

Part 2: Substance Abuse: Judith Butler

The hierarchical economy of the nature/culture opposition has appeared in many different forms throughout the history of western thought, and the sexualizing and racializing agenda that informs this division has endured with a persistence that continues to provoke analysis. One of the most thoughtful engagements with this problematic comes from Judith Butler, who explores the nature/culture interface through the question of corporeality. Butler's particular contribution is in her refusal to simply endorse the clichés of much postmodern writing while at the same time embracing many of its insights. Her work focuses on the notion of bodily inscriptions; engages the more general paradox within the assertion that the body is culturally constructed; and explores the ways in which what she calls the scenography or topography of this construction might be said to matter.

In the preface to *Bodies That Matter: On the Discursive Limits of "Sex,"*[1] we learn that the complexity of Butler's argument is often interpreted as a sign of the author's own personal failings, a sign of her desire to theorize away the unavoidable facticity of bodily life. Butler recounts being made to feel like "an unruly child, one who needed to be brought to task, restored to that bodily being which is, after all, considered to be most real, most pressing, most undeniable" (1993: ix–x). Butler captures the perceived abstraction of her position in the following claim:

> surely bodies live and die; eat and sleep; feel pain, pleasure; endure illness and violence; and these "facts," one might skeptically proclaim, cannot be dismissed as mere construction. Surely there must be some kind of necessity that accompanies these primary and irrefutable experiences. (xi)

Butler responds to the commonsense force in such admonitions by asking what makes them so compelling. For who could dispute that the material

stuff of human existence is a limiting horizon of some sort, perhaps *the* limiting horizon of what is both possible and impossible in the human condition? Yet Butler sets herself the difficult task of interrogating this apparently irrefutable assumption, or at least persuading us that its terms deserve closer scrutiny.

Butler's attention to what constitutes the ground of this debate, in this case matter itself, is consistent with postmodern and poststructuralist interventions that focus upon the representation of reality's foundations. However, as the quotation above attests, such inquiry can be deemed positively dangerous when the representation of reality is seen to displace reality itself. Critics of postmodernism warn against the effects of presuming to dissolve matter in an acid bath of rhetoric, for even if the mediated or constructed nature of reality is granted, the pressing facts of bodily existence still endure. The fear is that if the stuff of matter is problematized, or perhaps even lost, then the anchor of political contestation is also cast adrift.

Yet Butler's position is not consistent with this reading of postmodern interventions, for she has some serious reservations herself about "[t]he discourse of 'construction' that has for the most part circulated in feminist theory." Although in general agreement with many of its claims, Butler regards this discourse as "perhaps not quite adequate to the task at hand" (1993: xi). Her purpose then is one of clarification, an elaboration of the philosophical and political nuances of constructionist pronouncements that are often poorly understood even by those who espouse them.

Butler's aim is in some ways a reiteration of Cornell's project, another attempt to explain why the analysis of bodies "as a matter of signification" (1993: 67) is a political undertaking with political consequences. Her particular understanding of signification is therefore crucial to the success of her enterprise. Butler argues that a referent such as the body is intrinsically unstable because it cannot be fixed by any given signified. Through an interpretation that owes much to Jacques Lacan, she explains that the "referent persists only as a kind of absence or loss, that which language does not capture, but, instead, that which impels language repeatedly to attempt that capture, that circumscription—and to fail" (67). This failure is explained by the very difference between signifier and signified, and perhaps even more profoundly, by the difference between signified and referent. As Butler notes, "This radical difference between *referent* and *signified* is the site where the materiality of language and that of the world which it seeks to signify are perpetually negotiated" (69). The resulting inadequacy, or frisson, witnesses the frustrated nature of the transaction between concept and "thing."

In sum, Butler's account of the relationship between language/world, sig-

nifier/signified, and signified/referent, assumes that the difference is one of irreducible incommensurability. However this difference cannot be identified as a space separating two discrete entities, for it is a spac*ing* through which the very notion of a delimitable entity is both generated and threatened. Within this vacillating undecidability, each category is confused with/in the other. Butler clarifies this as follows:

> Although the referent cannot be said to exist apart from the signified, it nevertheless cannot be reduced to it.... Language and materiality are fully embedded in each other, chiasmic in their interdependency, but never fully collapsed into one another, ie., reduced to one another, and yet neither ever fully exceeds the other. (1993: 69)

Butler explicates a poststructuralist understanding of language and discourse and its relevance to a corporeal politics by foregrounding the contamination that undermines the integrity of a pure referent. She argues that there can be no access to a pure materiality outside or before signification and, by extension, no access to a pure materiality of bodily life that is separate from language.

This may sound as if Butler endorses the Derridean view that there is no outside of text, yet she clarifies her position by stating that "it is not the case that everything, including materiality, is always already language" (1993: 68). For Butler, materiality cannot be opposed to language nor simply reduced to it, because, although there is a necessary connection between these domains, they remain radically different. In order to better understand Butler's position here, it might be helpful to recall Drucilla Cornell on this same point. An avowed Derridean, Cornell appears to be in agreement with Butler when she asserts, "Very simply, reality is not interpretation all the way down" (1992: 1). Cornell contends that matter and ideality are absolutely separate, although her thesis does not preclude their intimate proximity, even possible lamination. In Butler, however, their connection could be likened to the enfolding overlap of a Venn diagram, wherein two recognizably different spheres are nevertheless involved in a mutual and constitutive relationship that compromises their integrity. In Butler's account, this figuring of the overlap between ideality and matter, or language and the body, allows her to deny that "the body is simply linguistic stuff" while at the same time insisting that "[the body] bears on language all the time" (1993: 68).

Although I will return to this point, I want to note here that, despite their differences, both Cornell and Butler share a very similar interpretation of Derrida's provocation "there is no outside of text." Cornell regards her

position as an endorsement of Derrida's aphorism because she makes "text" synonymous with the hermeneutic circle, that is, with the realm of the ideal where interpretation mediates the quite separate world of matter. In this case, the Venn diagram might involve two quite independent circles that, as I suggested above, may well be contiguous because laminated together, yet they are not overlapping in the sense that one penetrates the other. Matter remains the primordial ground against which ideality defines itself, and the transformational possibilities that arise through the play of difference are, for Cornell, confined to the domain of ideality. Where politics happen is therefore radically redefined within the performativity, or differential gaming, that is language itself.

Butler seems to share Cornell's deconstructive reading of textuality, although she comes to a different conclusion regarding its usefulness. Acutely aware of the need to question the conflation of materiality with receptivity, a conflation that Cornell seems happy to endorse, Butler is unwilling to situate her intervention too readily within what she perceives as the Derridean enclosure of textuality. Although Butler doesn't explain her specific disagreement with deconstruction here, perhaps she feels that the object of her interest is too quickly elided in the overarching sweep of a general textuality that denies exteriority. Butler recognizes the insidious agenda that accompanies the assumption that matter is the stuff of this exteriority, and that, as it is positioned outside analysis, its nature is beyond question. She thus strives to infuse matter with a constitutive energy and efficacy that will disrupt the inevitability of this logic. If matter can be rescued from its location as both prior and passive with regard to the notion of production, then conventional understandings of corporeality and matter are significantly problematized. Accordingly, the need to reconfigure materiality becomes the pivot of Butler's argument with the discourse of construction, a need made evident in the following passage:

> In an effort to displace the terms of this debate, I want to ask how and why "materiality" has become a sign of irreducibility, that is, how is it that the materiality of sex is understood as that which only bears cultural constructions and, therefore, cannot be a construction? . . . Is materiality a site or surface that is excluded from the process of construction, as that through which and on which construction works? Is this perhaps an enabling or constitutive exclusion, one without which construction cannot operate? What occupies this site of unconstructed materiality? And what kinds of constructions are foreclosed through the figuring of this site as outside or beneath construction itself? (Butler 1993: 28)

The difficulty in Butler's project is considerable, for she has to juggle a critique of the discourse of construction while still defending its most basic tenets. Wanting to secure a hearing from those whose patience with constructionist arguments is close to exhaustion, she begins by offering some basic reassurances about her own approach. As the discourse of construction is routinely perceived as linguistic idealism, Butler willingly acknowledges the insistent reality of bodies. She grants what she calls "the alleged facts of birth, aging, illness and death" and agrees that some minimal existence must be allowed "sexually differentiated parts, activities, capacities, hormonal and chromosomal differences," and so on (1993: 10). And she offers her "absolute reassurance" that these "can be conceded without reference to 'construction'" (10). The complication, however, is that to concede the existence of certain bodily facts is also to concede a certain interpretation of those facts. Butler conveys the conundrum by asking, "Is the discourse in and through which that concession occurs . . . not itself formative of the very phenomenon that it concedes?" (10).

Butler's critique is unavoidably convoluted because it targets two different expressions of the same argument, an argument that uncritically chooses sides in the materiality/ideality split. If we situate this debate within feminism, then those who purport to represent real women without recourse to quotation marks will presume themselves to be in receipt of the truth of (the) matter, as if the compelling facts of women's lives simply present themselves. According to this view, signifying practices are the mere vehicles of such truths, having no formative input of their own. Although they may well be regarded as inadequate, it is assumed nevertheless that they can be corrected. The other side of this debate stresses the constitutive force of signifying practices, concluding that we have no access to an extralinguistic reality because the truth of its apparent facticity is produced in language. Butler is in obvious sympathy with this latter position but disagrees with the conclusion that often accompanies it, namely, that the question of matter has been disposed of.[2] The insight that there is no outside of discourse can be styled as a moral injunction if the intricacies of this statement go unacknowledged. Although Butler agrees that we cannot access an "outside language" that is unmediated by language, she does not take this to mean that we can, or should, try to censor any mention of this outside. Indeed her thesis is that inasmuch as the received grammar of the debate will necessarily produce an exteriority, an outside discourse, that is nevertheless internal to discourse, the task is not to deny, or presume to exclude, this materiality but to analyze the "*process of materialization that stabilizes over time to produce the effect of boundary, fixity, and surface we call matter*" (1993: 9).

Butler's analysis of corporeality focuses upon the repudiation of matter because its rejection is a key ingredient in subject formation and in the determination of the subject's perceived value. Butler exposes the way in which difference from a valued norm is made synonymous with deficiency, such that deviation is moralized and pathologized as a flaw or as a fault. More importantly, the indebted nature of this valuation is denied. Butler explores the political implications of this denial, arguing that the mark of deficiency that attaches to certain bodies is made a convenient explanation for their abject status. The existence of these abject bodies is then considered beyond cultural intelligibility, beyond representation, and therefore outside the concerns of the democratic process. Refused entry into the domain of the fully human, these outcasts are then aligned with the unruly dangers of the natural, the brutish, and the animal—with the threat that is perceived to emanate from matter itself. Butler's goal is to disrupt the economy of this logic by asking, "What challenge does that excluded and abjected realm produce to a symbolic hegemony that might force a radical rearticulation of what qualifies as bodies that matter?" (1993: 16).

Butler's argument is clearly complex in both aim and execution, and I am in agreement with the passion and commitment of its overall direction. Yet if we are persuaded by Butler that the foreclosure of matter must be contested, then evidence of this same gesture in her own work deserves attention. In order to explore those parts of Butler's analysis where she retreats from her own insights, much of my argument will need to resemble hers and even to endorse the same theoretical commitments. This sense of mimicry that discovers my own argument inside Butler's is reminiscent of the way that Butler, in her turn, engages the discourse of construction. She is also committed to the very terms whose meaning she disputes. There is a reason why this mode of argumentation is parasitic, a reanimation of the host argument. If we concede that oppositional logic persists in the very act of its rejection (crudely put, "I am opposed to oppositional logic"), then its terms are more effectively destabilized and reinscribed if we do not pretend to abandon them.

Butler's discussion of the discourse of construction acknowledges the necessity of foreclosure, the inevitability of producing an "outside" or "beneath," a "before" or "beyond" language and discourse. In other words, Butler would not exempt herself from this same necessity. Her point, however, is that spatial and temporal separations between the ideal and matter are in fact internal to discourse: the political assumptions that inform them are therefore open to contestation. If language and discourse are constitutive of lived reality, then the possibility of change is discovered in the internal and

interminable movement *within* language. Thus, inasmuch as Butler's position is predicated upon the delimitation of this movement in language, it does not preclude the existence of an outside language that truly does exceed our perceptions and representations. Butler's aim is to remind us that the perception and representation of this outside, despite its convincing transparency, is always/already a language effect—a cultural production. Indeed, this point is underlined by Butler's reliance on the overarching term "culture" as an explanatory category that both locates and frames this shifting production.

Unfortunately, however, by privileging the term "culture" in this way, the identities and sexualized hierarchies between ideality and matter, culture and nature, and mind and body, are surreptitiously reinstalled. Although Butler's strategy might be described as placing the second term under erasure and rendering it unknown, the effect is to actually expand the first term by evacuating the contents of the second. Instead of opening *both* terms to their different implications, Butler has drawn a separating line of clarification between them. Her critique of separability *within* language is founded upon this essential separation.

The Venn diagram, offered earlier as a possible representation of Butler's thesis, now demands revision. On closer examination, the nature of the relationship between ideality and matter, if the latter is now understood to be under erasure, seems to involve no overlap at all. If we are only ever dealing with the signification of matter rather than with the stuff of matter as such, then "constructedness" cannot be opposed to the fact of matter: the mutually constitutive implication of their embrace now appears *within* the realm of ideality, as it does in Drucilla Cornell's argument in the previous chapter. According to Butler, the unavoidable confusion between matter and its representation can be explained if we remember that, "[t]o return to matter requires that we return to matter as a *sign*" (Butler 1993: 49). This is the founding assumption of Butler's overall thesis, witnessed again in the following explanation of the body's apparent pre-existence, before language:

> The body posited as prior to the sign, is always *posited* or *signified* as *prior*. This signification produces as an *effect* of its own procedure the very body that it nevertheless and simultaneously claims to discover as that which *precedes* its own action. If the body signified as prior to signification is an effect of signification, then the mimetic or representational status of language, which claims that signs follow bodies as their necessary mirrors, is not mimetic at all. On the contrary, it is productive, constitutive, one might even argue *performative*, inasmuch as this signifying act delimits and contours the body that it then claims to find prior to any and all signification. (1993: 30)

As the title *Bodies That Matter* makes clear, Butler's aim is to contest and to expand "the very meaning of what counts as a valued and valuable body in the world" (1993: 22). The argument that the body's substance is a sign rather than a fixed and prescriptive referent is furthered in the happy coincidence between the words "matter" and "materialize." While these words evoke a notion of physical substance, these signs are also synonyms for "meaning" and the larger semantic process of meaning making. As Butler describes it:

> To speak within these classical contexts of *bodies that matter* is not an idle pun, for to be material means to materialize, where the principle of that materialization is precisely what "matters" about that body, its very intelligibility. In this sense, to know the significance of something is to know how and why it matters, where "to matter" means at once "to materialize" and "to mean." (32)

Butler's reworking of the terms through which corporeality is conventionally comprehended certainly challenges their received meanings. But, it should now be apparent that the in-itself of matter, the substantive something that Butler's minimal, if qualified, concession to hormonal and chromosomal differences acknowledges, is not the object of her analysis. Indeed its absence is required in order for her thesis to have some purchase. Our sense of the materiality of matter, its palpability and its physical insistence, is rendered unspeakable and unthinkable in Butler's account, for the only thing that can be known about it is that it exceeds representation. Beyond cultural intelligibility, the existence of this external stuff ensures that our understanding of an outside, inasmuch as it is discourse dependent, can only be the dissimulation of an outside that *appears* as matter.

Given this reading, why does Butler insist that her argument is not a form of linguisticism? The taint of reductionism that such a description implies may sound like something to be avoided. Yet as Butler's argument rests on the functional entity of the linguistic sign, can the charge of linguistic reductionism easily be dismissed? As noted in an earlier chapter, Saussure himself was unhappy with the notion "sign," and we hear the sense of resignation in his comment, "As regards *sign*, if I am satisfied with it, this is simply because I do not know of any word to replace it, the ordinary language suggesting no other" (1974: 67). Saussure's argument strains in places to open the sign to an exteriority, a "systematicity" or "semiology," that would not be subsumed to linguistics. And Derrida also acknowledged the larger implications that flow from this gesture when he replaced "semiology" with "grammatology," thereby shifting the etymological stem of the word from

"seme" to "gram," that is, from "meaning" to "writing." But if mention of this reinscription has become hackneyed in critical discourse, its most challenging implications can easily be overlooked.

Butler's argument is an exemplary instance of a more general reluctance to take up these consequences even when the need to open the question of language is foregrounded. As a way of justifying what might read like an unfair judgment here, we might begin by noting that Derrida routinely receives the same accusation of linguisticism, a label that he, like Butler, vehemently rejects. And yet even though Butler makes considerable use of Derrida's work to explain her own position regarding language, these scholars eschew the label for different reasons. As we have seen, the trajectory of Butler's work is to expose the political implications that are involved in the production of abjection and its alignment with exteriority, matter, nature, the corporeal, the perverse—the feminine. At the basis of this exposure is the assumption that the representation of matter is something ultimately separable from matter itself. For Butler, what defines language *as* language is the play of substitution, enabled by a founding absence that the sign attempts to fill. In other words, a sign is a "sign of" or a "substitute for" something other than itself. As we saw above, Butler understands this absence or loss as the originary difference that language is unable to repair. The repeated attempt to surmount or to retrieve this difference is regarded as politically significant by Butler because it can be transformational—an opportunity that performs other possibilities. In sum, then, Butler doesn't dispute the existence of a world before or without language even if its unmediated substantiveness remains unthinkable and unrepresentable. Language and thought are therefore contained, according to Butler, such that the generative movement of their differentiation is a matter of cultural intelligibility. Linguistics is merely a part of this process.

Why do I want to insist that Derridean "textuality" is considerably more destabilizing to the way difference, and therefore language, is comprehended from the one represented so far? And what has "textuality" or "language in the general sense" to do with the excluded substance whose existence Butler places right outside cultural intelligibility? First, the difference *(différance)* that Derrida evokes doesn't so much exceed culture or defy intelligibility as it troubles our sense of what identifies or encloses these terms. Although it may seem that Butler has said much the same thing, Derrida does not assume that the human condition is bound within language/discourse nor that this binding mediates the unrepresentable substance of the world. Arguments that address the limits of representation may be important—and I count Butler's among the most provocative—but these arguments locate themselves within

the hermeneutic maze of language and representation that is regarded as separable from "something" that preexists humanness, "something" that lacks language.

As I have already mentioned, the term for this "something," this absolute exteriority, is very much under erasure in Butler's attempt to refigure what is *posited as outside*, namely, the natural order of matter and bodies. As Butler conceptualizes language as a mediating barrier, it is quite understandable that in her discussion of matter she might choose to avoid the word substance altogether: it too powerfully evokes the brute and unmediated reality that we imagine as absolute exteriority. Yet, when Derrida questions the difference between nature and culture in his claim "there is no outside of text," assaulting the self-presence of these categories as autonomous entities, he includes *within* the strange folds of this textual interiority what Butler would exempt from it. And here I am not merely including an outside that Butler has already retrieved. I am also acknowledging an outside that Butler refuses to admit. But how is this inclusion possible?

Let's return again to what might be called the atomic particle of Butler's thesis, the entity "sign." Despite the stress on signification in her understanding of materiality, Butler nevertheless concedes that "[t]his is not to say that the materiality of bodies is simply and only a linguistic effect which is reducible to a set of signifiers" (1993: 30). Butler makes this qualification by reminding us that the sign's identity is complex. Stressing the phenomenality of signifying processes, Butler notes that "signs work *by appearing* (visibly, aurally), and appearing through material means" (68). As the sign is made up of "the materiality of the signifier itself," Butler concludes that materiality is therefore "bound up with signification from the start" (30). However, this clarification makes the very assumption that is being put into question because it locates the substantive, material anchor of signification in the unquestioned nature of phenomenality. Interestingly, Butler understands the workings of phenomenality to be quite different from signification, defining what identifies nonphenomenal relations as "relations of differentiation" (68). But why should phenomenality be regarded as something outside relations of differentiation, as if perception itself is something other than a complex process of differentiations? Similarly, Butler's assumption that the signifier is the material part of the sign is surely something of a problem if we are to seriously rethink the matter/ideality separation and its political implications for rethinking the body.

Butler is quite willing to acknowledge that her use of the term "materiality" lacks consistency: "Do we mean 'materiality' in a common sense, or are these usages examples of what Althusser refers to as modalities of matter?"

(1993: 69). However this question is decided, Butler's insistence that there is a "radical difference between *referent* and *signified*"—a difference that she identifies in terms of a gap, however proximate, between "the materiality of language and that of the world which it seeks to signify" (69)—must surely indicate that her project is one of acknowledging the complex identity of ideality. Perhaps the habit in leftist rhetoric of using idealism as a dismissive slur explains why Butler might want to avoid the term until its complexity is granted. And yet we will see that the reading of Saussure that proves crucial to her enterprise, a reading that fails to appreciate that the atom of the sign is not an enclosed entity, has unnecessarily limited the scope of Butler's work.

It is important to understand how Butler's reading of the sign might install such a limit. Butler follows Saussure in describing the signifier as the material part of the sign, suggesting that "the materiality of the signifier (a 'materiality' that comprises both signs and their significatory efficacy) implies that there can be no reference to a pure materiality except via materiality" (1993: 68). Butler's representation is conveniently misleading, however, for Saussure's use of the term "materiality" was entirely heuristic. Consistent with the claim that language is "*a form, not a substance*" (Saussure 1974: 113), Saussure insisted that the signifier was not material in the physical sense. The signifier "is not the material sound, a purely physical thing, but the psychological imprint of the sound, the impression that it makes on our senses." Saussure went on to explain that "if I happen to call it 'material,' it is only in that sense, and by way of opposing it to the other term of the association, the concept, which is generally more abstract" (66). Saussure noted that the signifier had been likened to the body of the sign, a comparison he sought to complicate (103). And although the linguist rendered the signifier substantially *in*corporeal, his continued unease with this division is relevant to Butler's attempt to recast matter and the body as active and constitutive rather than as merely passive and receptive.

Saussure's sense of system, however imperfect its elaboration, is perhaps most remarkable in its appreciation of difference as the complexity of interiority and inseparability, wherein identity emerges *through* relational implication. Butler's argument about materiality and corporeality resonates with a very similar understanding, insisting that identity does not precede the differential process of its emergence. Her particular reading is certainly affirmed by passages and whole sections of the *Course in General Linguistics* that hold that linguistic entities are never discrete or autonomous. However, Saussure's frustration with regard to the term "sign" and to its internal components finds no echo in Butler's discussion. Saussure's profound dissatisfaction is not answered by Butler's recipe of admixture, no matter how thoroughly the

ingredients may be combined. Although the linguist was unable to reconcile the paradoxical nature of his insights, he clearly struggled to articulate a differential whose energy *is* the systematicity within which the gravity of identity emerges. And this energy entirely undoes the identity of the sign. We can understand why the critique of the sign is indeed hard to think, because it means that an entity is so utterly opened to/in exteriority, so profoundly recalled in/by anteriority, that the frame of space and time through which identity is conventionally figured collapses. The atom of the sign as an irreducible entity suffers a quantum leap in this implosion. The difference, conceived as conjunction, between the sign's internal parts and between the sign and other signs is internalized.

Conjuring the word "quantum" (whose meaning is uncannily close to Saussurean "value") when considering the timing and spacing of language reminds us that in physics, a subject whose etymological root evokes "the nature of nature," the question of matter and substance has been an ongoing puzzle. Although most of us in the humanities know very little about quantum mechanics and the contemporary debates it continues to generate, there is a general awareness that the stuff of the physical universe is strange, so strange in fact that even Albert Einstein himself remained unconvinced by some of his own conclusions. It appeared that subatomic particles did not behave as objects. They (quanta) possessed no dimension and only coalesced as entities in the presence of an observer. The paradox was that split particles traveling in opposite directions, regardless of their distance apart, would emerge as identical entities at the moment of observation or measurement. This, at least, was the prediction of quantum physics. But how could one particle "know" that the other was being observed such that it would manifest itself only at that precise moment and with exactly the same properties as its now distant twin? How was an apparently instantaneous communication made possible across the vast distances of space? According to Einstein, no "reasonable definition" of reality could concede faster-than-light communication, for this would break the time barrier. In other words, communication involved certain limitations. Quite simply, it took time. Einstein and his colleagues Boris Podolsky and Nathan Rosen (1935) concluded that quantum mechanics was an incomplete description of physical reality: something was missing that would explain this anomaly.

The Danish physicist Niels Bohr disagreed. And here we begin to see the shape of a debate whose nuances reappear in contemporary critical theories of language. In brief, Bohr's response to Einstein was that, in as much as quanta emerge as particles only with observation, then the notion of a particle is misleading. According to Bohr, there was no such thing as an inde-

pendent entity separated from other entities. The ghostly, faster-than-light communication that quantum physics seemed to demand in order to explain different particle behaviors was quite unnecessary if "particles" had never been separated. Bohr also questioned Einstein's assumption that his theory of physical reality was necessarily separate from the reality it presumed to describe. To put this into the more familiar parlance of contemporary critical theorizing, according to Bohr, representation was not second-order data, removed from an originary and therefore distant source.

This debate remained purely speculative until 1982, when physicists Alain Aspect, Jean Dalibard and Gérard Roger were able to test what had come to be called the EPR (Einstein, Podolsky, and Rosen) thesis (Davies and Gribbin 1992: 214–25). Their results, which met with the general satisfaction of the scientific community, concluded that "particles" are inseparable "identities" in/of space/time that are both infinite and indivisible, here *and* there, now *and* then. The quite astounding implication of their experimentation ruled out any sense of an enclosed identity of the particle. And it also ruled out any sense of an enclosed, or local, context within which causality might be identified and contained. The "nonlocatability" of "particles" meant that later experiments at distant locations could exert an effect that would travel backwards in time (perhaps more accurately here, we might think of the "properties" of "particles" being *of* time and not simply *in* time), so that future conditions must also be regarded as constitutive of identity.

These interrogations cut so deeply into the fabric of commonsense and rational thought that we are surely brought to a standstill, forced to pause and to wonder, truly, about the nature of substance. It seems that the universe is so thoroughly in touch with itself on the atomic level that information, if I can call it that, in its nonlocal ubiquity, is generalized. The physicist, Edward Harrison, captures the marvel of this paradox in the comment, "Spacetime is constructed in such a way that the distance traveled by light rays is always zero. Light rays . . . travel no distance whatever in spacetime. In the world of spacetime we are in contact with the stars" (1985: 152).

The curious nature of these results has pertinence for my reading of deconstruction and the question of matter. First, to raise this example is not to presume that the authority of science and its approaches simply override the questions Butler poses. On the contrary, what is interesting here is that "quantum weirdness," as physicist Paul Davies describes it, actually affirms Butler's criticisms of what might be called the classical understanding of relationality, difference, and causality.[3] More important, however, is the suggestion that the physical world is not excluded from the conundrum of identity that Butler attributes only to language. If data is already received before it is

sent, as these experiments assert, then the communication model of language that reads difference as absence (a "not here" or "not now" that must be overcome) is inadequate to explain such outcomes. Unfortunately, the spatial and temporal separations that Butler so effectively argues against sustain her model of language as a supplement, as a *later* technology, that represents a world that cannot articulate itself. If, however, there is no gap to be crossed or absence to be filled, then perhaps matter is considerably more articulate than Butler has imagined.

What I want to do here is to further Butler's argument, taking very seriously the critical impulse in her work that would imbue matter with constitutive animation: I want to implicate her insights within the very substance she has excluded from the discussion. For there are moments in Butler's analysis where her argument seems to test the confines of its admitted self-capture, as if it might still manage to rescue the enduring and palpable matter of the body from its unspeakable passivity. Yet, although the argument proceeds by placing matter in a relationship of contiguity with language—albeit as active adjunct or as demanding support—the originary status of matter is never in doubt. For example, matter is represented in the following passage as *the* originary, constitutive demand *for* language, a representation that illustrates that Butler's expressed complication of language and matter is actually a style of linguisticism:

> We might want to claim that what persists within these contested domains [of scientific discourse] is the "materiality" of the body. But perhaps we will have fulfilled the same function, and opened up some others, if we claim that what persists here is *a demand in and for language*, a "that which" which prompts and occasions, say, within the domain of science, calls to be explained, described, diagnosed, altered or within the cultural fabric of lived experience, fed, exercised, mobilized, put to sleep, a site of enactments and passions of various kinds. To insist upon this demand, this site, as the "that without which" no psychic operation can proceed, but also as that on which and through which the psyche also operates, is to begin to circumscribe that which is invariably and persistently the psyche's site of operation; not the blank slate or passive medium upon which the psyche acts, but, rather, the constitutive demand that mobilizes psychic action from the start, that is that very mobilization, and, in its transmuted and projected bodily form, remains that psyche. (Butler 1993: 67)

Matter for Butler may not be a blank or passive surface, but it is still a surface, and one that demands to be interpreted or written upon, by something other than itself. It seems that matter is unintelligible to itself, and this lack

of intelligibility can only be remedied by thought/language. Although matter possesses the capacity to call upon thought, it is apparently incapable of calling upon itself to interpret itself: matter can only expend itself in thoughtless activity. However, if the nature of matter is generative—if it conceives and construes itself through an involved re-presentation, or differentiation of itself—then why must we presume that thought/language is alien to its identity or to this process? Butler's questions about the nature of "matter" and "constructedness" stop short of opening the possibility that re-presentation is a material expression through and through.

The importance of Saussure's work to this section of the argument should now be clear. The linguist opened language to an exteriority so infectious that the very identity of language could not be contained and was rendered entirely problematic. Saussure found evidence of this infection in such disparate places as the glossolalic outpourings of a clairvoyant and in the mutating interiority of texts—the anagrams. Maddeningly, even his own thoughts and desires seemed subject to this virus. We can only surmise why the results of his obsessional inquiries went unpublished, but perhaps the linguist began to apprehend that language is not first and foremost a system of signification: meaning is not the defining purpose of its expression, and the difference in its reasoning is not simply captured by linguistics. As we saw in chapter 2, Derrida's insight was that even the broader purview of semiology, which Saussure envisioned as the systemic structure of the cultural order itself, would prove unable to contain this expression.

Saussure observed that "in language there are only differences *without positive terms*" (1974: 120). And although the linguist's explanations of difference were contradictory, in describing difference through the economic resonance of "value" Saussure hit upon something truly curious. The differential whose labor he was witnessing didn't precede identity nor surround it in any clear cut-way. Rather, the sense of conjunction and separation that difference conventionally presumes gave way to an imminence wherein "identity" was emergent. Saussure noted that "the notion of value envelopes the notions of unit, concrete entity, and reality" (1974: 110). In this assertion, the atom "sign," together with the universe of its expression, "the language system," suffered a fracture so violent that it opened every binding, every barrier, and every limit to a difference that could not be contained.

Digging over the dusty conceptual archaeology of poststructuralism certainly shifts the ways in which Butler's project might be reconceived. But does it specifically assist our understanding of Butler's political concerns regarding the conditions of oppressed subjectivity? Her engagement with Slavoj Žižek proves opportune here because her interest in his work, together

with her assessment of its political usefulness, addresses this question. However, Butler's critique of Žižek, a critique with which I am largely in agreement, inadvertently endorses the very aspect of his work that she most vehemently disputes. An explanation of how this instance of unacknowledged yet inevitable repetition has come about will illustrate why the notion "sign" has actually sabotaged the most important insights in Butler's intervention.

In the chapter "Arguing with the Real," Butler explores the uses and limits of psychoanalysis in Žižek's work with the aim of developing a more inclusive "theory of political performatives and democratic contestation" (1993: 20). Importantly, Butler's assessment of the social theorist's enterprise is made with explicit reference to the politics of the sign. As we have seen, the problematic of the sign involves rethinking the identity of the limit— that is, how the entity of the sign is enclosed. Butler challenges the reasoning whereby certain subjects are exiled outside the pale of humanity proper, as though they do not matter, by interrogating the way in which limits are determined and meanings ascribed. Taking the structure of the sign as an indication of how such limits and exclusions are produced, Butler investigates how the limit falls short of itself—how it fails to secure the integrity of its identity. As Butler argues that our world is a world of representation/language, her argument concentrates on the way that language "materializes" its own limit and exteriority. According to Butler, a true separation from this "constitutive outside" cannot be achieved because "identity always requires precisely that which it cannot abide" (188). Butler's question is, "How might those ostensibly constitutive exclusions be rendered less permanent, more dynamic?" (189).

In Žižek's use of psychoanalysis, Butler perceives a foundational commitment to a notion of the limit as prohibition and injunction. Although she agrees with Žižek that the subject emerges through a set of repudiations and foreclosures, she disputes the need to mark foreclosure as the real. For if the real is truly outside symbolization, as Lacan suggests, then we are left with the following dilemma, "Consider the rhetorical difficulty of circumscribing within symbolic discourse the limits of what is and is not symbolizable" (1993: 190). The Lacanian notion of the real is the lack of lack, the plenitude before the mark or cut of difference that is language. This account of originary integrity, or fullness, is then appropriated by the symbolic order (The Law of the Father). As a consequence, the cultural domain of language and representation is perceived to be full and self-sufficient, whereas the corporeal, or natural, ground of existence that precedes language is understood in terms of deficiency, a lack or loss deemed feminine in its very essence. The

effect of misrecognizing this difference as absence (I am what I am by dint of *not* being that) means that the limit of the symbolic order is figured as the threat of castration or of loss. Given the labor of feminist critics over the years to explain and to disrupt the inherent phallocentrism of Lacan's schema, it is not surprising that Butler is critical of Žižek's approving adoption of it. Butler cites Žižek's commitment:

> Žižek argues that "the Real is [language's] inherent limit, the unfathomable fold which prevents it from achieving its identity with itself. Therein consists the fundamental paradox of the relation between the Symbolic and the Real: the bar which separates them is *strictly internal to the Symbolic*." In the explication of this "bar," he continues, "this is what Lacan means when he says that 'Woman doesn't exist': Woman qua object is nothing but the materialization of a certain bar in the Symbolic universe." (1993: 279)

This conflation of woman with what is barred from existence, that is, with what falls short of full inclusion into the symbolic order, equates woman with evacuation, with the black hole of the unrepresentable and ineffable space of the real. As the political implications of this reading are disastrous, Butler argues that the limit of the real cannot be exempted from interrogation. In the presumptive givenness of the real's purported ahistorical endurance and universal application, a symbolic normativity of sexed subjectivity and sexuality is sanctioned. Butler uncovers pernicious implications in this commitment:

> That there are always constitutive exclusions that condition the possibility of provisionally fixing a name does not entail a necessary collapse of that constitutive outside with a notion of a lost referent, that "bar" which is the law of castration, emblematized by the woman who does not exist. Such a view not only reifies women as the lost referent, that which cannot exist; and feminism, as the vain effort to resist that particular proclamation of the law.... To call into question women as the privileged figure for "the lost referent," however, is precisely to recast that description as a possible signification, and to open the term as a site for a more expansive rearticulation. (1993: 218)

How then does Butler's rearticulation of signification intervene in this reading of difference as castration, lack, and deficiency?

Butler must rupture the bar that cuts presence from absence (lack), and language from what is considered prior to, or not, language, in order to open the possibility of a revaluation of different subjects. In other words, she must

engage the mode of production of these determinations, the hidden indebtedness to "the feminine" that has rendered it bankrupt. Butler explores the metaphysics of presence that opposes identity to difference as presence to absence, with the aim of refiguring difference as a generative force within whose transformational energies the sense of a fixed identity (as presence to self) is radically destabilized.

In order to achieve this, and despite her criticisms of Žižek's use of psychoanalysis, Butler finds his discussion of "political signifiers" particularly useful to this project. Žižek argues that political signifiers such as "woman" should not be regarded as descriptive designations of subject positions because they do not represent pregiven constituencies. Butler explains why Žižek's qualification is important:

> No signifier can be radically representative, for every signifier is the site of a perpetual *méconnaisance*; it produces the expectation of a unity, a full and final recognition that can never be achieved. Paradoxically, the failure of such signifiers . . . fully to describe the constituency they name is precisely what constitutes these signifiers as sites of phantasmatic investment and discursive rearticulation. It is what opens the signifier to new meanings and new possibilities for political resignification. It is this open ended and performative function of the signifier that seems to me to be crucial to a radical democratic notion of futurity. (1993: 191)

Butler is taken by the suggestion that political signifiers can be sites of mobilization and contestation, identificatory anchors whose constitutive force is transformational. Via Žižek then, Butler is able to rupture the fixed identity of the signifier and to insist that it is constantly mutating and therefore constitutionally incapable of erecting a secure barrier against exteriority. If women and other socially abjected subjects are themselves subjected to/through these same significatory transformations, then their existence and its significance must be determined *within* the symbolic order. Žižek's reading of the bar as an absolute prohibition, as if the cut of castration is a definite fact, reaffirms an "outside discourse" in derelict terms of trauma and castration. By appropriating Lacan's notion of the real to explain this foreclosure, Žižek actually endorses the violent inheritance of abject subject formation. Butler's intervention is important because it illustrates that the bar is not an absolute barrier. It is more of an *attempt* to bar, or to draw a line. The installation of the bar achieves *the effect* of both discovering and repudiating that outside as inherently deficient and *naturally* base.

By interrogating the foundation, or what is supposedly "given," as the

indifferent ground of valuation, and discovering that it is forged from the political determinations of significatory practices, Butler is able to dispense with the foreclosure of the real entirely. This strategy is surely reasonable enough when considered against Žižek's equation of difference with absence. But, as Butler's theoretical approach continues to rely upon a notion of absence in other aspects of its figuring, it is not surprising that the very same political implications in Žižek's work inevitably reappear in Butler's. For example, we see this in Butler's elaboration of how the significatory energy of transformation and desire is received by "empty signs which come to bear phantasmatic investments of various kinds" (1993: 191). We are left to wonder about the nature of this significatory support in the body of the sign. It bears phantasmatic projections that form the constantly changing ground of meaning and legibility. Yet the sign's existence is surely compromised by an internal emptiness that nevertheless possesses the functional capacity to receive. What can it mean to describe phantasmatic projections in terms of emptiness, as if the body of the sign bears nothing? If these projections are also significations, as Butler suggests, then why is the differential of giving and receiving understood through presence and absence, value and lack, that mirror the phallocentrism and heterosexism of male to female? How is the difference of phantasmatic projections translated into anything given their apparent lack of identity, their nonexistence?

Despite Butler's explicit attempt to avoid Žižek's conflation of woman with absence, her reliance upon the sign dooms her to repeat this logic in a different form. If we return again to the Saussurean sign and its psychoanalytic refiguring in cultural criticism, we see that the bar of prohibition remains foundational to this rearticulation.[4] Quite simply, the bar marks off the cultural order, glossed as "language," as an identifiable and delimitable object of study. I want to be as precise as I can about what is at stake in the maintainance of this reading. I am not suggesting that the bar of difference can be overcome or put aside. If this could be done it would reinforce the notion of difference as something superfluous, an extraneous supplement whose absence would not be missed. The problem is, rather, that in the Lacanian sign the identity of the bar is itself barred from scrutiny (and here I am making a similar point to Butler's when she questions the exemption of the real from analysis). Unified, undifferentiated, and therefore utterly impermeable, the bar represents pure prohibition. Castration is absolute. The bar, or limit, becomes a guarantee of property that encloses the concept sign within the domain of language. By extension, it also contains the intent of the sign, however wayward, within the domain of signification or meaning.

Butler's faith in the conceptual topography of the sign and its expression

through presence and absence must *inevitably* hit up against a difference deemed to be absolutely exterior to culture/language. In sum, Butler's interrogation of the bar and of its abjecting results merely relocates the cut of prohibition rather than opening foreclosure and absence *as such* to question. In the assumption that the integrity of the bar is itself barred from scrutiny, the bar's identity is reified as pure negativity. The bar of prohibition internal to the sign is banished, only to re-emerge as the sign's defining outer limit, the separating barrier between language and what is not language. The bar now surrounds the sign and protects its internal content, the domain of culture (language), from the threat of nature unveiled. The bar that is internal to the sign represents the threat of castration, that is, the threat to the wholeness and autonomy of man's identity. But, the exterior limit of the sign in its enlarged identity as the language system (culture) represents the threat to the identity of humanity itself once its abjected exiles have been properly recognized as meaningfully human. On the other side of this line of defense lies an unspeakable threat—the body of nature, the substance of radical alterity.

If we use this reading of the bar as an insight into how we might think of the law, we see that by unifying the law in this way we render resistance as a reactive and fairly futile response to the instrumental force of power as negation. Butler makes this very same point in her criticism of the Lacanian—or, perhaps more accurately here, the Kristevan—scheme that separates the Imaginary from the Symbolic registers:

> Does this view of resistance fail to consider the status of the symbolic as immutable law? And would the mutation of that law call into question not only the compulsory heterosexuality attributed to the symbolic, but also the stability and discreteness of the distinction between symbolic and imaginary registers within the Lacanian scheme? It seems crucial to question whether resistance to an immutable law is *sufficient* as a political contestation of compulsory heterosexuality, where this restriction is safely restricted to the imaginary and therefore restrained from entering into the structure of the symbolic itself. . . . feminine resistance is [thereby] both valorized in its specificity and reassuringly disempowered. . . . By accepting the radical divide between symbolic and imaginary, the terms of feminist resistance reconstitute sexually differentiated and hierarchized "separate spheres.". . . . [R]esistance . . . cannot enter into the dynamic by which the symbolic reiterates its power and thereby alter the structural sexism and homophobia of its sexual demands. (Butler 1993: 106)

My argument with Butler draws upon this very insight in the hope of furthering its implications. By contesting the nature of the division between the

domain of language as the law of the symbolic, and the domain of the imaginary as the pre- or proto-linguistic, Butler successfully undermines several assumptions, namely, the straightforward identity and integrity of the symbolic order; the integrity of the self-present subject of/as maleness; and the marginalization and even erasure of women and other denigrated subjects in this system of identity formation. However, Butler conceives the power of the law as the power to name, to assign, and to delimit, so that the very act of naming is considered a violence of sorts. As a consequence, the law *as such* appears as a unified force, just as the name is rendered coherent. Yet this notion of violence ignores an interesting ambiguity at the heart of the word "violence," for the force of rupturing and breaching involves both destruction and creation.

By reading power's purpose in terms of negation, prevention, constraint, and prohibition, Butler is unable to consider the possibility, indeed, the inevitability that a political rearticulation happens *within* the law or the name itself. Unable to consider such an outcome, Butler is forced to locate hope for change in the signifier's historicity—that is, in the necessary repetition of a name. Butler reminds us that hegemonic norms require maintenance: the law must be laid down again and again. And this constant reinvocation of the law is likened to a form of speech act, suggesting that "[d]iscursive performativity appears to produce that which it names, to enact its own referent, to name and to do, to name and to make" (1993: 107). Butler takes the apparent closure in this tautological reflex as proof that the legitimacy of discursive authority is a fiction. It cannot ground itself in an original authority because the act of citation, the repetitive difference that is language, is a practice of perpetual deferral to a source now lost or absent:

> It is precisely through the infinite deferral of authority to an irrecoverable past that authority itself is constituted. That deferral is the repeated act by which legitimation occurs. The pointing to a ground which is never recovered becomes authority's groundless ground. (108)

Acknowledging a Derridean understanding of the notion of repetition, however, Butler explains that *iterability* disrupts the sense of repetition that assumes a gap in time:

> Significantly, the Derridean analysis of iterability is to be distinguished from simple repetition in which the distances between temporal "moments" are treated as uniform in their spatial extension. The "betweenness" that differentiates moments of time is not one that can, within Derridean terms, be spatialized or bounded as an identifiable object. It is the nonthematizable

différance which erodes and contests any and all claims to discrete identity, including the discrete identity of the "moment." What differentiates moments is not a spatially extended duration, for if it were, it would also count as a "moment," and so fail to account for what falls between moments. This "entre," that which is at once "between" and "outside," is something like non-thematizable space and non-thematizable time as they converge. (1993: 245)

Butler acknowledges that the unspecified understanding of temporality and sequence presumed in the work of Michel Foucault, a theorist whose work is important to certain aspects of her argument, is entirely problematic when considered against the above complexities. Yet Butler's helpful elaboration of a more nuanced understanding of temporality does not appear in the body of her argument but in a rather long endnote to the Introduction. The pragmatic reality that a book's introduction is actually a concluding afterword, the summation of an argument that benefits from hindsight, probably explains this discrepancy. But it means that the notion of reiteration that Butler deploys in her overall argument is quite consistent with a concept of time as linear sequence, as illustrated in the following:

(performative "acts" must be *repeated* to become efficacious), performatives constitute a locus of *discursive production*. No "act" apart from a regularized and sanctioned practice can wield the power to produce that which it declares. Indeed, a performative act apart from a reiterated and, hence, sanctioned set of conventions can appear only as a vain effort to produce effects that it cannot possibly produce. (1993: 107)

In this comment Butler draws upon a Foucauldian sense of discourse and power that does not sit comfortably with Derridean *iterability*. As Butler herself has noted, a deconstructive reading would suggest that repetition inheres even within an apparently isolated act or event. And further to this, Derridean "textuality" cannot be subsumed to the Foucauldian understanding of "the discursive," with its presumptions about social regulation and social possibilities. What emerges from a Derridean reading, then, is that there is never a simple failure, or an absence, of production. Any and every "act" is, in a sense, utterly efficacious: there is no outside of text, no absence of writing, and no lack of differentiating. Although this may seem like a finicky point, the implications are considerable. Butler's reading assumes that there once was a definitive origin, a discrete entity quite separate from its representation in language/discourse. It follows from this that language, perceived as a second order *construct* or *substitute* for something now lost, founds its very identity on

the difference of this separating interval. Put simply, Butler's argument must assume that a now inaccessible reality precedes its representation, a representation whose status is that of fantasy and fiction, the phantasmatic field of *cultural* interpolation. Butler's insistence that these fictions are nevertheless powerful because they "real-ize" effects reverses the logic of causality but does not contest its linear discriminatons of difference as separability. It is precisely this linear sense of temporality and its corollary concepts of causality (efficacy here) that are quite confounded within the space/time complexity of Derridean *iterability*. As Butler herself concedes, a "moment" is an emergence *within* differentiation that has no exteriority.

The relevance of this for rereading power becomes clear if we return to Žižek's notion of "political signifiers." Žižek argued that signification should not be given the status of description, for there is a permanent recalcitrance, or a failure of fit, between the referent and symbolization. This gap, or difference, explains why Žižek might determine that the descriptive fact of the referent is more accurately understood as a phantasmatic construct, the desired product of hegemonic structures that are open to contestation. Endorsing this view, Butler emphasizes that political possibility is actually generated from the discrepancy between language and the actuality of the referent. As she explains here with specific reference to the signifier "woman," "[t]hat the category ["women"] can never be descriptive is the very condition of its political efficacy" (1993: 221). Butler eschews description because it is a gloss for what is purportedly timeless, essential, and outside the performative iteration, or alteration, of language. However, this founding exemption ties Butler once again to a notion of difference as substitution, wherein difference is read as the sign of something else, of some originary loss or absence. Loss and absence are therefore essential to Butler's reading, for she locates the problematic nature of identity in the constitutive *failure* to recuperate this loss. Because of the inevitable *incompleteness* of identity in this assumption, both Butler and Žižek understand any appeal to integrity in terms of *phantasmatic illusion*. However, against this psychoanalytic reading, the emergence and transformation of identity within Derridean *iterability* is not explained by an originary absence whose result is an inevitable impairment.

Butler is fully aware of the unfortunate consequences of an oedipal logic that aligns and fixes sexual positionalities. As her discussion of Žižek reveals, if the prediscursive is read through the logic of lack, then a sexualized and racialized battery of incontestable prescriptions seems to be endorsed by nature itself. Butler is adamant on this point, and her argument is most persuasive when she maintains its importance. For example, in her discussion of

Chantal Mouffe and Ernesto Laclau's theorization of radical democracy and its relevance to Žižek's thesis, Butler makes another assault on the insidious equation of difference with lack. She questions the compatibility between the Derridean logic of the supplement and the Lacanian notion of lack that these theorists assume. Mouffe and Laclau find the promise of an open-ended political futurity in the constitutive antagonisms and contingencies of identity formation. Making a similar point to Žižek's, they explain the possibility of renegotiating identity in terms of an inevitable failure of ideological structures to fix themselves as fact. Butler interprets Laclau to locate these contingencies and antagonisms within social relations, which he ambiguously describes as being "'outside' of posited identity" (1993: 194). Given this, Butler's question concerns the status of Laclau's statements about "the antagonizing force [that] *denies* my identity in the strictest sense" (194).

> The question, then, is whether the contingency or negativity enacted by such antagonizing forces is part of social relations or whether it belongs to the real, the foreclosure of which constitutes the very possibility of the social and the symbolic. In the above, it seems, Laclau links the notions of antagonism and contingency to that *within* the social field which exceeds any positive or objectivist determination or prediction, a supplement within the social but "outside" of posited identity. (1993: 194)

As we have seen, Butler criticizes Žižek for locating this constitutive antagonism and contingency outside the social, in the Lacanian real. We can see why she might prefer Laclau's account. But, since Laclau also explains the production of identifications in terms of "lack" while at the same time drawing on the Derridean notion of supplementarity, Butler inquires, "If the 'outside' is, as Laclau insists, linked to the Derridean logic of the supplement (Laclau, NRRT, 84 n. 5), then it is unclear what moves must be taken to make it compatible with the Lacanian notion of the 'lack'" (1993: 194). Butler's quandary is explained by her reading of the Derridean supplement as an *internalized* exteriority, one whose convoluted "attachments" return it to the realm of social reinscription.

Despite Butler's move here, and it is an important one, her commitment to a notion of lack or absence means that her question concerns the appropriateness of its location—either inside or outside the social. The identity of lack *as such* is not in question here. Consequently, her quandary regarding the compatibilty of the Derridean notion of supplementarity with the Lacanian notion of lack is based on the erroneous assumption that Derridean supplementarity never really leaves the social world. Although Derridean

supplementarity is indeed about an internalized exteriority, Butler's need to locate reinscription and political possibility within an interiority that she names "the social," as if the identity of "the social" and the efficacy of reinscription could be contained, is precisely the problem. The complexity of identity formation that Butler concedes to a word, to an individual, or to a particular social milieu, is not granted to "entities" such as "language," "the social," or "the cultural." Although forces breach and differentiate the respective interiorities of these identities, it seems that their identifying borders remain immune to this disturbance. Butler conceptualizes the limit of these entities as separate supplements to those entities, supplements that are not themselves open to the logic of supplementarity. By foreclosing the domain of differentiation, productivity, and mutability in this way, Butler builds her critique of difference (as lack) upon the very logic that she contests: the logic that equates difference with absence. Put simply, the substance of nature and whatever else culture exteriorizes as properly outside itself is rendered utterly absent by being placed under erasure. But what difference might the Derridean logic of the supplement effect upon this logic? Is it inevitable that *différance* returns to lack, if not immediately, then in the final instance, as Butler assumes?

There would be few scholars familiar with contemporary theoretical work on language who would be surprised to hear that Derridean *iterability*, or here, *supplementarity*, refigures temporality and spatiality such that our understanding of terms such as "description," "essence," "origin," and "ground" are riven within the differential of alter-ing. All of these terms assume a defined spatial and/or temporal locatability, and fixity, that Derrida's work renders ubiquitous and entirely plastic. Given the assault of deconstruction upon foundationist notions such as these, it isn't much of a stretch to include the notions "body" and "matter" within the orbit of these interrogations. But does this assault involve corporeal substance? As we have seen, Butler deploys the term "matter" rather than "substance" because the former is a synonym for significance/signification. To think of substance is to think of the very meat of carnality that is born and buried, the stuff of decay that seems indifferent to semiosis. Substance evokes the soil of groundedness itself; the concrete and tangible thingness of things. To avoid using the word "substance" is surely a careful decision on the part of a writer whose stated interest is in the materiality of bodies. What risk, then, is Butler's sustained avoidance of this term trying to minimize?

The concept "substance" has a long history of philosophical engagement that certainly complicates any commonsense assumptions, assumptions that perceive the body's complex interior densities as self-evidently (made of)

"substance." But acknowledging complication isn't necessarily achieved by dispensing with commonsense perceptions. Indeed, indifference to such perceptions fails to recognize that they are necessary ingredients in the very complication that concerns us. Interestingly, Butler's engagement with corporeality ignores the commonsense understanding of bodily substance as the sheer insistence and weight of the body's interiority. Instead, the body's surface becomes the site of engagement. Butler reads the body as a changing text, or as a discursive effect, such that the body's perceived outline is constantly changing. Butler regards these transformations of the body's morphology as a form of reckoning that "contours the bodily matter of sex" and "set[s] the limits to bodily intelligibility" (1993: 17). She draws on the work of several theorists in order to elaborate this notion of a contour/threshold, and renders it in terms of interpolation (Althusser), enunciation (Benveniste), body imago (Lacan), and inscription (Foucault). Yet, if her intention is to invest the surface/threshold itself with activity, Butler stops short of going all the way. Her intervention is limited to the surface of the surface because she assumes that the differentiation of contour-ing is given by/in signification. As signification is the play of form, substance is excluded from this activity. To question the identity of form in some depth by "thinking *through* the body," that is, through the surfaces within surfaces that couple exteriority within interiority, does more than testify to the vagaries of signification.

In chapter 2, I argued that despite her wonderfully suggestive phrase "thinking through the body," Jane Gallop also balked at exploring its most challenging implications, confining morphology to the question of specular reflection. Gallop's focus on the body's exteriority separated the flesh of the body's interior from the phantasmatic illusion of the body image. Despite their quite different interpretations, the form/substance (and inevitably, mind/body) split that underpins Gallop's reading also grounds Butler's. If, however, we take up Derrida's notion of "supplementarity" in which what is deemed separate (here, substance) is actually an internal complication that shifts the very identity of form (and substance), then the morphogenesis of language is not a bounded terrain, played out upon the body's surfaces. Instead, we might think of the morphogenesis of language in the general sense as a force field of emergent bindings that has no simple exteriority. Morphology might then be rethought as the shifting text of legibility itself. The transformative reading/writing of "the sensible" is a corporeal articulation through and through: it is not divided into separable spheres of mind/body, culture/nature, or language and perception. What I am trying to conjure here is some "sense" that word and flesh are utterly implicated, not

because "flesh" is actually a word that mediates the fact of what is being referred to, but because the entity of a word, the identity of a sign, the system of language, and the domain of culture—none of these are autonomously enclosed upon themselves. Rather they are all emergent *within* a force field of differentiations that has no exteriority in any final sense.

Another way of stating this is that *différance* is not the energy of attempted restitution, propelled by its own failure, as the Lacanian model of difference assumes. According to Lacan, the break from the origin can never be repaired because the origin is irretrievably lost—substitution is the only consolation. Nor is *différance* a force whose "productivity" or outcome can be confined to the model of power, discourse, or subject that informs the work of Michel Foucault. *Différance* suggests something that is not simply made compatible with the work of Foucault and Lacan, inasmuch as *différance* is not defined by exempting anything, it must also embrace and inhabit the work of these theorists. *Différance* is "becoming itself." It is a writing and reading whose many expressions include the workings of bio-logy in a conversation that reconfigures what and where "intelligibility" is. If the logic of morphing is the complex mutation of limit-ing, then this re-articulation cannot be restricted to the polysemous possibilities and constraints of what is conventionally understood as language.[5]

Butler's commitment to an inarticulate lost origin denies the possibility that nature scribbles or that flesh reads. For if nature is literate, then the question "What is language"—or more scandalously, "Who reads?"—fractures the Cartesian subject to its very foundation. The fiction of the self-conscious individual fully aware of his intentions and agent of his own destiny is quite clearly displaced here. But if the humanist subject comes undone in the face of nature's literacy, this unraveling does not stop with the critique of humanism. Antihumanism acknowledges a subject caught in the vicissitudes of language and constitutionally incapable of knowing himself. Yet the range or extent of this decentering is limited to the complexities of the cultural order and to its psychical and social determinations.

Much poststructural and postmodern criticism specifically addresses the complexities of language and discourse as expressions of power. But if the identity of culture and language is opened to an outside that reads, an outside that writes, then the identity of power is not synonymous with circumscription. Clearly, this has serious implications for Butler's thesis. Butler conceives power as "constitutive constraint," coupling Foucault's notion of power as production with a poststructural attention to power as valuation. As we have seen, Butler wants to contest the black and white of abjection, the engendering of exclusions that work to guarantee that a whole(some) sub-

ject is different and separate from what is denigrated as deficient. She wants to contest the economy that invests a proper subject with the belief that he is not made of the same devalued matter, indeed, not made of matter at all. Homophobia, racism, and sexism feed on this conceptual legacy, which is corporeal and substantive because it is wrought with/in flesh.

Butler outlines the need for sustained contestation of the nature/culture division and why it matters, why this questioning is itself a political practice and why intellectual work at this interface will always be necessary. My reading of Butler's work has been an attempt to acknowledge this necessity and has been elaborated in a way that endorses many of her own perceptions. It therefore seems appropriate to conclude with Butler's own representation of the importance of such contestatory readings of this problematic:

> The relation between culture and nature presupposed by some models of gender "construction" implies a culture or an agency of the social which acts upon a nature, which is itself presupposed as a passive surface, outside the social and yet its necessary counterpart. One question that feminists have raised, then, is whether the discourse which figures the action of construction as a kind of imprinting or imposition is not tacitly masculinist, whereas the figure of the passive surface, awaiting that penetrating act whereby meaning is endowed, is not tacitly or—perhaps—quite obviously feminine. Is sex to gender as feminine is to masculine? . . .
>
> This rethinking [of nature] also calls into question the model of construction whereby the social unilaterally acts on the natural and invests it with its parameters and its meanings. Indeed, as much as the radical distinction between sex and gender has been crucial to the de Beauvoirean version of feminism, it has come under criticism in more recent years for degrading the natural as that which is "before" intelligibility, in need of the mark, if not the mar, of the social to signify, to be known, to acquire value. (1993: 4–5)

If we agree with Butler that there are unfortunate and enduring political implications in this last assumption and that we need to dispute its logic, then it is imperative that we question Butler's insistence—a form of reassurance—that "to return to matter requires that we return to matter as a *sign.*" The enclosure of the sign's identity, if accepted, will not provide a fertile and generative departure point for difference. But, by putting the sign into question and exploring identity on the atomic level of its constitution, matter may well appear as a curious subject indeed.

five

Reality Bytes

Virtual Incarnations

In the closing years of the millennium the self-evidence of the corporeal can no longer be assumed. Human tissue incorporates a complex weave of dacron, silicon, and metal; edible chemistries of hybrid derivation routinely join the rhythms of biological dialogue; pig, human, baboon, and tomato are blended in strange recipes; electronic circuitries measure out the delicate pulse and possibility of life. This creole of technocultures has significantly refigured corporeal possibility in a way that extends to the larger and not unrelated question of what it means to be human. The constitution of the very stuff of the body has become strangely uncertain even as the code, or program, of humanness is cracked, reinvented, and marketed. Exemplary of this incessant and aggressive redefinition of the human condition is the phenomenon of cyberspace. The human subject is now digitized and decentered through the global stretch of cyberspace capillaries. Kinships of technicity are organized along bloodlines of data that have begun to complicate and displace more familiar identity alliances (Tomas 1989). As Mark Dery, editor of *Flame Wars:The Discourse of Cyberculture*, explains this phenomenon, "authors are sometimes anonymous, often pseudonymous, and almost always strangers." This "incorporeal interaction" heralds many new possibilities:

> [A] technologically enabled, postmulticultural vision of identity [is] disengaged from gender, ethnicity, and other problematic constructions. On-line, users can float free of biological and sociocultural determinants, at least to the degree that their idiosyncratic language usage does not mark them as white, black, college-educated, a high-school drop-out, and so on. (Dery 1993: 560–61)

Freed from the wet net of any carnal mooring, there are no apparent limits to the complex identities that these hybrid avatars of virtual life may

assume. Indeed, Jaron Lanier, one time media bad-boy of the virtual reality (VR) world and often cited as the author of the term "virtual reality," has confidently speculated that VR will even afford us the opportunity of assuming the body of a lobster (cited in McFadden 1991: 45).

VR is often used as a loose synonym for cyberspace. As one might expect, the notion of virtual reality takes its leverage from the material ground of *actuality*, from the palpable fact of the manifestly physical. In *Cyberspace: First Steps*, the jumbo collection of essays that marked the academy's first serious expression of interest in the subject, the editor Michael Benedikt notes, "what is real always pushes back.... '[R]eality' *is* that which displays intractability and intransigence relative to our will" (1992: 160). Against this, the reality of "the virtual" is a computer-generated world whose degree of inclusive experience varies across a range of access devices. "Immersive First-Person" systems, for example, involve a sensorium interface such as head-mounted stereoscopic displays, datagloves, and bodysuits that can track and meld the kinaesthetic with the visual and the auditory. The development of haptic feedback promises the added sensation of substance and force—the feel of textures and the weight of gravity that will enhance what is already described as phenomenologically engulfing. The virtual traveler enters a three-dimensional simulated space whose geographies and architectures can be negotiated in a variety of ways, such as by driving or flying through them with the aid of a directional cipher.

Of course, virtual reality has an attenuated existence in the simulation environments and arcade games that allow their hopeful pilots to flirt with death and win, even when they lose. But VR is merely a subset within the larger embrace of cyberspace, a place that science fiction writer William Gibson calls "a consensual hallucination ... abstracted from the banks of every computer in the human system. Unthinkable complexity" (1986: 67). This unthinkable complexity has certainly seized the general imagination: it feeds the garage hackers and techno-nerds who people the night world of the computer nets; it attracts the investment of the military and the entertainment industry; and it catches the interest of the scientific community who, among other things, test drives molecular research models and investigates a future that includes telepresence surgery and virtual freedoms for the disabled. Educators and recreationists alike are entranced. The explosion of arcane languages and specialist concerns also intersects with the pop cultures of cyberpunk, the subcultures of virtual communities (multiple-user dimension, or MUDs) camped in the ether, and the cool consumerist chic conjured in magazines such as *Wired, Mondo 2000*, and *Ray Gun*.

Despite the extended identity of things cyber, writers in the field tend to

apportion special significance to VR. In part, this status derives from the sense of possibility that attaches to the notion of a virtual corporeality, a status whose promise is underlined by the general agreement among cybernauts that a true virtual reality has yet to be achieved. The databody suits are, for example, still crude and cumbersome. Similarly, it is conceded that virtual reality can at this stage offer only a very reduced, or elemental, representation of what we might call a naturalistic, perceptual experience. Yet it is precisely in this same clumsy imperfection, this narrow bandwidth of information, that the promise of imagined futures has taken root. It is as if our manifest destiny is to possess the oxymoronic state of a totally real-ized artifice. Howard Rheingold, a writer who popularized the recent history of VR, gives an optimistic forecast of a *"ménage-à-mille,"* a multiple partner sexual fantasy mediated by a "machine" whose intrusiveness has been reduced to that of a "diaphanous bodysuit."[1] Likened to the snug fit of a condom and presumably possessing its sanitary appeal, Rheingold's fantasy of transport is no ordinary experience:

> Imagine plugging your whole sound-sight-touch telepresence system into the telephone network. You see a lifelike but totally artificial visual representation of your own body and of your partner's.... [Y]ou can find one partner, a dozen, a thousand, in various cyberspaces that are no farther than a telephone number. Your partner(s) can move independently in the cyberspace, and your representations are able to touch each other, even though your physical bodies might be continents apart. You will whisper in your partner's ear, feel your partner's breath on your neck. You run your hand over your partner's clavicle, and 6,000 miles away, an array of effectors are triggered, in just the right sequence, at just the right frequency, to convey the touch *exactly the way you wish it to be conveyed.* (1991: 346; emphasis added)

In this much quoted passage from *Virtual Reality,* we see that Rheingold's "teledildonics" is a supplement whose virtues promise to enhance and even to supplant the comparative routine of conventional sexual fumblings. It seems that desires will be answered "exactly" because there is no carnal drag through this frictionless medium, no physical obstacle to impede satisfaction. Unconstrained by the intractable and intransigent world of material substance, the stuff that Michael Benedikt describes as the limit that ultimately arrests our will, we are released into a world of hyperbolic agency. The post-corporeality of virtual space seems at last to answer the desire for utopia, that no-place that defies the conventions of location by its very ubiquity. For Nicole Stenger, this departure from "firm ground" can be likened to the land of Oz, "it is, we get there, but it has no location" (1992: 53).

Although the uncanniness of cyberspace is difficult to describe, there is a consistency among commentators in noting its *lack* of physicality. For Benedikt, cyberspace possesses an "inherent immateriality," a "mytho-logic" whose genetic filiation is the fictional, the magical, and the mystical. Cyberspace is "permanently ephemeral," the space where the perfect body is paradoxically acquired through an annihilation of the flesh. Vivian Sobchack, a writer whose work addresses questions of phenomenology, worries that this desire for an ultimate escape actually *demands* "Getting Rid of the Meat" (1993: 577). Sobchack describes the following lines from *Mondo 2000* as typical of the sort of snuff fantasies that seek to replace the body with a virtual avatar, or meat puppet. "Nothing could be more disembodied or insensate than . . . cyberspace. It's like having had your everything amputated" (577).

The religious resonance in this desire to finally transcend the flesh is succinctly captured in Gibson's *Neuromancer*, the cyberpunk classic about a console jockey's addiction to the giddying delirium of the virtual razor's edge. Case, the novel's principal character, is despondent with the realization that he can no longer access the thrill of chasing down life inside the matrix. On this side of the computer, the side of dumb, carnal necessity, he feels as if the very fact of having a body is a profound disability:

> For Case, who'd lived for the bodiless exultation of cyberspace, it was the Fall. In the bars he'd frequented as a cowboy hotshot, the elite stance involved a certain relaxed contempt for the flesh. The body was meat. Case fell into the prison of his own flesh. (1986: 12)

If humanity has often described itself as carnally incarcerated, then cyberspace seems to offer a unique form of reprieve. Lacking substance, it promises a virtual escape route from the constraints of prison life.

Allucquère Roseanne Stone, a writer who is very familiar with the marvelous intrigue of these electronic worlds, introduces us to one such story of virtual fulfillment. In "Will the Real Body Please Stand Up?" (1992a), we are introduced to Julie, a single and totally disabled older woman with no social life to speak of. Julie can, however, engage the computer keyboard with the aid of a headstick. Stone recounts that the woman's warm and perceptive intelligence won her many friends on the net, and her thoughtful and sympathetic advice was greatly valued. Within the intimacy of the virtual community Julie was much loved. As things turned out, however, Julie hadn't fully overcome the failures of the flesh. Eager to meet and to thank the physical manifestation of her virtual confidante, one of Julie's on-line chums finally tracked her down. But the delight of anticipation foundered on the

obstacle of Julie's body. Although she was indeed middle-aged, "Julie" possessed normal mobility and a profession that carried a good deal of authority and respect—she was, in fact, a psychiatrist, a male psychiatrist. The troubling fact of Julie's body had been of no significance previously, being just the vehicle of an expansive and generous on-line personality liberated from its broken housing. In view of this, what are we to make of the feelings of real betrayal that were inspired by this particular revelation of sexual difference?[2]

Not unrelated to this question about the confusion between RL (real life) and VR is the now infamous case of chat-room violation outlined several years ago in *The Village Voice*. In "A Rape in Cyberspace: How an Evil Clown, a Haitian Trickster Spirit, Two Wizards, and a Cast of Dozens Turned a Database into a Society," Julian Dibbell described the rather benign virtual community of LambdaMoo. "[T]he place was the living room—which, due to the inviting warmth of its decor, is so invariably packed with chitchatters as to be roughly synonymous among LambdaMOOers with a party"(1993: 37). What took place in this convivial atmosphere was an unprovoked and unexpected series of sexual assaults that became progressively violent. The final injury was one victim's forced self-abuse with a piece of kitchen cutlery. The virtual rapist, a character named Mr. Bungle, disabled his luckless victims by using a special program that enabled him to describe his victims' behaviors as if they were compliant and willing participants.

After recounting this tale of mayhem, Dibbell reminds us that the scene of personal humiliation was "made of nothing more substantial than digital code" (1993: 38). And just in case we are still unclear about the circumstances, he underlines that "[n]o bodies touched" (37). Yet if indeed no bodies touched, a fact that the literature on cyberspace is unanimous in conceding, then the victim's posttraumatic tears and real-life outrage seem a little excessive.[3] How could this MUD (multiple-user dimension) rape, this lurching crawl of sentences across a computer screen, be felt as a paralyzing physical assault?

Stone refers us to the prescient computer engineers, the progenitors of life on the nets, for an explanation. These early programmers "had long ago taken for granted that many of the old assumptions about the nature of identity had quietly vanished under the new electronic dispensation" (1992a: 83). The series of technological changes that herald the need for these assumption updates are clearly evolutions for Stone, a "succession of prosthetics" that can be deemed, albeit in retrospect, to augment what has been deficient, or lacking, in our lives.[4] Stone reads technology as the supplement that repairs a body rendered incomplete before its augmentation. Through the logic of the

fetish and investment in the fetish and in the implications that accompany it is quite explicit: "Penetration translates into envelopment. In other words, to enter cyberspace is to physically *put on* cyberspace. To become the cyborg, to put on the seductive and dangerous cybernetic space like a garment, is to put on the *female*" (1992a: 109).

Stone locates the first epoch of what she admits is a "virtual system's origin myth" in the development of the scientific paper in the seventeenth century. This form of academic writing is described as "virtual witnessing" because its readers successfully substituted text for an actual experiment. Through three more epochs, Stone charts the increasing level of mediation in the development of human communication. Stone doesn't question the status of this developmental narrative *as* narrative by her use of the word myth. Rather, the apparent qualification concedes only that there may be other ways to divide up this history of incremental, progressive change, and that its exact point of origin is necessarily an heuristic one.

The complex gee-whizzery of virtual systems and their conceptual "challenge and promise" is uniqely contemporary according to Stone, who charts the elusive ground of this recently discovered "new world" and decides that its settlers are indeed first. The literature reminds us again and again that there is no *body* in virtual space or, perhaps more precisely, that the parameters of virtual habitation are only now being determined. Yet there is an imperializing tenor in this observation that cannot escape notice. Within the conventions of conquest stories, new lands are very often perceived as empty, their useless vacancy inviting occupation and exploitation. Indigenous peoples are only accorded an attenuated human status because they are, by nature, part of the landscape and therefore invisible.[5] As the landscape of cyberspace is assumed to transcend the Cartesian coordinates that supposedly discover native existence, Stone has assumed that we are well clear of the problem.

Paraphrasing a notion explored by Donna Haraway, Stone figures this disruption of Cartesian space in terms of a "geography of elsewhere." Its strange contours result from the fact that cyberspace is said to be "purely conceptual," "a world of total representation," "pure information," and therefore untrammeled agency. It seems that this potent distillation of intellectual ascendancy and technological advance properly belongs to the domain of culture. Given Stone's quite definite separation of representation and information from physical life, we can also presume that the legend that charts this "new world" is illegible to the blind immaturity of carnal matter.

Michael Benedikt gives further emphasis to what he sees as a vast difference between the ideational and the physical world in his "Introduction" to

Cyberspace: First Steps. In an attempt to capture the full significance and wonder of future habitation in a "purely conceptual" space, Benedikt first describes and praises the virtues of its opposite, namely, the brute existence of primordial being. This was also an immersive existence, according to Benedikt, but one made special by the raw immediacy of life, the "universal, preliterate actuality of *physical doing*" (1992: 12). Benedikt is captivated by an Edenic, primordial existence that emerged on the plains of Africa two million years ago, an experience that was essentially full and complete, a sentient plenitude that was blissfully uninterrupted by a yet-to-evolve intellect. Unmediated by representation, the lives of our ancestors were consequently immersed within nature so completely that they were an expression of nature itself. Although Benedikt regards this pristine state with some nostalgia, he also sees it as imminently recuperable. He conjectures that VR technologies will soon be able to abandon symbolic forms of communication altogether. With nothing between us and our desires, "[w]e would become again 'as children,' but this time with the power of summoning worlds at will and impressing speedily upon others the particulars of our experience" (1992: 13). Benedikt's prediction of future relies upon a notion of past whose origin, or birthplace, is locatable in its lack of differentiation; namely, in its uncorrupted purity. Whereas primitive existence unfolds in the pure plenitude of unmediated nature, the consummation of the technological is an achievement of unmediated culture, that is, *pure mediation.*

It seems a little confusing that Benedikt understands this postliterate state of being in terms of pure representation. However, as this state promises to deliver the urgency of the will with uninterrupted efficiency—to become one with the transcendent and realizing power of the mind—we can see why the obstacle to its achievement is matter itself. It is clear that for Benedikt representation is prevented from simply mediating itself (as pure representation) because it remains bound to the corporeal. Consequently, the achievement of a true *post*corporeality will be a quintessentially cerebral experience, distilled from the material dross and distortion that is flesh itself.

Some writers have nevertheless expressed disquiet over these developments. In "The Erotic Ontology of Cyberspace," for example, Michael Heim expresses his misgivings about the ramifications of existence "outside of embodied presence":

> The living, nonrepresentable face is the primal source of responsibility, the direct, warm link between private bodies. Without directly meeting others physically, our ethics languishes. Face-to-face communication, the fleshly

bond between people, supports a long term warmth and loyalty, a sense of obligation for which the computer mediated communities have not yet been tested. (1992: 75–76)

Heim conjectures that the intrinsic ambiguity of cyberspace "may amplify an amoral indifference to human relationships" since electronic life permits us to "'hav[e] it both ways,' keeping a distance while at the same time 'putting ourselves on the line'" (1992: 76). Perhaps Heim is thinking here of the fraught identity of people such as Julie, or of the anonymity and surprise of cyber-rape.

Heim's caution anticipates a diminished sense of community with the expansion of on-line geographies, an inevitable "loss of innocence" that comes with the cynical recognition that trust is no longer possible, or perhaps even appropriate. Although he makes no mention of the phenomenon, we can presume that in the computer "bot" even Heim's worst fears are exceeded. These programs inhabit virtual communities as actual personas and their conversations can be sufficiently credible to convince their interlocutors that they are indeed real people. These instances of impersonation satisfy Alan Turing's test of machine intelligence, a situation that leads Sherry Turkle to surmise:

> the test has begun to seem less relevant. What seems most urgent now is not whether to call the machines or programs intelligent, but how to behave around them. Put otherwise: Once you have made a pass at an on-line robot, can you ever look at computers again in the same old way?[6] (1995: 36)

Turkle's position sounds positively playful when read against Heim's pessimism, and his bleak view is also discordant with Benedikt's delight at the prospect of virtual existence. Nevertheless, it is noteworthy that both Heim and Benedikt seem equally convinced that some experiential essence will indeed be sacrificed as we move into virtual worlds. Whereas Heim laments and worries about its passing, Benedikt celebrates the possibility of its enhanced retrieval.

A battery of assumptions about the significance of corporeal substance obviously motivates these different readings. It is interesting that the nature of corporeal substance *as such* is not the matter of contestation: the debate concerns the body's ethical valuation as either expendable or necessary. Within the *déjà vu* of contemporary criticism, however, it would be naïve to think that the political and ethical quandaries that accompany these new technologies have not been with us for some time. The geography of cyber-

space is not the only "place" whose legend acknowledges such things as the dispersal of the subject, the material efficacy of representation, the problematic nature of the body, the critique of production as causality, and the critique of Cartesian space as a composite of separable coordinates. Despite these attempts to displace the felt belief that the nature of quotidian existence is self-evident and uncomplicated, however, the emerging literature on cyberspace seems to instantiate it all the more robustly.

Although we have seen that the complex nature of identity *in* cyberspace is a topic for discussion, this is balanced against the view that what constitutes identity in other situations must be unproblematic. We witness this in the origin stories that invariably accompany these technologies. An origin is identified and its purported stability and simplicity are made the departure point for an evolving technical complexity. Degrees of distance from this origin are then interpreted as degrees of difficulty, as if history is the incremental repair of an original shortcoming. There is a sexual metaphorics in this conceptualization of progress that sees mind in terms of masculine control, separating itself from a body feminized as its natural, dumb support. The presence or absence of complexity is also informed by this sexual diacritics. But why should nature be deemed immutable and lacking in complexity, or why, if we concede that nature is indeed complex and mutating, are *these* intricacies considered separate from other expressions of complexity?

This refusal to include the identity of "nature" and of "the feminine" within the problematic of identity explains why the nature of flesh is considered self-evident, that residual "something" that technology is articulated against. It is as if we can only appreciate the strangeness of cyberspace if our preconceptions about the dumb, corporeal weight of human existence and the naïveté of the historical past are reinforced. The mediating barrier of technology's prophylactic interface, tangibly present in the form of a computer screen, becomes the palpable limit that protects the future and its perceived possibilities from rein*carnating* the past. The matter of this interface, however, the body of the screen itself, receives no particular attention. It is assumed that an interface merely mediates one thing and another, separating two independent entities from each other in an economic process of valuation from which it is somehow excluded.

This process of installing barriers is persistent and ubiquitous. It involves the separation and privileging of the ideational over the material, and in such a way that matter is denigrated as the base support of an ascendant entity (mind over matter, male over female, culture over nature, the West over the rest, and so on). Given the masculinism and ethnocentrism that benefits from this mode of calculation, it is particularly surprising that, after several decades

of sustained intervention within the politics of representation, the new world of cyberspace/VR should so faithfully mimic the old. It feels like something of a tired cliché to repeat, yet again, that a value exchange conflates woman with the body as the natural residue of a complex process of individuation that differentiates, and hierarchies, both species and subject. Nature, cast as a prior state from which complexity has evolved, is consequently separated from the emergence of a transcendent notion of culture coded as masculine and cerebral. The political alignment of "woman," "native," "other" as the locus of originary substance is thereby infinitely rehearsed. Indeed, that most familiar division between representation and reality, figured here as the difference between the virtual and the actual, is secured through this same political hierarchy.

It has been widely recognized in much postmodern literature that the question of sexual difference is inseparable from the more general question of corporeality as such. And in the veritable industry of literature that engages the problematic of the body and the question of sexual difference in particular, the dualism of René Descartes's mind/body split is predictably criticized. It is difficult to fully appreciate the need to explore the mind/body division, however, if it is assumed that the division itself can simply be rejected, as if a quick condemnation of Descartes will afford the critic a protective talisman against the evils of dualisms. But, writings about the new technologies are replete with such gestures, and Allucquère Roseanne Stone's discussion of cyberspace affords a clear illustration of this. In her closing hesitations about a future *post*corporeality, Stone acknowledges that cybernauts tend to rejoice uncritically in their Cartesian inheritance, an inheritance that would regard the human body as "obsolete, as soon as consciousness itself can be uploaded into the network." According to Stone, "Forgetting about the body is an old Cartesian trick" and the cost of this effacement is traditionally born by "women and minorities" (1992a: 113). Stone even warns us that "[a]s virtual systems burgeon, it is critical to remember that decoupling the body from the subject is an act that is politically fraught" (1992b: 620).

Stone's advisory appears to acknowledge a possible problem and to flag its dangers. Yet her argument is especially curious in that her critique of Cartesianism is its faithful repetition: Stone argues that the subject can indeed be decoupled from the mere housing of its body and "uploaded into the network." Stone's foil to what she regards as the "Cartesian trick" comes in the reminder that "virtual community originates in, and must return to, the physical" (1992a: 113). Yet, dualist thinking is still very much present in the notion that the locus of subjectivity—agency and self—inheres in mind, and that this site of reason has an essential independence from, and ascendancy

over, the matter of the body. Stone's concession that we must inevitably return to the physical implies that at some point we successfully took leave of it. Similarly, her insistence that "[n]o matter how virtual the subject may become, there is always a body *attached*" (111; emphasis added) understands personhood as a divided composite of mind *and* body, where the body is the separable outer envelope of the *cogito*. Perhaps it is worth returning briefly to the Cartesian trickster himself to see if Stone's understanding of the mind/body split is significantly different from Descartes's.

In both the *Discourse on Method* and *The Meditations*, Descartes investigates the mystery of what today we might call "the subject"—that is, our sense of self, personhood, and individual identity. Descartes strives to establish the incontrovertible proof of his existence and concludes, at least to his own satisfaction, that in essence man is a thinking being. For even when he doubts his ability to establish the proof of his existence, he cannot doubt that he doubts; and in doubting he thinks. Descartes locates what is peculiar to human existence by separating the matter of the body from the mind. He believes that the human body is the shared stuff of animal existence; and inasmuch as animals are incapable of human achievement, he determines that the human body is extraneous to the process of reasoning. Descartes further underlines the absolute autonomy of mind by insisting that thought is not derived from "the power of matter" for reason "must be created expressly" (1968: 76).

In the following passage, Descartes's position is made quite clear:

> [T]here is nothing that this nature teaches me more expressly, or more sensibly than that I *have* a body.... Nature also teaches me by these feelings of pain, hunger, thirst, etc., that I am not only *lodged* in my body, like a pilot in his ship, but, besides, that I am *joined* to it very closely and indeed so compounded and intermingled with my body, that I form, as it were, a single whole *with* it. (1968: 76; emphasis added)

Descartes's understanding of the conjunction between mind and body is considerably more nuanced than Stone's. Nevertheless it should be apparent that Cartesianism is repeated and not repaired in Stone's earlier admonition, "[n]o matter how virtual the subject may become, there is always a body *attached*." My point here is that the problem of the mind/body division and its insidious political agenda does not derive from splitting itself—a process, after all, whose result enables the separation of the corrective from the error. Rather, the problem resides in a mode of calculation whereby splitting is presumed to isolate two self-present entities; and differentiation, or splitting as

such, is instantiated as one seamless cut. Thus far, the literature on VR/cyberspace, despite its attention to the vagaries of identity, remains committed to a recipe of self-present ingredients.

We gain a sense of this when we recall that Stone regarded the very possibility of Julie's ambiguous identity as something peculiar to virtual space, a situation whose novelty was underlined by the fact that only the prescience of the computer programmers could adequately anticipate such complications. The same assumption explains Heim's anxieties about the ethics of on-line existence "outside of embodied presence." It is strange that these discussions rarely make mention of the technology of the book, with its attendant problematic of authorship. It isn't at all apparent why the ambiguous nature of Julie's identity should only arise from the electronic and not the printed word. Although Stone's genealogy of the virtual began with "virtual witnessing," an acknowledgment of the reader's entry into an experiment through a written representation, she does not regard written representation per se as a virtual technology. Benedikt and the mavens of hypertext concur with this view, explaining that books should not be deemed proper cyberspaces because "they are not constantly open to multi-use or to change, and do not themselves 'know' that they are being read" (1992: 190).[7]

Cybernauts regard the letter as dead because it seems inert. But, the inherent instability of textuality, the involvements of identity and the life of the letter, have become the very stuff of contemporary intellectual inquiry. Reading differentiates an object from itself through a veritable electricity of inter-relationships that sunders the unity of both the interpreting subject and the interpreted object, just as it questions their separability. The very status of what constitutes knowledge, together with the notion that knowledge is locatable, is placed "on the line" in a plethora of critical approaches.

Any critique of the metaphysics of presence soon discovers that the complex ambiguity that Stone and others consider peculiar to "virtual identity" can be generalized to include any identity claim. In other words, there is something alien within all identity that fractures its unity. If we attend to the ramifications of this claim, then the face-to-face meeting in which Heim secures the very possibility of ethics, the "primal source of responsibility, the direct, warm link between private bodies," is curiously qualified. To put this another way, "keeping a distance while at the same time 'putting ourselves on the line'" describes the constitutive paradox of all subjectivity, where identity is made fragile in an immersive incorporation within otherness, a virtual technology of sorts. What, then, does virtual reality measure itself against in order to realize the special nature of its millennarian promise?[8]

Yet if we grant that (the nature of) existence is a virtual technology, does

this then imply that so-called primitive existence has always been something of an "on-line" computation? If the importance of this question is conceded, however provisionally, we then have to reckon with the suggestion that the "off-world" territories of cyberspace were not necessarily empty prior to our arrival. But perhaps our understanding of what constitutes an arrival, and our assumption that space is an empty entity that awaits occupation, deserves reconsideration. As mentioned above, narratives of discovery are figured around the finding and filling of an absence. The following comment by Jaron Lanier demonstrates this way of thinking: "Columbus was probably the last person to behold so much usable and unclaimed real estate (or unreal estate) as these cybernauts have discovered" (cited in Biddick 1993: 47).[9] The "here" and "now" locatability of Cartesian existence is the spatial fact against which cyberspace geographies measure the wild novelty of their apparent dispersion. But what is it that compels us to believe that the diverse geographies of space/time have ever been stable or fixed in some congealed stasis that awaits the convulsion of conquest?

Given the comparisons that are drawn between cyberworlds and the colonization of the "new world," it is helpful to recall an anthropologist's musings about the creeping infection of western technology upon native existence. In Claude Lévi-Strauss's poignant meditation on the passing innocence of the Amazonian Nambikwara, we see his nostalgic investment in the idea of an unchanging origin whose virtue falls vulnerable to the onslaught of technology (1973). As a people without writing, the Nambikwara were regarded by Lévi-Strauss, as ignorant of the violence of the letter, the violence and perversion of mediation/writing. Not unlike Benedikt and Heim, Lévi-Strauss mourned the inevitable passing of their trusting innocence. Jacques Derrida, however, is unconvinced that life has ever been an expression of pure and inviolate immediacy. He analyzes the political investments in Lévi-Strauss's perceptions, questioning the anthropologist's assumption that speech, unlike writing, is innocent because full, as if meaning is transparently accessible and unmediated in the here and now of the breath (Derrida 1984: 101–140). The spoken word is regarded as truth*ful*, honest, and uncorrupted, just as for Heim the visibility of the face, the fact of embodied presence, is thought to bear witness as the face of truth: the fact of flesh.

Derrida's point is that what is posited as the origin, in this case speech (although this question of origins will also include the flesh of the body), articulates the involvements of writing. Given this, Derrida questions the notions of space and time that enable the speech/writing split to be interpreted as a separation of different, and evolving, complexity. Ethnocentrism interprets this difference as a lack of complexity, as if the technology of the

written word is a supplement, indeed, a re-presentation of, speech.[10] Derrida insists, however, that there can be no such thing as a people without writing, for the graphematic structure underwrites existence itself.

When VR writers assume the body's attenuation within these new technologies, they actually deny the problematic nature of corporeality. Amid the hoopla of debate that divides into exhilaration or panic over VR as augmentation or loss, extension or reduction, both sides of this skirmish seem already to know what it is that will be enhanced or diminished. But whether the body is rendered absent, heterotopic, or just plain strange in virtual worlds, it is precisely this mutability that would tend to preclude it from anthropological study. For within the traditions of anthropological inquiry, the interpretation of cultural difference is made possible through the unified perceptual locus of the ethnographer's body, a body believed to occupy the same time and space coordinates as the ethnographer's interlocutors. Indeed, the value of fieldwork is grounded in the shared immediacy of a corporeal guarantee that concedes no difference. The human condition is presumed to be the shared horizon of immutable matter (the body in nature) that mind (culture) variously interprets. It is the reality of this passive, universal biological substance, thought to be separable from the context of its cultural informing, that makes cross-cultural and historical research possible. The entire arena of Cultural Studies, predicated as it is on the fetishization of "culture" as a delimitable entity, *naturally* insists on the mind/body division as the very basis of its possibility.

As there have been many attempts to shift the logic of the mind/body, culture/nature split, perhaps we need to reassess exactly what might constitute a successful intervention. Stone's attempt to criticize the violence and political implications of Cartesian dualism certainly suffers from a general incomprehension about the division's difficulty. Yet it is quite obvious that Stone is not alone in this inadvertent repetition of the problem.

A quite different perspective on the puzzle of VR, and one that is not shy in engaging the political difficulties of corporeality that many other writers have ignored, is presented in Zoë Sophia's "Virtual Corporeality: A Feminist View" (1992). Sophia locates the origin of VR technology in military desires, but regards the relationship between origin and end as sufficiently perverse that this violent beginning is "no sure predictor of future" (11). But, Sophia's sure determination of past in this construction of VR's murderous, and relatively recent, origin excludes the ludic dimension of this technology's genealogy as well as the long historical stretch of its problematic. Invention is an historical becoming, an articulation of a body of complex forces whose entangled grammar thwarts the possibility of a unified origin. I men-

tion this here because if the puzzle of VR condenses around the problematic of the interface, a question about relationality and identity, then the question of the partition is already rehearsed in the notion of origin and end, cause and effect—the assumption once again that history is a lineal succession of separate moments in time.

As with other commentators on VR/cyberspace, Sophia's analysis of the various seductions of this technology also turns on the logic of the fetish. But whereas Stone, Heim, and Bendikt tend to ignore the political underpinnings of their approach, Sophia self-consciously addresses its patriarchal investments. Sophia reminds us that fragmentation, by its privileging of part over whole, is the symptom of an instrumental reason that denies the complex, mutual indebtedness of things. The masculinism of this "tyrannical synecdoche" alienates knowledge from the felt and embodied situation of its production. The computer microworld, an exemplary instance of this alienated separation, installs an "abstraction from the reality of the whole body" that facilitates a sense of mastery and domination (Sophia 1992: 13).

Sophia specifically engages several psychoanalytic notions of the fetish in her discussion of the seduction of transgression. Describing the fetish as a transitional object that defies easy location, an object that breaches the border between self and other and subject and object, Sophia decides that the computer is "arguably more transitional than most" (1992: 13). Sophia also endorses the view of Stone et al. that subjectivity is a unity whose integrity is only fractured by a fractioning machine. For these writers, it seems that subjectivity has only become problematic with the calculus of the computer:

> Computer writing erodes distinctions between original and copy, the text and the writer, and can proliferate differences between writers and personae (as in computer networks), upsetting conventional understandings of authorship. These transitionalities have excited some cultural critics, who find in them evidence that computers are machines for producing postmodern forms of subjectivity. (Sophia 1992: 13–14)

Sophia notes that human-computer interaction is already sexualized because the computer is fetishized as the body of woman, a point that Howard Rheingold's term, "teledildonics," underlines.[11] Sophia perceives the feminine associations of "mother boards," "consoles," and "user friendliness" as contemporary expressions of a very ancient, masculine anxiety about the nature of the maternal body:

> Masculine envy of, and identification with, maternal fertility fuels the subli-

> mation of infantile epistemophilia into cultural quests to discover or create new bodies of knowledge, land, resources, or technique as brainchildren and substitutes for the mother's body. In the Athena myth, female fertility is cannibalised and upwardly displaced onto intellectual production; the (masculine) brain is equated with the (maternal) womb, and produces a new body from the cannibalised mother. (1992: 14)

The argument closes with the suggestion that we might yet achieve a politically whole-some engagement with cyberspace technologies through a "more dialogical and negotiated style of interacting." In this reading of history as a relentless male appropriation of female fertility, it is not surprising that the likely mavericks of these different communication genres turn out to be women.

Yet Sophia's reading of the psychoanalytic itinerary of male subject formation is misleading. She assumes that the inability to properly cut from the mother's body, refigured here as machine, is the mark of masculinity. Against this view of male confusion, woman appears as a self-possessed, pragmatic realist whose subjectivity is to be privileged because she can naturally resolve what is properly owed to the maternal body. Sophia's position expresses a general anxiety about sexual ambiguity, as if ambiguity is a problem to be overcome. This confusion can never finally be resolved, however, because it witnesses the debt and condition of identity itself. Whether "male" or "female," subjectivity is a processual becoming that never fully arrives, just as the copulation within and between bodies is an involvement that dissolves the possibility of autonomy. The implication of this is that feminism is not the redemptive "other" to masculinism's demonology, for exactly what identifies feminism and masculinism cannot be adjudicated in this way.

Within the copulative logic of our Cartesian inheritance, the generative interface is figured as a union between two discrete entities, entities that come together and then separate. The difference that this joining articulates is a difference that measures distance between pregiven entities. This is the logic of one plus one, a logic that fetishizes difference as something extraneous and detachable, an excess that either augments the unity of identity or restores it to plenitude. Tidy borders delimit time from space, origins from ends, causes from effects, then from now, and one from two. The nature of one is seldom in question. But the phenomenon of virtual reality/cyberspace surely invites us to acknowledge the differential *within* unity, a copula-ting enmeshment that is never not pregnant in the delirium of becoming other. This invitation is profound in its suggestiveness because it does not confine

itself to a particular, so-called new technology, nor can it be periodized as postmodern. The ramifications are ubiquitous and complex.

Sophia's discussion of technology as the violence of synecdoche is salutary because it draws us into the possibility of a more provocative reading. She explains masculinism's need to sever part from whole, a denial of the generative debt to the body that allows the management and control of an abstracted microworld that is thought to be independent of it. This is an important point, and one that received little attention in the early literature.[12] Sophia's concern is that the body should not be forgotten but given its rightful value as irrefutable and necessary origin. But how different is this from Stone's admonition that virtual existence should acknowledge that the physical body, the supplement of the mental apparatus, is always "attached?" For Stone, the identity of the body remains intact, severed from the difference of its mental part, which is free to inhabit "a geography of elsewhere." Despite Sophia's criticism of the separation of part from whole, her argument is yet another fetishization. From a different perspective, this whole is just another part—a synecdoche of a synecdoche whose ecological stretch unfolds into the great body without organs. Sophia doesn't question the masculinist alignment of matter with mother—the phallocentric need to interpret the nature of matter as the matter of nature. In fact, rather than question the political agenda that motivates the desire to define and to contain matter with/as woman, Sophia insists upon it. As a consequence, the mind is masculine, the body as generative womb is properly feminine, and matter out of place is discovered in the misuse of maternal metaphors to explain the fertility of cerebral life.[13]

My disagreement with Sophia does not concern the obvious displacement in this re-membering of maternity as masculine fertility, a re-membering that forgets and denigrates matter by privileging the ideational over the physical. I want to argue, however, that the issue of value and our debt to the generativity of corporeal connection is poorly understood if the sexual violence of the opposition is simply reversed. The value of the female (body) cannot be appreciated if the male body is deemed lacking and diminished in fertility. Nor is it acknowledged by resolving that mental life is not physical life. The presumption that the material and the ideational are two conjoined realms, each attached to the other, must be contested if the question of corporeality is to be opened. The sexualized and racialized othering of matter as "lack" will inevitably reappear if the problematic of matter is confined to the question of its revaluation. We also need to ask how the in-itself of matter can be determined *before* the process of valuation, before the process of identity formation.[14]

Corporeal existence is generative and generous in its inclusiveness; an infinite partitioning, mediated from and within itself; an animated representation whose fractured mirroring includes cellular and atomic life. The intricate embrace of these recognitions is the matter of corporeality wherein recognition, a virtual splitting, is the stuff of reality. The difficulty here is that what might be called a hologramatic involvement of the ideational within the material, an implication that dissolves the self-evidence of each, is not simply comprehended.[15] This complexity is inadequately declared in the suggestion that the corporeal is corporate—that is, not body, but bodies. This conclusion can displace the need to think "the how" of connection, the labor of the body of the interface that is differentiating.

An example of this is in the hybrid impurity of the cyborg, a creature that seems to offer a good representation of this intrinsic contamination. In its strange unity, animal melds with human; silicon and metal sustain bone and muscle; and edible chemistries chatter and intervene in the rhythms of biological dialogues. Donna Haraway celebrates the cyborg as a creature whose sheer excessivenes, its "monstrous and illegitimate" identity, promises a different political horizon:

> An origin story in the "Western," humanist sense depends on the myth of original unity, fullness, bliss and terror, represented by the phallic mother from whom all humans must separate . . . both Marxism and psychoanalysis, in their concepts of labour and of individuation and gender formation, depend on the plot of original unity out of which difference must be produced and enlisted in a drama of escalating domination of woman/nature. The cyborg skips the step of original unity, of identification with nature in the Western sense . . . Nature and culture are reworked; the one can no longer be the resource for appropriation or incorporation by the other. The relationships for forming wholes from parts, including those of polarity and hierarchical domination, are at issue in the cyborg world. (1991a: 151)

The image of the cyborg has inspired critical discourse because its volatile instability, its unfixed contours, and its internal incoherence promise to disrupt the conventional politics that organize and legitimize sexual identity in terms of impermeability versus access, penetration versus reproduction, activity versus passivity, male versus female, culture versus nature. The identity of the cyborg is regarded as monstrous because there is nothing about a cyborg that can be regarded as essential. Yet in *out-lining* the peculiar transgressivity of the cyborg's identity, we see that the gestalt of its legibility appears through the logic of A/-A, a logic that conflates difference with absence.

Given the many disclaimers to the contrary, it is ironic that the cyborg is perhaps the most recent of Cartesian recuperations. Haraway's insistence that "[t]he cyborg skips the step of original unity" forgets that it is against the the unity of "the before," the purity of identity prior its corruption, that the cyborg's unique and complex hybridity is defined. Haraway doesn't interrogate the nature of the interface between the cyborg and its "other," or the implicit temporal and spatial hierarchizations of this differentiation. Haraway's "disassembled and reassembled" recipe for cyborg graftings is utterly dependent upon the calculus of one plus one, the logic wherein pre-existent identities are *then* conjoined and melded. The cyborg's chimerical complications are therefore never so promiscuous that its parts cannot be separated, even if only retrospectively.[16] Put simply, for Haraway, there once was not a cyborg.

Although Haraway celebrates the denaturalizing of nature and its promise to undo the political knot of the nature/culture opposition, the division surreptitiously reasserts itself. For example, in response to certain anti-essentialist feminist and cultural critics who maintain a deep suspicion of biology, Haraway justifies her own efforts in this field in the following way:

> [B]iology is not the body itself, but a discourse. When you say that my biology is such-and-such—or, I am a biological female and so therefore I have the following physiological structure—it sounds like you're talking about the thing itself. But, if we are committed to remembering that biology is a *logos*, is literally a gathering into knowledge, we are not fooled into giving up the contestation for the discourse. (1991b: 5)

This signature of postmodern criticism, namely, that language constitutes its object, underwrites Haraway's view that discourse mediates the body itself. According to Haraway, biology is not a natural determination because it is a *logos*, a representation, a knowledge claim. And in this assertion Haraway reinstalls the logocentric assumption that the arena of thought is circumscribed (culture) and different, or separate from, the body (of nature). This vote for the volatility and political healthiness of discursive contestation preserves the notion that the substance of life remains on the other side of the agential, on the other side of its political in-forming.[17]

The desire that form will finally divorce itself from substance is the aim of many cybernauts in their dream of uploading consciousness into the matrix. The autonomy of form and substance and the temporal priority of the latter organizes all origin stories and perpetuates their conservative agenda. Haraway's attempt to avoid the sins of history by dispensing with the origin is, finally, unsuccessful, for the nature of the origin cannot be sepa-

rated from the question of identity itself. The complex identity of originariness already incorporates the monstrous impossibility of the cyborg.

Another mode of engagement with cyberspace technologies might query their description as altogether new, potential, promising, fantastic, or illusory. For surely the divisions of culture and nature, and mind and body, are already conceptualized in terms of technology. The mind/body division presumes supplementation, articulation, interfacing, and progress, such that the body is figured as a tool or as an instrument of the mind. Given this larger context, we might consider the bodying forth of the virtual as a rearticulation of matter—indeed, the matter of rearticulation. By opening the question of matter in this way, sexual difference can no longer be posed on one side of the computer interface and settled on the other, as the faithful recapitulation of Cartesianism within VR literature would assume.[18] Our attempt to rethink corporeality in a way that wrests it from the role of dumb and passive container will need to grant that the body is already a field of information, a tissue of scriptural and representational complexity where deceptions, misrecognitions, and ambiguities constitute the virtual logic and language of bio-logy. The possibility of deception doesn't simply arrive with cyberspace or with comparative situations where the face-to-face guarantee of unmediated bodily presence is removed. There never was an unmediated integrity *before* difference. Instead of mind *and* body, the conjunction that assumes that difference happens at *one* interface, *between* entities, we might think the body as myriad interfacings, infinite partitionings—as a field of transformational, regenerative splittings, and differings that are never not pensive.

Flesh, blood, and bone—literate matter—never ceases to reread and rewrite itself through endless incarnations. Is it possible that the intricate code of this vital script is entirely enmeshed within the fantastic apparitions of the virtual worlds of cyberspace? What if the body's vital signs involve the pulse of elemental passions, passions whose ubiquity unfolds within a very different space/time from which nothing is divorced? Perhaps we can heed the challenges of VR and cyberspace technologies if we interrogate the attempt, by both its critics and its advocates, to either diagnose or celebrate its lack of substance.

Conclusion

Cannibal Subjects

The assertion that discourse constitutes its object, or that there is no outside of language, is now commonplace within interdisciplinary scholarship. Close attention to the workings of language and of representation has undermined the self-certainty of the Cartesian subject and emphasized the contingent nature of knowledge and of truth. Disciplinary subject divisions are increasingly difficult to maintain as a result, especially as the dissolve and mix of Cultural Studies, Gender Studies, Performance and Critical Studies have achieved academic legitimacy. The destabilizing possibilities of intellectual work that discovers a constitutive incoherence in both "the knowing subject" and "the subject known" is increasingly clear, even if many of its practitioners continue to feel besieged and isolated within conservative institutions. Yet, the political desirability of destabilizing the identity of "the subject" and its normative prescriptions is often argued in a way that excludes the possibility of destabilizing the identity of power itself. How, for example, do we credential a particular mode of engagement as politically savvy and presumably preferable if the grounds of truth, intentionality, judgment, and responsibility are so entirely compromised? We are used to recognizing the signature of a writer's attempt to be so credentialed in certain conventions. It is manifest in the choice of a particular vocabulary, in the kinship connections with certain proper names, and in the conceptual alignments that authorize specific forms of writing as *critical* writing. If, however, the question of identity is the enduring subject of all of these inquiries, then the identity of "the political" must be similarly fraught.

In previous chapters I have tried to engage this problem in the face of a growing unease that what had once provoked and enlivened my intellectual interest has now congealed into a *doxa*. It seems reasonable to assume that the critical purchase of any discourse will inevitably collapse under the burden of maneuvers made predictable through repetition. But simply to denounce this

repetition would involve another repetition, and precisely the kind of doxa whose stale predictability Roland Barthes described nearly twenty years ago: "[A] *Doxa* (a popular opinion) is posited, intolerable; to free myself of it, I postulate a paradox; then this paradox turns bad, becomes a new concretion, itself becomes a new *Doxa*, and I must seek for a new paradox" (1977a: 71).[1] In what follows I want to explore the question of the subject again, but in a way that might offer some resilience to "turning bad" too quickly. It will involve certain risks, though, because it challenges the very notion of "political usefulness" that might otherwise be deployed to assess its value.

My first appreciation that the world of my perceptions was not at all self-evident, but instead, a complex inheritance of cultural determinations was intoxicating. Postmodern criticism represented an assault on the very possibility of a reality check. And as there was so much about reality that was incontrovertibly ugly and downright unfair, this shift in my understanding was a promising and more hopeful one. Of course, "postmodernism" is an impossible term. As a category, postmodernism is so ambiguous and elusive, so apparently homogenizing about things heterogeneous, that as description it is almost useless. It is a problematic site because it is a site of problematics.

Negotiating the strange territory of postmodernism's discursive formations presents certain difficulties, for what grounds postmodern discourse is a deep skepticism about the nature of all grounds and of all origins. It seems that the bare facts of nature are never revealed, for it is the dissembling art of culture to masquerade as natural foundation. The nostalgic desire to return to the origin is therefore regarded as an impossible endeavor, a sign of theoretical naïveté and of political conservatism. What positivists and empiricists might regard as originary, or causal, is understood as a secondary, interpretive effect within what I am going to call, for the sake of analytical convenience, postmodern criticism. According to the latter forms of theoretical engagement, if there is no outside of representation, then the mirror of its production must be recognized as a total seduction from which there is no escape.

However, it seems to me that some reassessment needs to be made regarding the implications of exchanging nature for culture, reality for representation, and originary cause for interpretive effect. The reversal of several other binaries in critical discourse has also begun to "turn bad," as Barthes might say, becoming more paralyzing than enabling in their prescriptive routine. We are surely accustomed to finding the following lessons peppered through critical work like a catechism that might offer protection against the taint of political conservatism: universal knowledges stand condemned by sit-

uated, local understandings; anti-essentialism provides a remedial against essentialist reductionism; and political practices are authorized as *properly* political through descriptions that emphasize their materialist rather than, one might assume, their idealist appeal. Such claims are pervasive within much contemporary criticism, operating as a sort of shorthand sign-posting to what will count as critical engagement.

My increasing impatience with the morphology of such arguments is in some ways born from my sympathies with them. The problem is this: A very real, conservative determinism is certainly at work whenever nature is made a synonym for what is "given," presumed to be immutable, and therefore beyond question. But, the assumption that this conservatism is answered by conceding all efficacy to what we might suppose instead has been given by culture is an inadequate response. How is the notion of "the given" itself engaged in this simple relocation? In the flip-flop from cause to effect, our notions of causality and production continue to remain quite stable and straightforwardly comprehensible. Indeed, it is in the anticipation of full comprehension, that is, from pompous claim to humble fact, that the shift from universal to local knowledges is made.

Various theoretical approaches that fall within the loose description "postmodern" emphasize that *the humanist subject* is actually decentered, that the individual cannot secure his or her identity through intention, and that individuation as such is necessarily contingent. How *the subject of humanness* recognizes itself as a unified subject, individuates itself within species-being, and identifies itself as possessing sufficient stability to ground the destabilization of grounds, however, is entirely unclear. The inevitable implication is that instability can be localized. Antihumanist interventions recuperate the notions of will and agency from the slippery slide of the subject's intentional insecurity in the form of the individual's enlarged identity—as History, the Social, the Cultural, and so on. The problematic of identity is confined to the contents of culture and what is considered peculiar to the human condition, a condition held hostage to language.[2]

Even as the constraints of representation are noisily lamented, the assumption that language is an essentially human technology is underlined. The human condition is one of mediation, a state quite different from the separate substance of primordial nature. The rampant culturalism of so much postmodern theorizing is clearly evident in this division, wherein the identity of culture, taken as the re-presentation of the world, is both given and received by Man. This gift is a prophylactic against contagion—it isolates the essence of Man by identifying him as absolutely different from that animal part of himself received from nature.

What is the place of feminism within the inadvertent Cartesianism of this postmodern calculation? Musing over this puzzle recently, I found myself returning to one of my disciplinary origins, or rather realizing, not surprisingly perhaps, that I had never quite left it. Within the discipline of anthropology, contemporary theories of the subject that draw on continental philosophy have not been embraced with much eagerness. Even within more critical and marginalized work such as postmodern and feminist ethnographies, the constitutive relationship between sexed subjectivity and the gendered economy that underpins the construction of knowledges, including anthropology, has received relatively scant attention. Anthropology's reluctance to engage the more radical implications of such work has meant that critical interventions within ethnography understand alterity as something recuperable, rather than as the problematic of translation, or as interpretation itself. Granted, the discipline's current rescue operation has induced new strategies. However, the resulting solutions eschew claims to objective knowledge by trying to represent the dialogical messiness, the experiential pleasure and unease, of subjective interchange in the fieldwork situation. In other words, feminist and "new" ethnographies project a future anthropology that will more adequately represent "the other," acknowledging the shared horizon of intersubjectivity that parlays different interpretations. These appeals to "the subjective" only appear remedial if the binary divisions between nature and culture, objective and subjective, and body and mind, are preserved.

Elsewhere, I have discussed anthropology's reluctance to acknowledge some of the most challenging implications of postmodern and poststructuralist criticism for rethinking difference. And this is a curious oversight for a discipline that might reasonably be described as the discipline of difference *par excellence*. Although my own inquiries into the question of difference began in anthropology, my increasing interest in continental philosophy's theorists of difference left me somewhat stranded and isolated. The vocabulary and approach of this material was largely unfamiliar, threatening, or perhaps just plain irrelevant to anthropologists. To illustrate this, I recall being on a panel in a session at the annual meeting of the American Anthropological Association (AAA) in 1993. The subject was the relevance of Jacques Derrida's work to the discipline. In the hundreds of sessions that had taken place every year at AAA, only one had ever been allocated to Derrida's work prior to this. My point isn't that everyone should find Derrida's intellectual endeavors compelling. However, I do want to suggest that this apparent lack of interest in a theorist whose work specifically addresses the complexities of translation, and the anthropological endeavor in particular, seems something of an interested oversight.

Given this, it is not entirely surprising that feminist anthropology has cut itself adrift from many of the complex theoretical debates that inform contemporary feminism's broader, interdisciplinary identity. It would not be unfair to say then, that the intellectual context that informs my own discussion of corporeality has been quite marginal to anthropology.[3] Anthropology's relative silence on this subject is explained by the unashamedly empirical nature of its enterprise. Put simply, the puzzle of representation rather gets in the way of things. And yet anthropology's reluctance to interrogate either the subject of representation, or the representation of the speaking subject, is perhaps balanced in turn by a certain blindspot in postmodern argumentation: the subject of "the anthropological" is not itself in question.

This last claim may seem somewhat curious until we consider that the vast amount of scholarship devoted to the crisis of "the subject" never specifies that it is concerned with the identity of the *human* subject. It is so obvious that "the subject" means, in fact, "the human subject"—that is, "the interpreting subject"—that it goes without saying. Although human identity underpins what we mean when we say "the subject," the exact nature of *this* identity is not included in the crisis of identity. For it is the unified subject of humanity who interrogates "the subject" and who decides the limit of the question's calculation. It seems that the subject of the anthropological, the self-present identity of humanness to itself, is the closed container within whose limits the breaching of limits (difference) can be risked.

Feminist interrogations of the categories "woman," "nature," "body," "essence," and the like have, however, begun to challenge the politics of this closure. They have significantly shifted the positionings of all these terms, together with their corollaries—"man," "culture," "mind," and "anti-essentialism." Within feminist critical theorizing, man has been dethroned as the sovereign subject whose self-definition excluded the mode of his own production. Yet even theoretically ambitious feminisms unwittingly tend to repair the sovereign subject through a politics of inclusion that would restore to humanity its full identity. Now sexually differentiated, the matter of the subject is thought to be fully addressed. This is a form of Cartesianism that, although writ large, installs its agenda without fanfare. We see, for example, that matter continues to be understood as the substratum to which the self-presence of humanity's cognizance of itself is *attached*. Postmodern concessions to cultural diversity also rely on a logic of inclusion, a recognition of difference within the homogeneity of humanity. In both cases, the substance of "the subject" is carefully removed from the calculation of this difference.

I want to give a different address to the politics of "the subject" by returning to chapter 2, "Corpus Delicti: The Body *as* the Scene of Writing,"

in which I explored the work of several feminists who argued that biology is a necessary category in any feminist practice. Although these writers acknowledge the intimacy between biology and representation, I argued that in the apparent denaturalizing of nature a very traditional notion of biology was inadvertently installed as the disavowed foundation for their analysis. Through the neologism, "corporeo*graphy*," I tried to suggest that representation is "sensible" in that biology is not a supplementary ingredient to be included or excluded. The body is more than a mere visitor to the scene of writing: the body *is* the drama of its own re-markability. Re-membering the delirium of this scene of writing, a scene from which there is no leave-taking, I will try to register some related concerns in a slightly different tempo. To help me with this, I am going to refer to a writer who has consistently challenged the doxology of much contemporary criticism.

In a special issue of *differences* devoted to essentialism, Ellen Rooney interviews Gayatri Spivak and asks her to comment upon certain difficulties that seem to endure within feminist theorizing. On the enduring and difficult question of limits, Rooney asks:

> How is this problem of the subject related to the relationship between essentialism and the efforts to theorize the body, or bodies ...? Can we theorize our bodies without essentialising them as the body? Is our confusion about how to theorize bodies the root of the problem of essentialism? ... [T]here is another factor that keeps the question of essentialism kind of bubbling ... the effort to biologize gender is not over in the general culture.... How is your own effort to address bodies in some of your work part of your thinking about essentialism? And how do race and class actually enter in here, as well as the more obvious gender? (Spivak 1989: 148)

Spivak responds:

> The body, like all other things, cannot be thought, as such. Like all other things, I have never tried to approach the body as such. I do take the extreme ecological view that the body as such has no possible outline. You know, again, *Economic and Philosophic Manuscripts*, where Marx, talking about species life, says nature is the great body without organs. You know, if one really thinks of the body as such, there is no possible outline of the body as such. I think that's about what I would say. There are thinkings of the systematicity of the body, there are value codings of the body. The body, as such, cannot be thought, and I certainly cannot approach it. (149)

As I understand Spivak here, her position is an acknowledgment of the complex systematicities, the systems within systems, of the body *as such*. As this involvement eludes the grasping, proprietorial demands of thought, Spivak discerns that it cannot be an appropriate object for thought. Corporeality, in other words, involves a difference that cannot be known. If, however, we want to disrupt the political implications of limiting the identity of thought to something that is quite separate and autonomous from what then becomes the residue of the body, then we might consider how the body *as such* already incorporates knowledge itself. Perhaps the lure of the body *as such* is a matter that cannot be refused, for the approach has already taken place.

Although Spivak refuses this approach her argument is sufficiently nuanced to enable a different conclusion. Of relevance here is the fact that Spivak is quite notorious for a certain pragmatic irreverence when it comes to what she regards as high theory fundamentalism.[4] This is clearly apparent from another interview, and interestingly one whose question covers a topic similar to the Ellen Rooney dialogue. Elizabeth Grosz inquires of Spivak, "I am interested in how to *use* universalism, essentialism, etc., strategically, without necessarily making an overall commitment to these kinds of concepts" (Spivak 1990a: 11). Spivak responds:

> You see, you *are* committed to these concepts, whether you acknowledge it or not . . . since the moment of essentialising, universalising, saying yes to the onto-phenomenological question, is irreducible, let us at least situate it at the moment, let us become vigilant about our own practice and use it as much as we can rather than make the totally counter-productive gesture of repudiating it. One thing that comes out is that you jettison your own purity as a theorist. (11–12)

Although I share Spivak's irritation over knee-jerk repudiations of essentialism and universalism, I am unclear about the nature of the difference between political strategy and political theory that Spivak assumes here. It is as if practice soils the pure expectation of theoretical possibility with its very groundedness. I am particularly interested in the theory/practice split as it pertains to the subject (of the) body.

Before I discuss this division in more detail, however, I want to make a detour via Jacques Derrida's "'Eating Well,' or the Calculation of the Subject." In this essay, the body as such becomes for Derrida an enlarged scene of "executions of ingestion, incorporation, or introjection of the corpse" (1991: 112). This conjures Artaud's evocative phrase again, a phrase more

recently associated with Deleuze and Guattari and used by Spivak to gloss Marx's notion that "Nature is man's inorganic body."[5] This "body without organs" is arguably as extreme in its ecological stretch as Spivak's "body as such [that] has no possible outline." Importantly, Derrida states that "nothing should be excluded," and proposes that this frenzied injestion implicates "'the nonliving' [with] the 'vegetal,' the 'animal,' 'man,' or 'God.'" (1991: 106). While Spivak shies away from approaching the "as such" of this generalized cannibalism, Derrida seems compelled to think with/in it, perhaps because he apprehends that he is also on the menu.

Derrida notes that this feeding frenzy is not an undifferentiated circuit of swallowings because a "carnivorous virility," a "*carno-phallogocentrism*," animates the scene (1991: 113). The suggestive difference between what could be called the "omni-phagy" of Derrida's "body as such" and Spivak's "body as such with no possible outlines" ("the body, as such, that cannot be thought") is that, for Derrida, thinking *is* in-corporation. What is infinite about the body with no outer limit can also be read as the sheer infinity of limits and (b)orders that are, at the same time, internal to the spacing of its tissue.

Questions of cultural and sexual difference become especially curious in this enlarged and involved context. I have argued elsewhere (1989b: 1989c; 1991; 1993) that ethnographic writing presumes a universal body as the ground of interpretation. And that even within the most self-consciously vigilant feminisms this same universal body, whose presence is actively disavowed, returns as the biological body of scientific discourse. In other words, if the matter of the body is quite naturally present for positivists and empiricists, this same body reappears, its naked truth culturally clothed, in some of the most sophisticated expressions of feminist critical theory. The material prop in these arguments is a body variously represented as "off limits." In feminist writings, for example, that rely on psychoanalysis to explain subjectivity, the body is veiled before or behind language. We see another version of this notion of spacing as distance in Spivak's insistence that the body as such extends outside or beyond thought.

Spivak's position is perhaps captured in a rather clever comment by Maurice Blanchot, who muses that

> there is an "I do not know" that is at the limit of knowledge but that belongs to knowledge. We always pronounce it too early, still knowing all—or too late, when I no longer know that I do not know. (Blanchot, as cited in Taylor 1986: 1)

For Blanchot and Spivak, thought has a limit that it is incapable of grasping. The line between what is either possible or impossible for thought is therefore

undecidable. Undecidability then, at least as the term is often used in critical discourse, doesn't necessarily deny that a limit is very much present. Rather, the term marks a limit, as presence to self, of the human condition's will to interpret, a will to reflection that is interned within the prison house of linguistic deception. In other words, we simply can't get outside the vagaries of our mediating representations.

The subject of "humanness" resides at the same address as the subjects of "language" and of "thought." But what happens if the problematic of the subject includes the subject of humanness, or species-being—that is, if it is conceded that identity is fuzzy because complexity cannot be contained? Complexity itself might be recast as the differential of thought/language, and this might enable us to render problematic the subject of humanness itself, as well as the nature/culture divide. The problematic of the subject would not, then, be founded on the separation of language/knowledge from the residue of nature—the material body of the world. Instead, the thought/natural language couple could be seen to be so entirely promiscuous that it invades whatever it is defined against. As a consequence, the nature of thought/language, and its corollary assumptions about the nature of man as that creature to whom language properly belongs, unravels into an interminable genetic debt. The skein of questions that flows from these unravelings cannot be knitted up into the familiar ego-logical understandings of subjectivity and intersubjectivity of postmodernism. Postmodern critiques of the subject argue for intrinsic dislocation and noncoincidence. However the question of subjectivity, although fraught, is usually answered much too swiftly by a return to/through man.

I am increasingly persuaded that the problematic of sexual and cultural difference has been made to obey the dictates of this analytical frame, caught as it is within an ethics and a politics, that install consciousness, or its inverse, at the fulcrum of their anthropocentrism. This economy of transactions is reinscribed in a context whose returns will not flow back to a center (at least not as swiftly) if we interrogate the *as such* that is always/already enlisted into our arguments as their very foundation.

Once again, I take my cue from Derrida here. In *Of Grammatology*, Derrida returns us to origins, to the nature of language "as such"—not in order to merely write about it, but to write it, to write "on" it—to reinscribe the textile of a different opening for another subject. And in "Eating Well," Derrida returns us to the "as such" of the subject:

> Why have I rarely spoken of the "subject" or of "subjectivity"? ... Because the discourse on the subject, even if it locates difference, inadequation, the

dehiscence within auto-affection, etc., continues to link subjectivity with man. Even if it acknowledges that the "animal" is capable of auto-affection (etc.), this discourse nevertheless does not grant it subjectivity. (1991: 105)

Of course, Derrida is not suggesting that the closure around the question of subjectivity will be opened if we generalize subjectivity as an attribute of man *and* animal *and* plant *and* stone. Rather, the provocation he offers is one of

ceaselessly analyzing the whole conceptual machinery, and its interestedness, which has allowed us to speak of the "subject" up till now.... [I]t is first of all necessary to submit to the test of questioning the essential predicates of which all subjects are the subject. (109)

But how might we achieve a return that will effectively reinscribe the origin that is consistently relied upon to bear the weight of our theorizations? My own work has "fastened upon" the biological body as a way to think through a *différential* logic that is not as easily recuperated for consciousness. In "Corporeal Habits," I engaged Irigaray's notion of the morphology of sexual difference. And as I now see it, the one sentence in that argument that most succinctly anticipates my current direction comes in the suggestion that "such is the implication of biology that Irigaray's *'poétique du corps'* might also be thought as biology rewriting itself." Perhaps, after "Eating Well," this generalized bio-graphy might not seem to cast quite as wide a net as a generalized geo-graphy (as the body of the world) might promise. It is there, after all, that the process of the rock's becoming human would meld with questions about the human becoming virtualized.

What can be gleaned from all this is that although the nature/culture division is both obstinate and enduring, it is constantly opening itself to reinscription. In an attempt to elaborate this further, I want to return to Spivak's argument regarding essentialism and the unapproachability of the body as such. Spivak explores the nature/culture problematic by referring us to Karl Marx's "Economic and Philosophic Manuscripts." Marx is enlisted because, as we have seen, he gave considerable thought to this notion of materiality writ large. But how is Marx's notion of materiality informed by the interventions of Derrida, Foucault, Deleuze, Irigaray, and others? If this sounds like a curious reversal of history's lesson, it is made in an attempt to disrupt the sort of evolutionary narrative that would, for example, position Marx as Derrida's deficient and less sophisticated precursor. It is clear that a grammatological reading of Marx is possible and that, in fact, Spivak herself has made significant contributions toward this.[6] Nevertheless, Marxian value

must remain restricted and closed against *différance* if difference is located at an *outer* limit, around the fuzziness of borders.

When Spivak insists that although the body as such cannot be thought, nevertheless "biology, a biology, . . . is one way of thinking the systematicity of the body," it sounds as though biology is a contained system. We are reminded here of Saussure's struggle to determine the nature of language wherein he imbued linguistics with a cohesive integrity that presumed it was an enclosed system. Believing that there was a perimeter, or out-line, to the entity of linguistics, Saussure felt no need to inquire into the "being-language-of-language." He did not inquire into "the becoming system of the linguistic system," a system that must itself emerge within differentiations. Given that Saussure's understanding of language was based on difference "without positive terms," he would have been faced with the fact that the world, in all its articulations, was the stuff of the language system. Acknowledging the workings of a force field whose frame of reference is everywhere present, we can turn Spivak's comment around and think biology as systematicity itself. What happens if we attempt this turn, where biology is a changing, *différential* script?

Spivak's comments about essentialism and biology in the same interview with Rooney are helpful here:

> I would look at why they're essentialising, rather than to say that "this is bad" necessarily, because I think there is something, some biological remnant in the notion of gender, even in the good notion of gender. Biology doesn't just disappear, except it should not be offered as a ground of all explanations. (1989: 148)

In one sense I don't disagree with what Spivak is trying to do here. But perhaps the political force of its challenge is further emphasized if the body "as such," even in its expression as "biological remnant," is read grammatologically. Within such a reading the biological body would never not be a ground of explanation. What we define as "the biological," however, would become (a) very different matter—matter different again from its interpretation in gender and feminist studies, cultural studies, and postmodern discourse generally.

I want to try to evoke something of the political shift that such a retake on the subject of "the biological" might demand and here Spivak helps me again. In the Rooney interview and elsewhere, Spivak argues that we must interrupt our theoretical directions in the face of pragmatic political necessities that might be overlooked by what can amount to the abstract rigors of

high theory.[7] But, if this so-called high theory includes an attention to grammatological implication, then it seems that the most careful critique of purity and the most nuanced thinking about "the political" can be the very stuff of these interrogations. When we suspend the critical rigor of "high theory," as if what counts as "the political" is a separable realm, a realm where the realities of practice and pragmatic necessity are merely framed by theory, we actually forfeit a political practice that has some resilience against normative recuperation.

I have tried to argue that sexual and cultural difference involves a terrain of difficulties that demand this sustained theoretical attention. And again, the difference that this might herald is illustrated in the Rooney interview. In her discussion of the vexed issue of how to deal with essentializing arguments, Spivak condemns sociobiology, cognitive studies, and artificial intelligence in the belief that naming these discourses "politically offensive" will help in "undermining the vanguardism of theory" that would "wait to theorize essentialism in order to say that" (Spivak 1989: 142). Yet, the complex nature of "textuality" in its refiguring of the materialism/idealism or nature/culture split is not acknowledged if we feel satisfied with the ready appeal of such dismissals.

The difficulty is this: The political force of prescriptive and essentializing discourses is not confined to the validity of their truth claims. The matter of essentialism exceeds the politics of correction because the body as the scene of writing is an inscripting of *all* essentialisms, even of the politically offensive. With/in the complexity of the resulting weave, the stuff of essence is rearticulated: it is no longer a simple unity whose efficacy is directly legible. The substance of a discourse endures its rejection because the production of the trace is a labor of in-corporation where nothing is excluded. To "just say no" is to refuse to open the question of matter and to return the politics of representation, despite the vocabulary revamp, to the narrow confines of ideology critique.

Although my argument seems to have fastened upon the problematic of essentialism and sexual difference, it certainly extends its ramifications to the politics of cultural difference. A more careful elaboration of this argument will need to be undertaken, an elaboration that can show that, despite its necessity, the corrective alone is an inadequate critique of colonial discourse. Such an undertaking might question the battery of observations epitomized by Edward Said's critique of Orientalism, where Orientalism is read as an error of representation whose effects, albeit with difficulty, can be disengaged. However important and necessary these interventions are, such accounts consistently repress the productive efficacy of the trace, the mani-

festation of its "bodying forth." "The corrective" also underestimates what can be an empowering mutability that inhabits these same "wrong" writings.[8] In sum, the politics of representation are always implicated in a constitutive economy that exceeds the classical notion of mediation and identity. The determination of the culturally different subject, though a problematic designation, must remain a vexed one if we are to take seriously our responsibility to "protect the other's otherness" (Derrida 1991: 111)

Within the terms of my argument, the specificity of location as a "corporeography" cannot be delivered up once the errors of globalizing oversights have been cleared away. I have tried to argue for a notion of specificity that is different again from what is conjured in recent calls for situated knowledges and the need for a politics of location. There is a need for critical vigilance against the return of the *cogito* as the subject who only speaks for him or herself. For the politics of situation and location, with the infinity of coordinates that produce the re-markability of the body, are entirely reduced in this reversal of the universal/specific binary. The problem involves doing something more than merely replacing what inflates itself as a universal perspective with what humbles itself as a particular and merely individual one. Even a particular point of view is never a simple unity: it is always and necessarily different from itself, dislocating and displacing the very property of *one* point of view.

Can we question the nature of humanity's point of view in a way that will address the subject differently? How is the subject of the political changed, as indeed, the very notion of thinking itself, if we open logocentrism, phallocentrism, and ethnocentrism through the question of anthropocentrism? If the subject of humanness as such is opened to a generalized *corporeography*, perhaps the politics of the subject can be *substantially* reconceived.

Notes

Introduction

1. For more information about this ritual, see Singhan (1976). Of related interest, see also Donna and Grosvenor (1966); and Kosambi (1967).

one Corporeal Complexity

1. All citations from the *Course* will refer to this translation. For a more recent interpretation see Harris (1983).
2. For a list of resources that were available to the editors, as well as references to subsequent writers such as Robert Godel and Rudolph Engler, who attempted to retrace an accurate archeology of the *Course*'s history, see Gadet (1989: 21–24); and Koerner (1973: 213–22).
3. There are of course exceptions to this, and this chapter is indebted to them. See Gadet (1989); Jay (1987–88); but especially Derrida (1984); and Weber (1976).
4. See for example, Jakobson (1987: 413–27); Koerner (1973: 312–24); Kristeva (1989: 104–16); and Weber (1976). Weber credits Aristotle as "the first theoretician of the '*arbitraire du signe*.'"
5. For a discussion and explanation of Saussure's curiously brief and quite misleading representation of nomenclature, see Harris (1987: 56–58).
6. In an interesting discussion of Saussure's precursors, Hans Aarsleff (1982) draws our attention to the conceptual similarities between Hippolyte Taine and Saussure. He notes that Taine also used this "striking metaphor" of the recto and verso of a surface to describe the connection of physical and mental events in communication. Aarsleff argues that Taine had already dismissed the nomenclaturist view of language and deployed such notions as *valeur*, system and structure, the bipartite nature of the sign, *langue*, *parole*, and simultaneity and successivity. Although Taine never expressly discussed them, Aarsleff also insists that the philosopher took for granted the principles of arbitrariness and the linearity of speech. Aarsleff's revisionist history discovers a continuous tradition in linguistic thought that stretches back to Condillac and the *idéologues*, and even further back to Locke.

 Aarsleff offers a persuasive case against the notion that the origin of a particular intellectual paradigm is simply located. Whereas Aarsleff stresses continuity over discontinuity here, the implications of the Saussurean contribution to the question of temporal differentiation, i.e., how we think history itself, is

arguably more complex. As we will see, both continuity and discontinuity are reconceived in the strange genesis of the Saussurean sign.

Aarsleff's focus on the similarity of these thinkers comes at the expense of acknowledging the significance of their differences. For example, when Saussure likens the connection between signifier and signified to that of hydrogen and oxygen in the chemical compound water, Aarsleff judges this analogy "unhappy." The reason for his disapproval is that Taine's metaphorization of the relationship between the two parts of the sign never threatens to dissolve the identity, that is, the very separability of each side in this rather suggestive way. Related to this, Aarsleff comments, "As for Taine, Saussure's '*images acoustiques*' are only instruments of thought, but in themselves they are nothing *until they become 'des entités linguistiques*' by being joined to concepts" (1982: 358; emphasis added).

It is important to remember that for Saussure the two sides of the sign are each produced within the other. The implicated nature of the differential does not concede an *a priori* independence to the two sides, as Taine's description allows. The provocation of Saussure's work comes in the suggestion that signification is not ahistorical, such that the the thought of Locke and Saussure can be blurred in this way across the centuries. As I will argue, even the use of the very same words will not secure the same significations. There is always a differential at the heart of resemblance, even for contemporary language speakers who share a common language.

7. Various commentators have questioned the authenticity of the text at this point, blaming the editors for the resulting confusion. The addition of the third diagram, the arrows in all three diagrams, and the phrase, "each [element] recalls the other," all appear to be editorial intrusions. However, Gadet's conclusion regarding this debate seems a fair one: "the responsibility for the contradiction cannot be attributed exclusively to them; it derives from Saussure's own equivocations" (1989: 162). For a more detailed discussion of these additions, see Harris (1987: 59–62).

Given the evidence of a heavy editorial hand throughout the *Course*, this issue rehearses the more general question of Saussure's responsibility for the text and the worth of commentaries that presume his authorship. Does the *Course* faithfully capture the intentions of the linguist? As my own position is captured in Jacques Derrida's response to this same question, I include part of it here:

> Need we specify that, *here at least*, we cannot consider it to be pertinent? ... caring very little about Ferdinand de Saussure's *very* thought *itself*, I have interested myself in a *text* whose literality has played a well-known role since 1915, operating within a system of readings, influences, misunderstandings, borrowings, refutations, etc. What I could read—and equally what I could not read—under the title of *A Course in General Linguistics* seemed important to the point of excluding all hidden and "true" intentions of Ferdinand de Saussure. If one were to discover that this text hid another text—and there will never be anything but texts—and hid it in a determined sense, the reading that I have just proposed would not be invalidated, at least for that particular reason. (1984: 329)

8. Note the drift in the meaning of the signified between these sentences:
 > Some people regard language, when reduced to its elements, as a naming-process only—a list of words, each corresponding to the *thing* that it names.... This conception is open to criticism at several points. It assumes that ready-made *ideas* exist before words.... (Saussure 1974: 65; emphasis added)
9. The article is an extended review of Culler (1986).
10. See especially Descombes (1986: 156–66). Descombes is analyzing the image in Saussure (1974: 65).
11. Descombes seems to make two related points here. The inability of semiological linguistics to address adequately the grammatical category of definiteness is covered over by Saussure's recourse to Latin: *arbor* displaces a question about the article. Is it tree, a tree, or the tree? In this same maneuver the use of Latin encourages the covert appearance of reality/the referent. On this last point, Alan Rumsey has drawn my attention to the way in which Latin operated as a sign of reality following the nomenclature of Linnean biosystematics.
12. Descombes's claim, noted above, that semantic issues are excluded from Saussurean linguistics is quite misleading. It can be argued that the notion of semantics is entirely refigured by the *Course* rather than simply abandoned.
13. There is also an echo here of Ogden and Richards's earlier comment: "[t]he disadvantage of this account is, as we shall see, that the process of interpretation is included by definition in the sign" (1956:5). Ogden and Richards take the paradox as evidence of an error in the Saussurean schema that consequently demands the theory's dismissal. Derrida prefers to engage the paradox by reconceptualizing and complicating the notion of language and in such a way that it must include such anomalies.
14. For a detailed analysis of Benveniste's recourse to Aristotle's *a priori* categories of thought, see Derrida (1982: 175–205). Derrida is critical of the way that Benveniste ignores attempts since Aristotle to constitute a table of categories that are not a mere reflection of language. He cites as examples Kant, Brunschvicg, Bergson, Cassirer, and Heidegger. Related to this oversight, Derrida notes that in Benveniste's comment "we may dispense with philosophical technicalities" there is a failure to appreciate that the names of categories of thought were given by philosophy. Benveniste uses the words "category" and "linguistics" as if the history of their emergence were not of integral relevance to his question.
15. The editors justify their (unstated) addition by referring to other parts of Saussure's text that make this same point, for example, the connection between german *blau* "blue," and *durchblauen*, "thrash soundly," where one member of the pair is reinterpreted through an association of ideas. See Saussure (1974: 174).
16. The other functional categories are emotive, referential, phatic, metalingual, and conative. See Jakobson (1987: 71).
17. The six different factors are—addresser, context, message, contact, code, and addressee. See Jakobson (1987: 66).
18. The division between form and meaning is one of fundamental functional

importance for linguistics. Although they are correlative concepts, the definition of these terms and the nature of their relationship are much debated. For a discussion of the methodological necessity for their separation that goes some way toward acknowledging the accompanying difficulties, see Benveniste, "The Levels of Linguistic Analysis" (1971); and "*La forme et le sens dans le langage*" in the later volume (1974: 215–38).

19. Saussure's analytical focus on the stable system of linguistic norms that constitute *langue*, to the complete exclusion of utterance (*parole*), is critically assessed by V. N. Volosinov (1973). See especially part 11, "Toward A Marxist Philosophy of Language," chapters 1–3. Faced with the problem of how to delimit language as a specific and manageable object of study, Volosinov argues that linguists have relied upon modes of thought which derive from the study of "*defunct, alien languages preserved in written monuments*" (1973: 71):

> The *isolated, finished, monologic utterance*, divorced from its verbal and actual context and standing open not to any possible sort of active response but to passive understanding on the part of a philologist—that is the ultimate "donnée" and the starting point of linguistic thought. (Volosinov 1973: 73)

Against this, Volosinov argues that the living, concrete reality of language as it unfolds in the generative process of verbal interaction must be the proper object of linguistics. If Saussure brackets out the individual (*parole*) from the social (*langue*), Volosinov's emphasis on utterance refuses to simply reverse this decision. For Volosinov, the individual is not a separable entity, divorced from the social milieu. "The structure of the utterance and of the very experience being expressed is a *social structure*" (1973: 93). Volosinov's attention to the dialectical implication of these apparent binaries heeds the sociological and political context that organizes these divisions.

Volosinov's interventions against his linguistic inheritance in general and Saussure's contribution in particular are certainly important and provocative. Nevertheless, Saussure's notion of "value" (difference) can, in its turn, provide a powerful critique of Volosinov's own analytical stance. For example, Volosinov defines verbal interaction through the paradigmatic speech act of dialogue. However, he concedes that books too are

> a *verbal performance in print* . . . something discussable in actual, real-life dialogue . . . calculated for active perception, involving attentive reading and inner responsiveness . . . it responds to something, objects to something, affirms something, anticipates possible responses and objections, seeks support, and so on. (1973: 95)

The written text here is not isolated, finished, and therefore monologic, because its meanings are communicated and received within the concrete bond of an historical situation. But against this generous and open description, how is the identity of a monologic text determined, or even conceivable?

Volosinov's description of such texts as "cadavers" presumes that they are now lifeless and inert because the social context that informed them is also dead and gone. Hence, philologists engage them with "passive understanding." No longer

alive with communication, such texts can merely represent the evidence of what was, not what is. But this binary opposition between the living and the dead, the present and the absent, with its privileging of the first over the second, is entirely undermined by Saussurean "value." Each category is relationally produced: each inhabits the other such that they are no longer discrete entities. If Volosinov would mutually implicate the individual and the social, refusing their oppositional status, Saussure's work begins a similar intervention against the categories of presence and absence. This division underpins the phonocentrism of Volosinov's sense of utterance, of history, and indeed of the social. It is curious that Volosinov's conception of history (time) presumes the linearity and closure of conventional metaphysics, since the term "intertextuality," which disrupts appeals to unity and sequence, was first used by Volosinov/Bakhtin.

Although Volosinov dissolves the fulcrum of humanistic analysis in the self-conscious subject, elsewhere he recuperates the logical assumptions of this organizational convenience. In his uncritical appeal to notions of "content," "import," and "meaning," the intending, rationalist subject is now writ large as "the sociological," an entity whose needs and motivations are determined and anthropomorphized through the analytical categories of "function," "use," and "efficacy."

In this brief summary of Volosinov's argument, I do not want to suggest that he is simply wrong. I am in sympathy with his attempt to broaden what he sees as the confined nature of linguistics proper, and his contribution goes a considerable way toward this. However, a radical reading of the Saussurean text allows us to do more than make linguistics vulnerable to sociological analysis. A more generalized notion of language must also call into question the very category of "the social," its own identity and delimitation, and in a way that further complicates Volosinov's dialectical notion of difference, as indeed, the corollary notion of politics.

20. As mentioned above in note 7, there is much debate about the authorship of various claims in the *Course*. This particular representation of *langue*, reiterated in the text's final sentence—"*the true and unique object of linguistics is language [langue] studied in and for itself*" (1974: 232)—was actually added by the editors. The point may be moot, but it does remind us that Saussure's own position regarding *parole* is somewhat unclear and even confused.

21. It is not my intention to argue for a more radical reading of Saussure by way of an implied denigration of a more radical reading of Peirce. Freadman is also careful to insist that it is not a matter of choosing between the two linguists, for their differences derive from their exploration of quite different questions. Freadman suggests that structuralists have wrongly inferred a complementary relationship between Saussure and Peirce (Freadman 1986). Peirce addresses the issue of representation, whereas Saussure investigates the economy of signification, and this distinction cannot be elided or simply conjoined.

Although Freadman's reading of the differences between Saussure and Peirce is instructive, I want to argue that the set of attentions thought to be absent in

Saussure can be discovered there. The provocation in this rereading is that the identity of such notions as "the referent," "use," "the subject," "agency," "intention," "function," "meaning," etc., becomes more complicated, as does the apparent separation between representation and signification.

Perhaps Freadman could more effectively defend Peirce against Benveniste's criticisms, namely, that there is a collapse of the object with the sign in Peirce that undermines the semiotic specificity of language; that also undermines the ontological distinction between sign and world; and that further denies the theoretical force of the principle of arbitrariness—if she acknowledged that these very same accusations can also be directed against Benveniste's reading of Saussure.

22. Of particular pertinence to the following discussion, see Benveniste (1971), "The Nature of Pronouns," and "Subjectivity in Language."
23. See also Benveniste (1974), "*La forme et le sens dans le langage.*"
24. Among many linguists who dispute the conceptual opposition between speech and system is Noam Chomsky. A division he prefers to gloss as performance and competence, Chomsky also focusses his attention on the curious status of the sentence in the *Course*. Addressing the ambiguity that surrounds the linguistic unit in Saussure, Chomsky notes that the linguist:

> regards *langue* as basically a store of signs with their grammatical properties, that is, a store of word-like elements, fixed phrases, and, perhaps, certain limited phrase types ... He was thus quite unable to come to grips with the recursive processes underlying sentence formation, and he appears to regard sentence formation as a matter of *parole* rather than *langue*, of free and voluntary creation rather than systematic rule (or perhaps, in some obscure way, as on the border between *langue* and *parole*). There is no place in his scheme for "rule-governed creativity" of the kind involved in the ordinary everyday use of language. (1970: 23)

Despite this intervention, which further implicates speech and language, Chomsky has competence preceding performance as its condition of possibility.
25. For a detailed discussion of the notion of a generalized "dissemination," where the production of meaning cannot be comprehended by the metaphor of a dictionary, see Derrida (1981).
26. For an intricate discussion of the linearity of the signifier and the metaphysics of presence, see Derrida (1984: 72–73, 85–87).
27. According to Lotringer, Saussure's struggle to comprehend the operation behind the anagram "remain[ed] bound within the problematics of a unitary, unsplit subject, of a subject who is the master of the name and the receptacle of meaning" (1973: 5). Lotringer's intervention acknowledges the powerful insights of Lacanian psychoanalysis, which couple Freud with Saussure. Yet, Lotringer seems unaware that his own analysis also deploys an unquestioned unity. Although Lotringer shows us evidence of "the linguist's incapacity to fracture the enclosure of the subject" (1973: 6), he remains unaware of his own incapacity to fracture the enclosure of language. The concession that language is a process of differentiation does not necessarily engage the subject of language

as such. How is the identity of language (albeit one fractured internally) sustained? Similarly, Lotringer's certainty of the subject's uncertainty, his investment in "the gap" as a sort of negative confirmation of the subject's (unconscious) presence, recapitulates the problem in reverse form.
28. Derrida's comment repeats Saussure's original words here.

two Corpus Delicti

1. The actual context of this assertion bears repeating. Derrida elaborates the notion of "writing in general" through a discussion of the work of Jean-Jacques Rousseau. He suggests that:

 > There is nothing outside of the text [there is no outside-text; *il n'y a pas de hors-texte*]. And that is neither because Jean-Jacques' life, or the existence of Mamma or Thérèse *themselves*, is not of prime interest to us, nor because we have access to their so-called "real" existence only in the text and we have neither any means of altering this, nor any right to neglect this limitation. All reasons of this type would already be sufficient, to be sure, but there are more radical reasons.... [I]n what one calls the real life of these existences "of flesh and bone," beyond and behind what one believes can be circumscribed as Rousseau's text, there has never been anything but writing. (Derrida 1984: 158)

2. I would like to thank Joseph Pugliesi for generously sharing his research findings on dermagraphism. It seems that dermatology textbooks witnessed the last cases of this phenomenon in the 1940s. For an interesting reading of Hawthorne's *The Scarlet Letter*, a literary reference to the stigmata of dermagraphism, see Pugliesi (1991).

3. In this image of the body as art, I am reminded of the way in which the changing iconography of the crucifixion is mirrored as a stigmatic registration on the bodies of the devout. Interestingly, since arguments about the Turin shroud have revealed that Christ was probably nailed to the cross through the wrist, many contemporary stigmatics now bleed accordingly. For further discussion of stigmata that also refers to dermagraphism, see Wilson (1988). Of related interest, see Wilson (1978); Owen (1971); Didi-Huberman (1987b); J. Copjec (1987); Caillois (1987); and Beizer (1994).

4. The phenomenon of synesthesia also raises questions about the integrity of sign systems, as the following example suggests. Describing the classic case of S., A. R. Luria observes:

 > Presented with a tone pitched at 2,000 cycles per second and having an amplitude of 113 decibels, S. said: "It looks something like fireworks tinged with a pink-red hue. The strip of color feels rough and unpleasant, and it has an ugly taste—rather like that of a briny pickle ... you could hurt your hand on this.
 >
 > ... I recognize a word not only by the images it evokes, but by a whole complex of feelings that image arouses. It's hard to express ... it's not a matter of vision or hearing but some over-all sense I get. Usually I experience a word's taste and weight, and I don't have to make an effort to remember it—the word seems to recall itself. (as cited in Cytowic 1989: 94–95)

The cases of phantom vision and blindsight are also relevant here. Cytowic explains that patients who are blind following cortical surgery or brain lesions can nevertheless achieve a number of visual perceptions in their "blind" field of vision. Accurate behavioral responses by these patients to optical information regarded as entirely restricted to the visual mode suggest that what constitutes "vision" and "seeing" may involve more than the eyes. Although Cytowic interprets such phenomena from a cognitive approach, arguing against interpretations that privilege language as the binding template that explains the development of synesthesia, we could productively read such data as evidence of the grammatological textile, that is, as evidence of Derrida's "language in the general sense." For further discussion of synesthesia, see Cytowic (1993); and Luria (1968).

5. See Metz (1974a, 1974b); and Wollen (1972).

In "Space for the Subject" (1993), Sue Best discusses more recent endeavors to isolate a workable semiotics of the visual, making particular reference to Preziosi (1984) and Kress and van Leeuwen (1990). In an argument whose point is similar to my own, Best gives some account of the desire for absolute closure in this type of work and explains its inevitable disappointment. As Best's citations from Kress and van Leeuwen succinctly capture the problem, I will repeat them here:

> The visual component of a text is an independently organised and structured message—connected with the verbal text, but in no way dependent on it. . . . We take the view that language and visual communication both realise the same more fundamental and far-reaching systems of meaning that constitute our culture, each by means of its own specific forms, and independently. (Kress and van Leeuwen 1990: 4)

Yet Best notes with interest that the assumption that perceptual modalities are isolatable and independent is later undermined in another of these authors' assertions:

> Language has a more developed theoretical and descriptive vocabulary than the semiotics of images. Consequently we establish the kinds of things we wish to talk about by first describing what happens in language, and use that as an analogy for our discussion of images. (16)

Best illustrates that the search for autonomous semiotic realms takes us through a tangled web of inter-dependency from which there is no escape.

6. For further discussion of Aristotle's relevance to this debate, see Spelman (1982); Laqueur (1990); and Butler (1993).
7. For an excellent summation of the masculinism that drives philosophy, see Lloyd (1984).
8. Although there have been many important feminist critiques of the enduring masculinism in Beauvoir's work, my interest here is in its usefulness as a starting point for this discussion. For further analysis of Beauvoir's contribution, see Mackenzie (1986); Spelman (1988); Moi (1990, 1994).

9. For an early and important analysis of the connection between the nature/culture division and sexual difference, see Ortner (1974).
10. Grosz's point is that essentialism is, ironically, a slippery and unstable notion that defies definition. This fixed essence is strangely wayward and may be discovered in biology, psychology, or culture. Very briefly, she describes essentialism and its cognates as follows:

> Essentialism—refers to the existence of fixed characteristics, given attributes, and ahistorical functions which limit the possibilities of change and thus of social reorganisation.
>
> Biologism—women's essence is defined in terms of their biological capacities.... In so far as biology is assumed to constitute an unalterable bedrock of identity, the attribution of biologistic characteristics amounts to a permanent form of social containment for women.
>
> Naturalism—may be asserted on theological or on ontological rather than on biological grounds ... it may be claimed that women's nature is derived from God-given attributes which are not explicable or observable simply in biological terms.... More commonly however, naturalism presumes the equivalence of biological and natural properties.
>
> Universalism—the attributions of invariant social categories, functions and activities to which all women in all cultures are assigned. (1990: 334–335)

11. The "two lips" refers to the essay "This Sex Which Is Not One" (Irigaray 1985a). As morphology is an elusive notion, the following explanation of the term may prove helpful:

> The concept of morphology, a term Irigaray uses frequently, mediates between a purely anatomical and a purely psychological account of the body and its pleasures. It denotes the determinacy of the body's form in the formation of the imaginary body or body image (cf. Lacan's mirror phase for the construction of the libidinal and identificatory relation to the child's own body as constitutive of the boundaries and structures of its ego in "The Mirror Phase ..." in *Écrits* and "Some Reflections on the Ego" in *International Journal of Psychoanalysis*, Vol. 34, 1953). The body's morphology is thus both constitutive of and constituted by how it is inscribed, marked, and made meaningful. (Campioni and Grosz 1991: 397)

12. I am deliberately repeating this phrase from the quotation in endnote 1, where Derrida describes "flesh and bone" as "text." The deconstructive scene of writing includes the perceived density and immediacy of lived experience together with the critique of such empiricist truth claims. The empirical fact of the body is not simply rejected by a deconstructive gesture; rather it is complicated and rewritten within the weave of these paradoxical implications.

For a discussion of the way in which the category "experience" has been deployed within contemporary debate on identity, see Scott (1992). This article represents an important intervention against the intellectual paralysis that results when "experience" is taken as the last word in an account of the politics of identity.

13. For an incisive analysis of the unquestioned assumptions that accompany the sex/gender distinction, see Gatens (1991). After fourteen years (the essay was originally published in 1983), Gatens's handling of this problematic still remains a fertile and provocative one. Gatens's argument in many ways anticipates Judith Butler's, remarking the material efficacy of language (signification and/or discourse) as the organizational domain of the sex/gender distinction. Gatens is impatient with the category "gender" and makes some attempt to collapse it into the category "sex" because the latter is, actually, already an *arti*fact or cultural determination. But, the constitutive irreducibility of binary splitting is itself elided in the correction. This point will become clearer in the later discussion of Drucilla Cornell and Judith Butler on this same topic.
14. On the question of essentialism and its cognates, see Heath (1978); Spivak (1983); Schor (1986, 1987); Jardine (1987a); Braidotti (1989); Fuss (1989a); on the issue of *differences*, see "The Essential Difference: Another Look at Essentialism" (1989), especially the article by Schor and the interview between Spivak and Rooney; Butler (1990, 1993); Grosz (1990); Sedgwick (1990); Cornell (1991); Vasseleu (1991).
15. See for example, Moi (1988: 138–39). Moi regards Irigaray's work as tainted because she has presumed to enter discourse as a woman. She mentions Margaret Thatcher to illustrate the folly of a woman who entered a man's arena *as* a woman, for inevitably a woman must act as if she were a man and thereby deny the specificity of her difference. Moi cites the battery of questions that Shoshana Felman raises regarding the place of enunciation in Irigaray's *le parler femme*, and Irigaray stands condemned for her pretension. Moi grants no value to the Derridean strategy that levers a text open by attending to the differences that always inhabit it, even as these differences are finessed and suppressed. She misreads Derrida when she refers to his claim that there is no outside of metaphysics, drawing the conclusion that Irigaray's project is therefore doomed to failure because there is ultimately no escape. Derrida argues from the inside out, trying to articulate an "inside" of metaphysics where "the logic of the same" cannot maintain its supposed self-identity. Clearly, Irigaray makes use of this strategy to reread phallogocentrism for women. Against the philosophical complexity of Irigaray's work, Moi's argument can only work as *ressentiment*. It is as though Moi believes she can escape the question of enunciation in her own work and prove that she is outside the "Thatcher effect" by pointing to error and guilt elsewhere. Acknowledging that identity is always problematic does not mean that we can remove ourselves from the politics of identifying processes.
16. This is a revised version of a chapter that appears in Fuss (1989a).
17. Among anglophone readers, Irigaray's better known works include "Women's Exile" (1977); *This Sex Which Is Not One* (1985a); *Speculum of the Other Woman* (1985b); "I Subject of Science Sexed?" (1985c); *The Irigaray Reader* (1991a); *Marine Lover of Friedrich Nietzsche* (1991b); *Elemental Passions* (1992); *je tu, nous: Towards a Culture of Difference* (1993); *An Ethics of Sexual Difference* (1994).
18. Of course, the assumption that the metaphoricity of language is quite separate

Notes

from the reality to which it refers is already undermined by the very word "literal," which couples the sense of "adhering to fact" with "expressed in letters."

19. This article also appears in a slightly revised version, Gallop (1988). I have concentrated on this article because, as Fuss comments, Jane Gallop is a noted defender of Irigaray and one whose work represents "the most promising line of argument to follow" (Fuss 1989b: 65).

20. By way of arguing against a too literal reading of Irigaray, it may be that Gallop has invested in a too literal reading of Freud. The provocative ambiguities in Freud's work have certainly been fertile for arguments such as Gallop's.

21. Gallop is not alone in excluding biology from consideration. There seems to be an almost consensual agreement among Irigaray's most sophisticated defenders that a limit must be determined with regard to the notion of materiality, textuality, and anatomy in Irigaray's texts. See, for example, Whitford (1986: 7; and 1989: 121–23). Whitford is careful to exclude biology from Irigaray's interventions. "She [Irigaray] is speaking not of biology but of the *imaginary*, in which one may make male *or* female identifications, regardless of one's biological sex" (1986: 7). "Biology" in this account isn't open to the problematic of recognition. It is the "given" of sex that should not be confused with the complexities of gender identification.

See also Burke (1981: 303–304). A certain poetic play within Burke's writing style is able to sustain a sense of the uncertain nature of the body's materiality. Burke suggests that the problematic intersection of sexuality and representation could be thought through an attention to the notion and use of figurative language, a study that has still to be undertaken. This seems to imply that figuration may involve some material efficacy, that it may not be a separable "other" to what it represents. Burke goes on to cite Nietzsche, who muses as to whether all philosophy "has not been merely an interpretation of the body and a misunderstanding of the body." Of course, the subject of the genitive is ambiguous here. "Body" could be the subject or the predicate of the sentence, or their performative implication. The mind/body split is made unstable in this statement, and this undecidability suggests the inextricable nature of language and materiality, indeed, of language *as* a particular expression of materiality. Yet, Burke confines the ambiguity in the passage to the words "interpretation" and "misunderstanding." This containment tends to "read" the body back into the position of object, burying its substance beneath the debris of our understandings or misunderstandings. Consequently, Burke is only able to acknowledge the worth of reinterpreting the "conceptual" systems through which the body is understood. And although the conclusion to this piece evokes the possibility that reading is an action—that reading enacts differences and therefore has effects—the interpretive model through which this is argued inevitably privileges mind over matter. As Burke suggests, "we may find that we emerge from this difficult reading process with our minds, literally, changed." (1981: 303)

And see Grosz (1989: xix–xx). Grosz's discussion of morphology (see note

11 above) sets up a surface/depth model, a culture/physiology (biology) split. An inevitable result is that the productive force of Irigaray's *parler femme* is confined to the notion of "inscription" upon the body's surface. Anatomy is interpreted as the body's external shape.

My own argument is not in opposition to these excellent readings; indeed, I am entirely indebted to their intelligent provocations. I see my intervention as a further elaboration of this work, an attempt to read it to the letter. In other words, although I agree with Burke that our minds are literally changed, I want to insist that such transformations are through and through corporeal. Such a reading would imply that "mind" is now generalized such that it is no longer a self-present entity *within* the body.

22. See, for example, Plaza (1978); Moi (1988: 127–49); Kuykendall (1984); and Sayers (1986: 42–48).

23. See, for example, Lacan (1977). Elizabeth Grosz has suggested to me that perhaps a radical reading of Lacan's mirror stage would go toward generalizing Lacan's field of language. Such an interpretation promises an interesting and provocative line of inquiry, where perhaps we could consider the mirror stage of a biological cell. We might think of any differentiating membrane or partition through the mirror problematic. Certainly, this sense of a "stage" should be read as an heuristic device that opens the processual, interminable staging of the "becoming subject" in/as spacing/timing. Another direction might be Deleuze and Guattari's reading of desire as production rather than lack:

> If desire produces, its product is real. If desire is productive, it can be productive only in the real world and can produce only reality.... Desire does not lack anything; it does not lack its object.... Desire and its object are one and the same thing.... Desire is not bolstered by needs, but rather the contrary; needs are derived from desire: they are counterproducts within the real that desire produces. (Deleuze and Guattari 1983: 26 and 27)

24. An illustration of this tendency to close off the possibility of a Derridean reading of "writing," "language," and "textuality" is evidenced in Gallop (1982). Gallop's intervention takes up an oversight or blind spot in the collection *Writing and Sexual Difference*, an inability to take account of what Barbara Johnson describes as "not a difference between ... but a difference within. Far from constituting the text's unique identity, it is that which subverts the very idea of identity." Johnson describes this as a "literature that inhabits the very heart of what makes sexuality problematic for us speaking animals" (as cited in Gallop 1982: 284). Gallop quickly assumes that "Johnson's puzzling remark could best be explained by recourse to Lacanian psychoanalysis," although she goes on to concede that "my attempt to explain Johnson's provocative remark is far from satisfactory" (285).

The original context in which Johnson's apparently enigmatic words appeared was *The Critical Difference: Essays in the Contemporary Rhetoric of Reading* (Johnson 1980). Johnson is quite specific in describing this volume as a working through of the Derridean notion of *différance*, "the record of one reader's

Notes

struggles to come to grips with the problems posed by contemporary so-called deconstructive critical theory" (1980: xi). When Gallop confines this enterprise to the problematic of psychoanalysis, a "critical difference" is thereby elided.

25. Several critics have noted the way in which Derrida's work received a sanitizing translation as it crossed the Atlantic. See, for example, Gasché (1979); Spivak (1984); Johnson (1985); Weber (1987); and Kirby (1989b).

26. It strikes me that the title of Gallop's article, "Quand Nos Lèvres S'Écrivent" (a play on Irigaray's "Quand nos lèvres se parlent") could also be read through the circuitry of the mystic writing pad. The reflexive casts an ambiguity that has the lips being written upon by the spacing within which they thereby reinscribe/differentiate themselves.

27. Irigaray has often been taken to task over her cryptic comment, "I think we must go back to the question not of the anatomy but of the morphology of female sex" (1977: 64). See also Moi (1988: 143); Fuss (1989a: 77); Plaza (1978: 31). A more nuanced engagement with the question of morphology, one enabled by a deconstructive reading, might take Irigaray's comment as an attempt to open the very notion of "form" to a different reading. In this same passage, Irigaray takes up the phallocentric designation of woman as having "no sex." Measured against "the privilege of unity, form of the self, of the visible, of the specularisable, of the erection (which is the becoming in a form)," woman's form is not easily identified or delineated. Irigaray notes:

> There is indeed a visible exterior of the female sex, but that sex is also "interior." Besides, the sexual functioning of the woman can in no way lend itself to the privilege of the form: rather what the female sex enjoys is not having its own form. (1977: 64)

28. On the question of reference, Derrida argues:

> The text is not the book, it is not confined in a volume itself confined to the library. It does not suspend reference—to history, to the world, to reality, to being, and especially not to the other, since to say of history, of the world, of reality, that they always appear in an experience, hence in a movement of interpretation which contextualizes them according to a network of differences and hence of referral to the other, is surely to recall that alterity (difference) is irreducible. *Différance* is a reference and vice versa. (1988: 137)

29. Derrida notes that the *maintenance* of the writing operation is not simple. The implications of Derrida's intervention on Freud's understanding of the writing operation would mean that the double gesture that appears to require two hands would already be present in the *maintenance* of one. The gesture of one hand writing *in time*, that is, within the apparent self-presence of "nowness" (*maintenant*), is itself moved, or "written," by a force that exceeds this temporal envelope.

three Poststructuralist Feminisms
Part 1: Accommodating Matter: Drucilla Cornell

1. For shorthand convenience, I am making an elision between the terms post-

modernism and poststructuralism. Although these terms have different histories and are deployed to different effects, they are nevertheless used interchangeably by many contemporary writers. For a helpful introduction to some of these debates, see Huyssen (1986); Rajchman (1987); Silverman (1983); Foster (1986); and Kirby (1994).
2. See Cornell (1992). Drucilla Cornell has authored and edited several other influential books in this area; see also Cornell (1991, 1993); and Benhabib and Cornell (1987).
3. For a provocative reading of the complexity of the gift, see Derrida (1992). See also the interview between J. Derrida and J-L. Nancy, "'Eating Well,' or the Calculation of the Subject: An Interview with Jacques Derrida" (1991). Here, Derrida wrests "the subject" from both its humanist and antihumanist frame.
4. The implications of Derrida's engagement with the metaphysics of presence involve a re-reading of the problematic of death. See for example, J. Derrida, *The Gift of Death* (1995).
5. The flux, ambiguity, and general porousness of what makes up "the biological" are perhaps best confirmed by biologists themselves. For a suggestive introduction to some of these complexities, see G. Simondon, *L'Individu et sa genèse physico-biologique: L'Individuation à la lumière des notions de forme et d'information* (1964). The translated introduction to this text appears in J. Crary and S. Kwinter (1992).

four **Poststructuralist Feminisms**
Part 2: Substance Abuse: Judith Butler

1. Judith Butler's reputation as a significant contemporary scholar in theoretical and political debate derives from an impressive body of work whose span of address includes philosophical argument, feminist and queer theory, and the broader reach of art and political commentary. She is perhaps best known as the author of *Gender Trouble: Feminism and the Subversion of Identity* (1990) and *Bodies That Matter: On the Discursive Limits of "Sex"* (1993).
2. This is obviously Butler's point of departure, as is made clear from the quotation marks around the word "sex" in the book's subtitle. At the risk of anticipating my own argument here, I am reminded of a comment made by a colleague, Elizabeth Wilson, regarding their use. Given Butler's argument, Wilson wondered why they were so necessary. To use or not to use: what difference does it make? Perhaps the use of quotation marks around everything we want to problematize is redundant if the puzzle of reality is ubiquitous and insistent.
3. For an accessible introduction to many of these issues, see Paul Davies, *The Matter Myth* (1991). I should note here that I am not trying to forge some simple equivalence between Niels Bohr's and my own position. Bohr's assumption that "particles" did not exist prior to observation rearticulates the metaphysics of presence that I am trying to complicate. Existence is either present or absent for Bohr, just as observation is an unproblematic moment by a particular subject *in* time. More recently, David Bohm has taken quantum mechanics in an interest-

ing direction by exploring some of Bohr's assumptions more closely. See Bohm's *Wholeness and the Implicate Order* (1980) and "The Enfolding-Unfolding Universe: A Conversation with David Bohm" (1982).
4. Although Butler is aware of the following work, describing it as "a reading of Lacan which argues that prohibition or, more precisely, *the bar* is foundational" (1993: 268), she does not explore its implications. See Jean-Luc Nancy and Philippe Lacoue-Labarthe, *The Title of the Letter: A Reading of Lacan* (1992).
5. Although Rupert Sheldrake's argument is a far cry from this discussion, and certainly has its own share of problems, it does open the question of morphology in suggestive and tantalizing directions. See *A New Science of Life: The Hypothesis of Formative Causation* (1981); and *The Presence of the Past: Morphic Resonance and the Habits of Nature* (1988).

five Reality Bytes

1. For a different and much more provocative history of cyberspace, see Geoffrey Batchen's "Spectres" (1995).
2. The sense of betrayal over Julie's off-line identity was so extreme in some cases that the sense of personal violation was likened to rape. Some even repudiated the emotional gains in their lives that Julie's advice had made possible.
3. I would be delighted to discover that my blanket statement that all cyberspace literature assumes that "no bodies touch" is mistaken. However, at the time of writing, the authors with whom I am familiar take this assumption as given.
4. See Stone (1991, 1992b, 1993). Her reliance on the notion of prosthesis in her conceptualization of technology is even more explicit in these articles.
5. The assumption is not simply one that belongs in the past. For example, it was not until June 3, 1992, that a decision regarding native title (termed the Mabo decision, after Eddie Mabo) overturned the 204-year-old legal doctrine of *terra nullius*, which held that the lands of the Australian continent were "practically unoccupied" at the time of the proclamation of British sovereignty.
6. Briefly, the Turing test (after Alan M. Turing) involves engaging a person in a form of conversation with a computer program. If the person is unsure if his or her interlocutor is a human or a machine, the machine is regarded as intelligent. We see a quite different twist on this deception in the case of psychotherapy programs such as DEPRESSION 2.0, from "whom" some people *choose* to seek counsel. The assumption that a computer program can speak to a person's most intimate needs is provocative when read against the sense of betrayal when Julie's identity became known.

Leonard Foner, who analyzes MUD conversations, is cited by Turkle as proof that the Turing test is now a tad limited. In response to an attempt by the suitor, Barry, to seduce an evasively flirtatious "bot" named Julia, Foner notes that despite her sometimes odd responses to his ardor, Barry seemed blissfully unaware of the compromised identity of his temptress. Foner notes with some amusement that "[f]rankly, it's not entirely clear to me whether Julia passed a Turing test here or Barry failed one" (Foner, as cited by Turkle 1995: 38).

7. We see this same assumption in discussions around electronic information, for example, Landow (1992). Landow interprets the interactive blurring between reader and writer, together with the computer's ability to immerse one text within another (hypertext), as technology's realization of Jacques Derrida's notion of "textuality." Landow's misreading fails to appreciate that the involvement granted the electronic word already inhabits the notion of difference *as such*. Inasmuch as Derridean "textuality" undermines any easy identification of complexity as the result of a progressive, lineal unfolding, Landow's narrative of technological enhancement is the precise target of Derridean intervention. Indeed, the compulsive addiction of MUDSites, those virtual communities that are "no more" than a textual interaction upon a screen, should provoke a reconsideration of the nature of the word.

 For a more elaborated critical analysis of Landow's position, as well as that of other contributors to this emerging field, see Grusin, "What is an Electronic Author? Theory and the Technological Fallacy" (1996). Grusin's intervention is salutary as his argument explores the trope of dematerialization in this literature. Yet with the assumption that the material context of electronic writing has been marginalized, and that the stuff of this context is "social, institutional and political practices," Grusin inadvertently closes the question of textuality. Materiality for Grusin has been treated as an oversight whose elision he seeks to redress. The identity of materiality, however, is not in question.

8. Discussions of cyberspace that deploy Jacques Lacan's work on the mirror stage are alert to this suggestion. Lacan argues that the proto-subject, or *hommelette*, can only emerge as a subject through a virtual (mirror) recognition. The paradox of this recognition splits the subject even as it provides the (illusional) imago through/within which a corporeal cohesion is made possible. A psychoanalytic approach to the question of the virtual replaces the self-presence of the Cartesian subject (*cogito*) with its opposite, the delusions and fantasies of the nostalgic subject (*desidero*). We should note, however, that in fracturing the *cogito* Lacan nevertheless continued to circumscribe the problematic of the subject. In other words, the split did not fissure the subject of "the subject" from its unified identity as a human subject. For a provocative discussion of cyberspace that presumes a Lacanian reading, see Hayles (1993a; 1993b).

9. Biddick's article is an important contribution to this literature, exploring many of the resonances between colonial histories and virtual claims.

10. Harris (1986) offers an interesting critique of this notion that the history of writing is a history of attempts to represent speech. He argues that the alphabet is quite wrongly regarded as the most sophisticated form of writing because it represents, in abstract form, the phonetic building blocks of speech.

11. We should not be surprised by this. After all, it was Freud who explained man's possession of the phallus in terms of woman being the phallus. Sherry Turkle (1984), Andreas Huyssen (1981–2), Claudia Springer (1991), and Alice Jardine (1987b) are just a few of the writers who have made a similar observation about woman as machine. It seems strange, however, that the equation between

woman and machine isn't engaged more critically, given that the mind/body, male/female division can become quite fluid around the computer (as indeed any) interface. Although the machine-as-woman seduces the subject away from himself, this "mindsuck" or "jack-in" is also figured as intercourse between flesh and information. In this last instance, however, the seduction of the computer's reasoning abilities are coded as masculine.

12. This issue is, however, specifically addressed by Balsamo in a special issue of *The South Atlantic Quarterly* (1993); Grosz (1992–93); Hayles (1993a); Kendrick (1996); and Springer (1993).

13. Sophia coins the term "Jupiter Space" to refer to the way in which ancient myth has:

> retained currency in allusions to mental "conceptions," or successive "generations" of "brainchildren" projected from Man's "fertile" mind, etc., the Greek god Zeus (Roman Jupiter) ate Methis, the pregnant goddess of wisdom, and later the fully formed, fully armed Athena sprang from his head. (1992: 14)

Sophia reads this scenario as cannibalistic matricide, and her critique rests on trying to return notions of fertility and pregnancy to the appropriate parts of the female body. Yet, the very possibility of this ubiquitous scene of birthing, where eating becomes a form of copulation, suggests a different way of reading corporeality. In this instance, the fertility of thought cannot be interpreted as essentially masculine, nor as the other of mat(t)er.

14. It was Saussure's notion of "value" *(valeur)*, the differential within whose economy identity is emergent, that allowed Derrida to reread the linguist's conceptualization of difference as the opposite of identity. And yet, to my knowledge, all of the literature on VR remains uncritically caught in a structuralist commitment to identity versus difference, substance versus form, presence versus absence, and reality versus its re-presentation.

15. A hologram (whole writing) has the curious "property" of distributing information entirely, such that any fragment contains the whole image, albeit differently. In other words, the fragment's perspective is inclusive yet particular, and in its turn represents another differentiated whole.

16. Paul Rabinow's work, which addresses what he regards as the now chimerical mix of nature within culture in the Human Genome Project, represents another example of this supposition. The very concept of "denaturalization" instantiates an originary nature whose purity pre-exists a later contamination. See Rabinow (1992; 1993).

17. A specific example of this can be seen in Haraway's understanding of political coalitions. They may hold together such apparently disparate members as "witches, engineers, elders, perverts, Christians, mothers, and Leninists long enough to disarm the State." Haraway's point is that these groups express affinities, "related not by blood but by choice" (1991a: 155). Is blood indeed mindless and without choice, or is there another way to think "choice" that could include the fluid language games of blood?

Notes

18. The suggestion that space doesn't simply *contain* sexed bodies because it is aready sexualized and sexualizing is provocatively argued in Best (1995).

conclusion Cannibal Subjects

1. Barthes also discusses the notion "doxa" in "Change the Object Itself" in *Image Music Text* (1977b).
2. The notions of "the prison house of language" and "the burden of representation" are exemplified in the work of Frederic Jameson and Terry Eagleton. See, for example, Jameson (1981) and Eagleton (1983).
3. As one always says too much and too little in a blanket statement such as this one, I should emphasize by way of qualification that this is not meant as a general condemnation of anthropological research. However, certain attempts at reflexivity within the discipline are sometimes cloyingly self-congratulatory in ways that actually avoid the most troubling implications of translation. For a discussion of the ways in which difference has been negotiated in anthropology by feminism and "new ethnography," see Kirby (1987, 1989a, 1989b, 1989c, 1991, and 1993).
4. In just one of many examples, Spivak recounts her treatment by the "giggling," "card-carrying female deconstructivists . . . (who) wouldn't touch anti-sexist work because that would only prove once again that they were not being theoretically pure deconstructivists." Spivak recounts this scene as a form of cautionary tale against deconstruction's foreclosure of the pragmatic, political necessities of the everyday. See Spivak interview with E. Grosz (1990a: 13).
5. Although Marx's argument separates nature from culture and organic from inorganic, as the following excerpt makes clear, it is wonderfully suggestive and seems to anticipate a Deleuzian understanding:

 > Just as plants, animals, stones, the air, light, etc., constitute a part of human consciousness in the realm of theory, partly as objects of natural science, partly as objects of art—his spiritual inorganic nature, spiritual nourishment which he must first prepare to make it palatable and digestible—so too in the realm of practice they constitute a part of human life and human activity. . . . The universality of man is in practice manifested precisely in the universality which makes all nature his *inorganic* body—both inasmuch as nature is (1) his direct means of life, and (2) the material, the object, and the instrument of his life activity. Nature is man's *inorganic* body—nature, that is, insofar as it is not itself the human body. Man *lives* on nature—means that nature is his *body*, with which he must remain in continuous intercourse if he is not to die. That man's physical and spiritual life is linked to nature means simply that nature is linked to itself, for man is a part of nature. (Marx in Tucker 1978: 75)

6. This project is always present in Spivak's work. For articles that quite specifically address this question, see Spivak (1984, 1987b, 1990b, and 1990c). Derrida has also made specific contributions to this rereading. See, for example, Derrida (1985c, 1994).
7. In Spivak's interview with E. Grosz (1990a), she argues for an abrasive critical

strategy wherein the discourses of Marxism, feminism, and deconstruction are each interrupted by the other. My aim is to question the voluntarism that empowers this appeal to "strategic interruption" with its assumption that these discourses are not already interwoven and interdependent. Although there is certainly a pragmatic irreducibility about using terms as if they are discrete, there is an equally compelling necessity to acknowledge their "implicate order."

8. Said does in fact make a passing reference to the embodiment of Orientialism in the Introduction to *Orientalism*:

> Much of the personal investment in this study derives from my awareness of being an "Oriental" as a child. . . .
>
> In many ways my study of Orientalism has been an attempt to inventory the traces upon me, the Oriental subject, of the culture whose domination has been so powerful a factor in the life of all Orientals. . . . The nexus of knowledge and power creating "the Oriental" and in a sense obliterating him as a human being is therefore not for me an exclusively academic matter. (1978:25–27)

The limitations of Said's reading of both Foucault and Derrida mean that he never fulfills this promised analysis of a tracing that does, simultaneously, both create and obliterate itself in the Orientalization of the subject. Foucauldian "discursivity" and Derridean "textuality" could, in their different ways, address the material dynamic of this apparent paradox.

Bibliography

Aarsleff, H. (1982). "Taine and Saussure." In *From Locke to Saussure: Essays on the Study of Language and Intellectual History*. Minneapolis: University of Minnesota Press.

Bally, C., and Sechehaye, A. with Reidlinger, A. (eds.) (1974). "Preface to the First Edition." In F. de Saussure, *Course in General Linguistics*, trans. W. Baskin. Suffolk: Fontana Collins.

Balsamo, A. (1993). "Feminism for the Incurably Informed." In M. Dery (ed.), *Flame Wars: the Discourse of Cyberculture*. Durham, NC: Duke University Press.

Barthes, R. (1968). *Elements of Semiology*, trans. A. Lavers and C. Smith. New York: Hill and Wang.

—— (1977a). *Roland Barthes by Roland Barthes*, trans. R. Howard. New York: The Noonday Press.

—— (1977b). *Image Music Text*, trans. S. Heath. New York: Hill and Wang.

Batchen, G. (1995). "Spectres." *Afterimage* 23, 3: 6–7.

Beauvoir, S. de. (1953). *The Second Sex*, trans. H. M. Parshley. London: Jonathan Cape.

Beizer, J. L. (1994). *Ventriloquized Bodies: Narratives of Hysteria in Nineteenth Century France*. Ithaca, NY: Cornell University Press.

Benedikt, M. (ed.) (1992). *Cyberspace: First Steps*. Cambridge: MIT Press.

Benhabib, S., and Cornell, D. (1987). *Feminism as Critique: On the Politics of Gender*. Minneapolis: University of Minnesota Press.

Bennington, G., and Derrida J. (1993). *Jacques Derrida*, trans. G. Bennington. Chicago and London: University of Chicago Press.

Benveniste, É. (1971). *Problems in General Linguistics*, trans. M. E. Meek. Coral Gables, FL: University of Miami Press.

—— (1974). *Problèmes de linguistique générale*, Vol. 2. Paris: Gallimard.

—— (1985). "The Semiology of Language." In R. Innis (ed.), *Semiotics: An Introductory Anthology*, trans. G. Ashby and A. Russo. Bloomington: Indiana University Press.

Best, S. (1993). "Space for the Subject." In J. Macarthur (ed.), *Knowledge and/or/of*

Experience: The Theory of Space in Art and Architecture. Brisbane: Institute of Modern Art.

———. (1995). "Sexualising Space." In E. Grosz and E. Probyn (eds.) *Sexy Bodies*. London: Routledge.

Biddick, K. (1993). "Humanist History and the Haunting of Virtual Worlds: Problems of Memory and Rememoration." *Genders* 18: 47–66.

Bohm, D. (1980). *Wholeness and the Implicate Order*. London: Routledge & Kegan Paul.

——— (1982). R. Weber, "The Enfolding-Unfolding Universe: A Conversation with David Bohm." In K. Wilbur (ed.), *The Holographic Paradigm*. Boston and London: New Science Library.

Bourneville D. M., and Régnard, P. (1878). *Iconographie photographique de la Salpêtrière Aux Bureaux du Progrès Médical*. Paris: Delahaye and Lecrosnier.

Braidotti, R. (1989). "The Politics of Ontological Difference." In T. Brennan (ed.) *Between Feminism and Psychoanalysis*. London and New York: Routledge.

Burke, C. (1981). "Irigaray Through the Looking Glass." *Feminist Studies* 7, 2: 288–306.

Butler, J. (1990). *Gender Trouble: Feminism and the Subversion of Identity*. New York and London: Routledge.

——— (1993). *Bodies That Matter: On the Discursive Limits of "Sex."* New York and London: Routledge.

Butler, J., and Scott, J. W. (eds.) (1992). *Feminists Theorize the Political*. London and New York: Routledge.

Caillois, R. (1987). "Mimicry and Legendary Psychasthenia." In A. Michelson, R. Krauss, D. Crimp and J. Copjec (eds.), *October: The First Decade 1976–1986*. Cambridge: MIT Press.

Campioni, M., and Grosz, E. (1991). "Love's Labours Lost: Marxism and Feminism." In S. Gunew (ed.) *A Reader in Feminist Knowledge*. London and New York: Routledge.

Chomsky, N. (1970). *Current Issues in Linguistic Theory*. The Hague and Paris: Mouton.

Copjec, J. (1987). "Flavit et Dissipati Sunt." In A. Michelson, R. Krauss, D. Crimp and J. Copjec (eds.), *October: The First Decade 1976–1986*. Cambridge: MIT Press.

Cornell, D. (1991). *Beyond Accommodation: Ethical Feminism, Deconstruction and the Law*. New York and London: Routledge.

——— (1992). *The Philosophy of the Limit*. New York and London: Routledge.

——— (1993). *Transformations: Recollective Imagination and Sexual Difference*. New York and London: Routledge.

Crary, J., and Kwinter, S. (eds.) (1992). *Incorporations*. New York: Zone/MIT Press.

Culler, J. (1975). *Structuralist Poetics: Structuralism, Linguistics and the Study of Literature.* Ithaca, NY: Cornell University Press.

——— (1986, orig. 1977). *Ferdinand de Saussure.* Ithaca, NY: Cornell University Press.

Cytowic, R. E. (1989). *Synesthesia: A Union of the Senses.* New York and Berlin: Springer-Verlag.

——— (1993). *The Man Who Tasted Shapes: A Bizarre Medical Mystery Offers Revolutionary Insights into Emotions, Reasoning and Consciousness.* New York: G. P. Putnam's.

Davies, P. and Gribbin, J. (1991). *The Matter Myth: Beyond Chaos and Complexity.* London: Penguin.

Deleuze G., and Guattari, F. (1983). *Anti-Oedipus: Capitalism and Schizophrenia,* trans. R. Hurley, M. Seem, and H. R. Lane. Minneapolis: University of Minnesota Press.

Derrida, J. (1977). "Limited Inc . . . abc," trans. S. Weber. *Glyph* 11: 172–97.

——— (1981). *Dissemination,* trans. B. Johnson. Chicago: University of Chicago Press.

——— (1982). "The Supplement of Copula: Philosophy before Linguistics." In *Margins of Philosophy,* trans. A. Bass. Chicago: University of Chicago Press.

——— (1984). *Of Grammatology,* trans. G. Spivak. Baltimore and London: Johns Hopkins University Press.

——— (1985a). "Semiology and Grammatology: Interview with Julia Kristeva." In *Positions,* trans. A Bass. Chicago: University of Chicago Press.

——— (1985b). "Freud and the Scene of Writing." In *Writing and Difference,* trans. A. Bass. London, Melbourne and Henley: Routledge & Kegan Paul.

——— (1985c). "Positions: Interview with Jean-Louis Houdebine and Guy Scarpetta." In *Positions,* trans. A. Bass, Chicago: University of Chicago Press.

——— (1986). "Proverb: 'He that would pun . . .,'" in J. P. Leavey Jr. (ed.), *GLASsary,* trans. J. P. Leavey Jr. Lincoln and London: University of Nebraska Press.

——— (1987). *The Truth in Painting,* trans. G. Bennington and I. McLeod. Chicago: University of Chicago Press.

——— (1988). "Afterword: Toward an Ethic of Discussion." In *Limited INC,* trans. S. Weber. Evanston IL: Northwestern University Press.

——— (1991). "'Eating Well,' or the Calculation of the Subject: An Interview with Jacques Derrida," (Interview with J-L. Nancy), trans. P. Connor and A. Ronell. In E. Cadava, P. Connor, and J-L. Nancy (eds.), *Who Comes After the Subject.* New York and London: Routledge.

——— (1994). *Specters of Marx: The State of the Debt, the Work of Mourning, and the*

New International, trans. P. Kamuf. New York and London: Routledge.
——— (1995). *The Gift of Death*, trans. D. Wills. Chicago: University of Chicago Press.
Dery, M. (1993). *Flame Wars: The Discourse of Cyberculture*. Durham, NC: Duke University Press.
Descartes, R. (1968a). *Discourse on Method*, trans. F. E. Sutcliffe. Harmondsworth, UK: Penguin.
——— (1968b). *Meditations*, trans. F. E. Sutcliffe. Harmondsworth, UK: Penguin.
Descombes, V. (1986). *Objects of All Sorts: A Philosophical Grammar*, trans. L. Scott-Fox, and J. Harding. Baltimore: Johns Hopkins University Press.
Dibbell, J. (1993). "A Rape in Cyberspace: How an Evil Clown, a Haitian Trickster Spirit, Two Wizards, and a Cast of Dozens Turned a Database into a Society." *The Village Voice* (December 21) 38, 51: 36–42.
Didi-Huberman, G. (1984). "Une notion du 'corps cliché' au xixe siècle." *Parachute* 35: 8–14.
——— (1987a). "The Figurative Incarnation of the Sentence: Notes on the 'Autographic' Skin." *Journal* 47, 5: 66–70.
——— (1987b). "The Index of the Absent Wound (Monograph on a Stain)." In A. Michelson, R. Krauss, D. Crimp and J. Copjec (eds.), *October: The First Decade 1976–1986*. Cambridge: MIT Press.
Donna, K., and Grosvenor, G. M. (1966). "Ceylon." *National Geographic* 129, 4: 447–97.
Eagleton, T. (1983). *Literary Theory: An Introduction*. Oxford: Blackwell.
Einstein, A., Podolsky, B., and Rosen N. (1935). "Can Quantum-Mechanical Description of Physical Reality Be Considered Complete?" *Physical Review* 47: 777–80.
Foster, H. (1986). *The Anti-Aesthetic: Essays on Postmodern Culture*. Port Townsend, WA: Bay Press.
Freadman, A. (1981). "On Being Here and Still Doing It." In P. Botsman, C. Burns, and P. Hutchings (eds.), *The Foreign Bodies Papers: Local Consumption Series 1*. Sydney: Local Consumption Publications.
——— (1986). "Structuralist Uses of Peirce: Jakobson, Metz et al.," In T. Threadgold, E. A. Grosz, G. Kress, and M. A. K. Halliday (eds.), *Semiotics, Ideology, Language*. Sydney: Pathfinder Press.
Fuss, D. (1989a). *Essentially Speaking: Feminism, Nature & Difference*. New York and London: Routledge.
——— (1989b). "'Essentially Speaking': Luce Irigaray's Language of Essence." *Hypatia: A Journal of French Philosophy* 3: 362–80.
Gadet, F. (1989). *Saussure and Contemporary Culture*, trans. G. Elliott. London: Hutchinson Radius.
Gallop, J. (1982). "Writing and Sexual Difference: The Difference Within." In E.

Abel (ed.), *Writing and Sexual Difference*. Brighton and Sussex: Harvester Press.

——— (1983). "Quand Nos Lèvres S'Écrivent: Irigaray's Body Politic." *Romanic Review* 74, 1: 77–83.

——— (1988). "Lip Service." In *Thinking Through the Body*. New York: Columbia University Press.

Gasché, R. (1979). "Deconstruction as Criticism." *Glyph* 6: 177–215.

Gatens, M. (1991). "A Critique of the Sex/Gender Distinction." In S. Gunew (ed.), *A Reader in Feminist Knowledge*. London and New York: Routledge.

Gibson, W. (1986). *Neuromancer*. London: Grafton.

Grosz, E. (1989). *Sexual Subversions: Three French Feminists*. Sydney: Allen and Unwin.

——— (1990). "Conclusion: A Note on Essentialism and Difference." In S. Gunew (ed.) *Feminist Knowledge: Critique and Construct*. London: Routledge.

——— (1992–93). "Lived Spatiality: Insect Space/Virtual Sex." *Agenda* 26–27: 5–8.

Grusin, R. (1996). "What is an Electronic Author? Theory and the Technological Fallacy." In R. Markley (ed.), *Virtual Realities and Their Discontents*. Baltimore and London: Johns Hopkins University Press.

Haraway, D. (1991a). "A Cyborg Manifesto: Science, Technology, and Socialist-Feminism in the Late Twentieth Century." In *Simians, Cyborgs, and Women: The Reinvention of Nature*. New York: Routledge.

——— (1991b). "Cyborgs at Large: Interview with Donna Haraway." In C. Penley and A. Ross (eds.), *Technoculture*. Minneapolis: University of Minnesota.

Harris, R. (1983). *Course in General Linguistics*, La Salle, IL: Open Court.

——— (1986). *The Origin of Writing*. La Salle, IL: Open Court.

——— (1987). *Reading Saussure: A Critical Commentary on the Cours de linguistique générale*. London: Duckworth.

Harrison, E. (1985). *Masks of the Universe*. New York: Macmillan.

Hawkes, T. (1977). *Structuralism and Semiotics*. London: Methuen.

Hayles, K. (1993a). "Virtual Bodies and Flickering Signifiers." *October* 66: 69–91.

——— (1993b). "The Seductions of Cyberspace." Unpublished paper, Humanities Research Institute Conference, "Located Knowledges," UCLA, April.

Heath, S. (1978). "Difference," *Screen* 19, 3: 50–112.

Heim, M. (1992). "The Erotic Ontology of Cyberspace." In M. Benedikt (ed.), *Cyberspace: First Steps*. Cambridge: MIT Press.

Hjelmslev, L. (1961). *Prolegomena to a Theory of Language*, trans. F. S. Whitfield. Madison: University of Wisconsin.

Huyssen, A. (1981–82). "The Vamp and the Machine: Technology and Sexuality in Fritz Lang's Metropolis." *New German Critique* 24–25: 221–37.

——— (1986). "Mapping the Postmodern." In *After the Great Divide: Modernism,*

Mass Culture, Postmodernism. Bloomington, IN: Indiana University Press.

Irigaray, L. (1977). "Women's Exile," trans. C. Venn. *Ideology and Consciousness* 1 May: 62–76.

—— (1985a). *This Sex Which Is Not One*, trans. C. Porter with C. Burke. Ithaca, NY: Cornell University Press.

—— (1985b). *Speculum of the Other Woman*, trans. G. C. Gill. Ithaca, NY: Cornell University Press.

—— (1985c). "Is the Subject of Science Sexed?" trans. E. Oberle. *Cultural Critique* 1: 73–88.

—— (1991a). *The Irigaray Reader*. Ed. M. Whitford. Oxford: Basil Blackwell.

—— (1991b). *Marine Lover of Friedrich Nietzsche*, trans. G. C. Gill. New York: Columbia University Press.

—— (1992). *Elemental Passions*, trans. J. Collie and J. Still. New York: Routledge.

—— (1993). *je, tu, nous: Towards a Culture of Difference*, trans. A. Martin. New York and London: Routledge.

—— (1994). *An Ethics of Sexual Difference*, trans. C. Burke and G. C. Gill. Ithaca, NY: Cornell University Press.

Jakobson, R. (1987). "Quest for the Essence of Language." In K. Pomorska and S. Rudy (eds.), *Language in Literature*. Cambridge, MA and London: Belknap Press of Harvard University.

Jameson, F. (1981). *The Political Unconscious: Narrative as Socially Symbolic Act*. Ithaca, NY: Cornell University Press.

Jardine, A. (1987a). "Men in Feminism: Odor di Uomo Or Compagnons de Route?" In A. Jardine and P. Smith (eds.), *Men in Feminism*. New York and London: Methuen.

—— (1987b). "Of Bodies and Technologies." In H. Foster (ed.), *Discussions in Contemporary Culture 1*. Seattle: Bay Press.

Jay, G. S. (1987–88). "Values and Deconstructions: Derrida, Saussure, Marx." *Cultural Critique* 8: 153–196.

Johnson, B. (1980). *The Critical Difference: Essays in the Contemporary Rhetoric of Reading*. Baltimore and London: Johns Hopkins University Press.

—— (1985). "Taking Fidelity Philosophically." In J. F. Graham (ed.), *Difference in Translation*. Ithaca, New York and London: Cornell University Press.

Kendrick, M. (1996). "Cyberspace and the Technological Real." In R. Markley (ed.), *Virtual Realities and their Discontents*. Baltimore and London: Johns Hopkins University Press.

Kirby, V. (1987). "On the Cutting Edge: Feminism and Clitoridectomy." *Australian Feminist Studies* 5: 35–55.

—— (1989a). "Corporeographies." *Inscriptions: Journal for the Critique of Colonial Discourse* 5: 103–19
—— (1989b). "Re-writing: Postmodernism and Ethnography," *Mankind* 19, 1: 36–45.
—— (1989c). "Capitalising Difference: Feminism and Anthropology." *Australian Feminist Studies* 9: 1–24.
—— (1991). "Comment on Frances E. Mascia-Lees, Patricia Sharpe, and Colleen Ballerino Cohen 'The Postmodernist Turn in Anthropology: Cautions From A Feminist Perspective,'" *Signs: Journal of Women in Culture and Society* 16, 2: 9–15.
—— (1993). "Feminisms and Postmodernisms: Anthropology and the Management of Difference," *Anthropological Quarterly* 66, 3: 127–33.
—— (1994). "Viral Identities: Feminisms and Postmodernisms." In A. Burns and N. Grieve (eds.) *Australian Women: Contemporary Feminist Thought*. Melbourne: Oxford University Press.
Koerner, E. F. K. (1973). *Ferdinand de Saussure: Origin and Development of His Linguistic Thought in Western Studies of Language: A Contribution to the History and Theory of Linguistics*. Braunschweig, Germany: Vieweg.
Kofman, S. (1989). "Ça cloche," trans. C. Kaplan. In H. Silverman (ed.), *Derrida and Deconstruction*. New York: Routledge.
Kosambi, D. D. (1967). "Living Prehistory in India." *Scientific American* 216, 2: 104–14.
Kress, G., and van Leeuwen, T. (1990). *Reading Images*. Geelong, Victoria: Deakin University Press.
Kristeva, J. (1989). *Language: The Unknown: An Initiation into Linguistics*, trans. A. M. Menke. New York: Columbia University Press.
Kuykendall, E. H. (1984). "Toward an Ethic of Nurturance: Luce Irigaray on Mothering and Power." In J. Trebilcot (ed.), *Mothering: Essays in Feminist Theory*. Totowa, NJ: Rowman and Allanheld.
Lacan, J. (1977). "The Function and Field of Speech and Language in Psychoanalysis." In *Écrits*, trans. A. Sheridan. New York and London: W. W. Norton.
Landow (1992). *Hypertext: The Convergence of Contemporary Critical Theory and Technology*. Baltimore and London: Johns Hopkins University Press.
Laqueur, T. (1990). *Making Sex: Body and Gender from the Greeks to Freud*. Cambridge: Harvard University Press.
Lévi-Strauss, C. (1973). *Tristes Tropiques*, trans. J., and D. Weightman. London: Jonathan Cape.
Lloyd, G. (1984). *The Man of Reason*. London: Methuen.
Lotringer, S. (1973). "The Game of the Name." *diacritics* 3, 2: 2–9.

Luria, A. R. (1968). *The Mind of a Mnemonist*. New York: Basic Books.

McFadden, R. (1991). "Jacking into Lobsters: Images of Masculinity in Virtual Reality Humour." In M. A. Moser (ed.), *Virtual Seminar on the Bioapparatus*. Canada: Banff Centre for the Arts.

Mackenzie, C. (1986). "Simone de Beauvoir: Philosophy and/or the Female Body." In C. Pateman and E. Gross (eds.), *Feminist Challenges: Social and Political Theory*. Sydney, London, and Boston: Allen and Unwin.

Marx, K. (1978). "Economic and Philosophic Manuscripts of 1844." In R. C. Tucker (ed.), *The Marx-Engels Reader*. New York and London: W. W. Norton and Co.

Metz, C. (1974a). *Film Language: A Semiotics of the Cinema*, trans. M. Taylor. New York: Oxford University Press.

—— (1974b). *Language and Cinema*, trans. D. J. Umiker-Sebeok. The Hague: Mouton Press.

Moi, T. (1988). *Sexual/Textual Politics: Feminist Literary Theory*. London and New York: Routledge.

—— (1990). *Feminist Theory and Simone de Beauvoir*. Oxford: Blackwell.

—— (1994). *Simone de Beauvoir: The Making of an Intellectual Woman*. Oxford: Blackwell.

Nancy, J-L., and Lacoue-Labarthe, P. (1992). *The Title of the Letter: A Reading of Lacan*, trans. F. Raffoul and D. Pettigrew. Albany: SUNY Press.

Ogden, C. K., and Richards, I. A. (1956). *The Meaning of Meaning*. New York: Harcourt, Brace & Co.

Ortner, S. (1974). "Is Female to Male as Nature is to Culture?" In M. Rosaldo and L. Lamphere (eds.), *Woman, Culture and Society*. Stanford: Stanford University Press.

Owen, A. R. G. (1971). *Hysteria, Hypnosis and Healing: The Work of J. M. Charcot*. London: Dennis Dobson.

Plato (1875). "Cratylus." In *The Dialogues of Plato, Vol. I*, trans. B. Jowett. Oxford: Clarendon Press.

Plaza, M. (1978). "'Phallomorphic power' and the Psychology of 'Woman,'" *Ideology and Consciousness* 4: 57–76.

Preziosi, D. (1984). "Advances in the Semiotics of the Built Environment." *Semiotica* 49, 1/2: 175–89.

Pugliesi, J. (1991). "Nietzsche's Physio-semiology of Morals: The Political Economy of the Body." In L. Bradshaw, D. Falconer, R. Harling, M. Roberts, and E. Wilson (eds.), *Not My Department: Texts, Disciplines, Margins 1*. Sydney: Not My Department Publications.

Rabinow, P. (1992). "Artificiality and Enlightenment: From Sociobiology to Biosociality." In J. Crary and S. Kwinter (eds.) *Incorporations*. New York: Zone/MIT Press.

—— (1993). "Meta-Modern Milieux—Real Chimera." Unpublished paper, Humanities Research Institute Conference, "Located Knowledges," UCLA, April.

Rajchman, J. (1987). "Postmodernism in a Nominalist Frame: The Emergence and Diffusion of a Cultural Category." *Flash Art* 137: 49–51.

Rheingold, H. (1991). *Virtual Reality*. New York: Simon and Schuster.

Ryan, M. (1979). "Is There Life For Saussure After Structuralism?" *diacritics* 9, 4: 28–44.

Said, E. (1978). *Orientalism*. New York: Vintage Books.

Saussure, F. de (1974). *Course in General Linguistics*, C. Bally and A. Sechehaye with A. Reidlinger (eds.), trans. W. Baskin. Suffolk: Fontana Collins.

Sayers, J. (1986). *Sexual Contradictions: Psychology, Psychoanalysis, and Feminism*. London: Tavistock.

Schor, N. (1986). "Introducing Feminism." *Paragraph* 8: 94–101.

—— (1987). "Dreaming Dissymmetry: Barthes, Foucault, and Sexual Difference." In A. Jardine and P. Smith (eds.), *Men in Feminism*. New York and London: Methuen.

—— (1989). "This Essentialism Which Is Not One: Coming to Grips with Irigaray." *differences* 1, 2: 38–58.

Scott, J. W. (1992). "Experience." In J. Butler and J. W. Scott (eds.), *Feminists Theorize the Political*. New York and London: Routledge.

Sedgwick, E. K. (1990). *Epistemology of the Closet*. Berkeley and Los Angeles: University of California Press.

Sheldrake, R. (1981). *A New Science of Life: The Hypothesis of Formative Causation*. Los Angeles: J. P. Tarcher.

—— (1988). *The Presence of the Past: Morphic Resonance and the Habits of Nature*. London: Collins.

Silverman, K. (1983). *The Subject of Semiotics*. Oxford: Oxford University Press.

Simondon, G. (1964). *L'Individu et sa genèse physico-biologique: L'Individuation à la lumière des notions de forme et d'information*. Paris: P.U.F.

—— (1992). "The Genesis of the Individual," trans. M. Cohen and S. Kwinter. In J. Crary and S. Kwinter (eds.), *Incorporations*. New York: Zone/MIT Press.

Singhan, E. V. (1976). *Timiti Festival*. Singapore: E. V. S. Enterprises.

Sobchack, V. (1993). "New Age Mutant Ninja Hackers: Reading Mondo 2000." In M. Dery (ed.), *Flame Wars: the Discourse of Cyberculture*. Durham, NC: Duke University Press.

Sophia, Z. (1992). "Virtual Corporeality: A Feminist View." *Australian Feminist Studies* 15: 11–24.

Spelman, E. V. (1982). "Woman as Body: Ancient and Contemporary Views." *Feminist Studies* 8, 1: 109–31.

―― (1988). *Inessential Woman: Problems of Exclusion in Feminist Thought*. Boston: Beacon Press.

Spivak, G. C. (1983). "Displacement and the Discourse of Woman." In M. Krupnick (ed.), *Displacement: Derrida and After*. Bloomington: Indiana University Press.

―― (1984). "Marx After Derrida." In W. E. Cain (ed.), *Philosophical Approaches to Literature: New Essays on Nineteenth and Twentieth Century Texts*. Lewisburg, PA: Bucknell University Press.

―― (1987a). *In Other Worlds: Essays in Cultural Politics*. New York: Methuen.

―― (1987b). "Some Scattered Speculations on the Question of Value." In *In Other Worlds: Essays in Cultural Politics*. New York: Methuen.

―― (1989). "In a Word: Interview," (Interview with E. Rooney). *differences* 1, 2: 124–156.

―― (1990a). "Interview with E. Grosz: Criticism, Feminism, and the Institution." In S. Harasym (ed.), *The Post-Colonial Critic: Interview, Strategies, Dialogues*. London and New York: Routledge.

―― (1990b). "The Making of Americans, the Teaching of English and the Future of Culture Studies." *New Literary History* 21: 781–98.

―― (1990c). "Poststructuralism, Marginality, Postcoloniality and Value." In P. Collier and H. Geyer-Ryan (eds.), *Literary Theory Today*. London: Polity Press.

Springer, C. (1991). "The Pleasure of the Interface." *Screen* 32, 3: 303–23.

―― (1993). "Sex, Memories, and Angry Women." In M. Dery (ed.), *Flame Wars: the Discourse of Cyberculture*. Durham, NC: Duke University Press.

Starobinski, J. (1979). *Words Upon Words: The Anagrams of Ferdinand de Saussure*, trans. O. Emmet. New Haven and London: Yale University Press.

Stenger, N. (1992). "Mind is a Leaking Rainbow." In M. Benedikt (ed.), *Cyberspace: First Steps*. Cambridge: MIT Press.

Stone, A. R. (1991). "Background Texts." In F. Dyson and D. Kahn (eds.), *Telesthesia*. San Francisco: San Francisco Art Institute.

―― (1992a). "Will the Real Body Please Stand Up?" In M. Benedikt (ed.), *Cyberspace: First Steps*. Cambridge: MIT Press.

―― (1992b). "Virtual Systems." In J. Crary and S. Kwinter (eds.), *Incorporations*. New York: Zone/MIT Press.

―― (1993), "Split Subjects, Not Atoms; or How I Fell In Love With My Prosthesis." Unpublished paper, Humanities Research Institute Conference, "Located Knowledges," UCLA, April.

Taylor, M. C. (ed.) (1986). *Deconstruction in Context: Literature and Philosophy*. Chicago: University of Chicago Press.

Tomas, D. (1989). "The Technophilic Body: On Technicity in William Gibson's Cyborg Culture." *New Formations* 8: 113–29.

Tucker, R. C. (ed.). 1978. *The Marx-Engels Reader*. New York and London: W. W. Norton.
Turkle, S. (1984). *The Second Self: Computers and Human Spirit*. New York: Simon and Schuster.
—— (1995). "Ghosts In The Machine." *The Sciences* 6, 35: 36–39.
Valéry, P. (1989). "Some Simple Reflections on the Body." In M. Feher with R. Naddaff and N. Tazi (eds.), *Fragments for a History of the Human Body Part Two*. New York: Urzone.
Vasseleu, C. (1991). "Life Itself." In R. Diprose and R. Ferrell (eds.), *Cartographies: Poststructuralism and the Mapping of Bodies and Spaces*. Sydney: Allen and Unwin.
Volosinov, V. N. (1973). *Marxism and the Philosophy of Language*, trans L. Matejka and I. R. Titunik. New York and London: Seminar Press.
Weber, S. (1976). "Saussure And The Apparition Of Language: The Critical Perspective." *MLN* 91: 913–38.
—— (1987). *Institution and Interpretation*. Minneapolis: University of Minnesota Press.
Whitford, M. (1986). "Luce Irigaray and the Female Imaginary: Speaking as a Woman." *Radical Philosophy* 43: 3–8.
—— (1989). "Rereading Irigaray." In T. Brennan (ed.), *Between Feminism and Psychoanalysis*. London and New York: Routledge.
Wilson, I. (1978). *The Turin Shroud*. Harmondsworth: Penguin Books.
—— (1988). *The Bleeding Mind: An Investigation into the Mysterious Phenomenon of Stigmata*. London: Weidenfeld and Nicolson.
Wollen, P. (1972). *Signs and Meaning in the Cinema*. Bloomington: Indiana University Press.

Index

agency, 37–40, 48, 54, 90, 128, 131, 134, 138, 151
Althusser, L., 126
anagrams, of Saussure, 47, 115
anthropocentrism, 67, 157, 164
Anthropology, 2, 152–3
anti-essentialism, 40, 52, 54–5, 69, 72, 75, 78–9, 151, 153
antihumanism, 2, 5, 127
arche-writing, 53, 56
Aristotle, 22–3, 47, 66
Artaud, 155
Aspect, A., 113
autographism, 57–9

Barthélémy, 57–8
Barthes, R., 30, 53–4, 150
Bataille, G., 24
Beauvoir, S. de, 67, 68–9, 80
Being, 25, 61
Benedikt, M., 130–2, 134–6, 140–1
Bennington, G., 90
Benveniste, E., 10, 16–25, 28, 33, 43–46, 53–4, 63–4, 126
Beyond Accommodation, 87
binary oppositions, 56, 59, 64–7, 75, 85, 91–2, 95, 138, 142, 152, 161
biologism, 68
biology, 3, 70, 76–8, 88, 91, 98, 147, 154, 158–9
Blanchot, M., 85–6, 88, 156
Bohr, N., 112

Bourneville, D.M. and Régnard, P., 58
Butler, J., 5, 83–4, 101–28

Cahiers, 28
Cartesianism, 5, 59, 92, 127, 134, 137–42, 144, 147–9; *see also* Descartes, R.
Charcot, 56–60
citation, 48, 66, 121
Cornell, D., 5, 84–99, 102–4, 107
corporeality, 1–5, 9, 70, 80, 84, 86–7, 95, 101, 104, 106, 108, 111, 126, 131, 138, 142, 145–6, 148, 153
Course in General Linguistics, 7, 9, 10–12, 19, 25, 27, 33–5, 41, 53, 62, 111
Critical Studies, 149
Culler, J., 8, 36–7, 40–1, 44
Cultural Studies, 142, 149
cybernetics, 60, 134
cyberspace, 5, 129–44, 148; geography of, 136
Cyberspace: First Steps, 130, 135
cyborg, 134, 146–8

Dalibard, J., 113
Davies, P., 113
deconstruction, 4, 66, 84–7, 97, 104, 113, 125
Deleuze, G. and Guattari, F., 156, 158
dermagraphism, 57–62

Index

Derrida, J., 4, 9, 10, 15–16, 47–8, 51, 53–5, 60–3, 66, 77–81, 83–7, 90–4, 98, 103, 108–110, 115, 125–6, 141, 152, 155–8, 161
Dery, M., 129
Descartes, R., 59, 98, 138–9; *see also* Cartesianism
Descombes, V., 12–16, 21, 64
Dibbell, J., 133
différance, 55, 63, 66, 79, 85–6, 96, 109, 122, 125, 127, 159
Discourse on Method, 139

écriture, 60
Einstein, A., 112
embodiment, 39, 65–7, 70, 75
énonciation, 43
essentialism, 29, 39–40, 52–5, 62, 67–81, 89, 97–8, 151, 153–5, 158–60
ethnocentrism, 62, 137, 164
ethnography, 4, 152

feminism, 2, 67–74, 77, 80, 84, 87, 94, 105, 117, 128, 144, 152–3
Feminists Theorize the Political, 83
Firth, J., 33
Flame Wars: The Discourse of Cyberculture, 129
form/substance, 66, 126; *see also* binary oppositions
Foucault, M., 4, 122, 126–7, 158
Freadman, A., 42–3, 46–7
Freud, S., 57, 59, 74; on mystic writing pad, 78, 81; *see also* psychoanalysis
Fuss, D., 66, 73, 97

Gadet, F., 7–8, 32, 34–5, 65
Gallop, J., 5, 73–8, 80, 126
Gender Studies, 149
Gibson, W., 130, 132
Glas, 15, 16
GLASsary, 16

Glennie, E., 62–3
Godel, R., 34–5
grammatology, 53, 56, 64, 80, 94, 98, 108, 157–8, 160
Grosz, E., 68–71, 155

Haraway, D., 134, 146–7
Harris, R., 7, 14–15, 21, 33
Harrison, E., 113
Hawkes, T., 7
Heidegger, M., 47
Heim, M., 135–6, 140–1, 143
Hjelmslev, L., 35–6
hologram, 64–5
holography, 64, 146
human existence, 20, 24, 52, 61, 102, 109, 129, 137, 139, 142, 151, 157
humanism, 2, 5, 67, 127
hysteria, 56–9

Iconographie photographique del la Salpêtrière, 58
identity, of gender, 87; of humanity, 90, 120; man's, 67, 120; sexual, 67, 95, 146; of the sign, 20, 24, 45, 51, 64, 110, 112, 118, 128; virtual, 140; women's, 67, 88, 98
Irigaray, L., 70–8, 158
iterability, 121–5

Jakobson, R., 10, 16, 35–7, 56
Jay, G. S., 51

Kant, I., 5
Koerner, E., 7, 26
Kofman, S., 79
Kristeva, J., 10, 120

Lacan, J., 102, 116–20, 124, 126–7
Laclau, E., 124
langue, 10, 27–8, 30–32, 37–8, 40–6, 64–5

Index

Lanier, J., 130, 141
linguisticism, 90, 108–9, 114
linguistics, 7–9, 12–14, 18–20, 26–7, 30, 32–3, 36, 40–8, 52–4, 63–4, 108, 115, 159
Lotringer, S, 48

MacKinnon, C., 88–9, 91, 99
Marx, K., 154, 156, 158
masculinism, 137, 143–5
materiality, 9, 14, 20, 55–6, 61, 70–3, 86, 89, 92, 95, 102–5, 108, 110–14, 125, 158
Meaning of Meaning, The, 12
Meditations, The, 139
metaphysics of presence, 79, 86, 92–3, 95–6, 118, 140
Metz, C., 64
mimicry, 57, 106
mind/body, 2, 5, 59, 73, 76, 92, 126, 138–9, 142, 148; *see also* binary oppositions
modernism, 67, 76
Moi, T., 71–2
Mondo 2000, 130, 132
morphology, 53, 70, 77, 79–80, 126, 151, 158
Mouffe, C., 124

naturalism, 68
nature/culture, 2, 4–5, 52, 61, 68–70, 75, 101, 110, 128, 147, 152, 157–160; *see also* binary oppositions
Neuromancer, 132
nomenclature, 10–11, 17, 19, 28, 39, 52

Ogden, C. And Richards, A., 12
Orientalism, 160

parole, 38, 40–3
particles, 112–13
Peirce, C. S., 42–3, 86

performativity, 78, 98–9; Butler on, 104, 121
phallocentrism, 55, 62, 72–5, 79–80, 99, 117, 119, 164
Philosophy of the Limit, The, 84, 87.
Podolsky, B., 112
poétique du corps, 75, 77–8, 158
poiésis, 76–7
postmodernism, 2, 4, 52, 54, 83–4, 99, 101–2, 127, 138, 143, 145, 147, 150–3, 159
poststructuralism, 83–4, 127
psychoanalysis, 5, 59, 77, 116, 118–19, 123, 143–4, 146, 156

quantum physics, 23, 112–13
Questions de poétique, 37

referent, 12–14, 17, 19, 21, 28–9, 44, 74, 76–7, 80, 88–9, 102–3, 108, 111, 117, 121, 123
reiteration, 17, 33, 40, 102, 122
repetition, 79, 81, 88, 94–5, 116, 121–22, 138, 142, 150
representation, 2, 5, 10–14, 18, 20, 25, 29, 45, 52, 55, 57, 60–4, 70, 78, 84, 86, 88–99, 102, 106–9, 111, 114, 116, 128, 131, 134–5, 137–8, 140, 146–60
Rheingold, H., 131, 143
Roger, G., 113
Rooney, E., 154–5, 159–60
Rosen, N., 112
Ryan, M-L., 12, 14–15

Said, E., 160
Saussure, F. de, 4, 7–48, 52–5, 62, 64–6, 89–90, 108, 111, 115, 159
Second Sex, The, 67
Scott, J.W., 83
semiology, 10, 53, 108, 115
semiotic, 37, 44, 62–3

sexual difference, 66–8, 77, 79–80, 87, 90, 92, 94, 133, 138, 148, 156, 158, 160
sign, 32, 111; arbitrary nature of, 9, 16, sign *(cont.)*, 18, 29, 31, 52; linguistic, 10, 14, 16, 17, 43, 44, 54, 108; Platonic conception of, 10
signification, 12, 15, 24, 27–9, 43, 45, 54–6, 66, 83, 93, 102–3, 107, 110, 115, 117, 119, 123, 125–6
Sobchack, V., 132
somatophobia, 55, 73
Sophia, Z., 142–5
Spelman, E., 80
Spivak, G.C., 80, 97, 154–6, 158–60
Starobinski, J., 8, 47
Stenger, N., 131
Stone, A.R., 132–4, 138–40, 142–5
subject/object, 59; *see also* binary oppositions
subjectivity, 45, 67, 115, 117, 138, 140, 143, 144, 156–8; humanist, 127, 151; inter-subjectivity, 152, 157; sexed, 152
supplementarity, 5, 73, 87, 114, 119, 124–6, 131, 133, 142, 145

Taylor, M., 24, 85, 156
technology, 114, 129, 133–45, 148, 151
teledildonics, 131, 143
textuality, 2, 4, 76–7, 83–4, 90, 92, 94–5, 104, 109, 122, 140, 160
thaipusam ritual, 3
transcendental signified, 31, 54
Turing, A., 136

undecidability, 52, 103
universalism, 68–9, 155

Valéry, P., 65, 73
value, Marxian, 158; Saussure's theory of, 17, 26–9, 33, 44, 46, 49, 52, 55, 64–5, 112, 115
Village Voice, The, 133
virtual reality, 5, 130–1, 133, 135, 138, 140, 142–4, 148
visual arts, 64

West, R., 88–9, 91, 98, 137
Wired, 130
Wollen, P., 64

Žižek, S., 115–19, 123–4